# A PERFECT DAY FOR A WALK

# A PERFECT DAY *for a* WALK

The History, Cultures, and
Communities of Vancouver, on Foot

## BILL ARNOTT

ARSENAL PULP PRESS
VANCOUVER

A PERFECT DAY FOR A WALK
Copyright © 2024 by Bill Arnott

ARSENAL PULP PRESS
Suite 202 – 211 East Georgia St.
Vancouver, BC V6A 1Z6
Canada
*arsenalpulp.com*

The publisher gratefully acknowledges the support of the Canada Council for the Arts and the British Columbia Arts Council for its publishing program and the Government of Canada and the Government of British Columbia (through the Book Publishing Tax Credit Program) for its publishing activities.

Arsenal Pulp Press acknowledges the xʷməθkʷəy̓əm (Musqueam), Sḵwx̱wú7mesh (Squamish), and səlilwətaɬ (Tsleil-Waututh) Nations, custodians of the traditional, ancestral, and unceded territories where our office is located. We pay respect to their histories, traditions, and continuous living cultures and commit to accountability, respectful relations, and friendship.

Cover and text design by Jazmin Welch
Maps by Jazmin Welch
Edited by Catharine Chen
Proofread by JC Cham

Printed and bound in Canada

Library and Archives Canada Cataloguing in Publication:
Title: A perfect day for a walk : the history, cultures, and communities of Vancouver, on foot / Bill Arnott.
Names: Arnott, Bill, 1967– author.
Description: Includes bibliographical references and index.
Identifiers: Canadiana (print) 20240317963 | Canadiana (ebook) 20240317998 | ISBN 9781551529639 (softcover) | ISBN 9781551529646 (EPUB)
Subjects: LCSH: Walking—British Columbia—Vancouver—Guidebooks. | LCSH: Neighborhoods—British Columbia—Vancouver—Guidebooks. | LCSH: Vancouver (B.C.)—Guidebooks. | LCGFT: Guidebooks.
Classification: LCC FC3847.18 .A76 2024 | DDC 917.11/33045—dc23

*For those who explore and discover,*
*wander, and wonder*

*In nature, we never see anything isolated, but everything in connection with something else before it, beside it, under it, and over it.*
—JOHANN WOLFGANG VON GOETHE

# CONTENTS

# AUTHOR'S NOTE

THERE'S A QUOTE that I like from William Fiennes, in his book *The Snow Geese*, a travel memoir inspired by the lovely and tragic old novel *The Snow Goose*. In his book, Fiennes ventures from England across the Atlantic, then from the US through Canada, all the while tracking the migration of snow geese, following the birds as they make their way north. En route, the excursion becomes introspective—the author's very own migration, as well as a homecoming. The quote I like captures the gist of his expedition, discovered as geography unfolds: "We tend towards home."[1] An idea that could well apply to any and every journey, perhaps starting with Homer's *The Odyssey*, which may be the first travelogue, albeit fiction and shared as a poem. I find that circularity of excursions and exploration appealing—steering us back to where we began, ideally with fresh insight and knowledge. At least that's the idea, most often. Not including getaways designed for just getting away, having fun, and *not* reading Homer.

My own little odyssey walking throughout Vancouver also tends toward home. Ranging from a few city blocks to a couple of half-marathon, twenty-kilometre days, these strolls have taken place over a span of six months, October to March. Setting aside solstices, it's been autumn and winter with a taster of spring. References to weather, streetscapes, and clothing reflect this finite city window. Summers here are lovely as well, with plenty of sun and warm weather. But for this book, I've shared a select calendar swath that I feel works well on several levels.

Geography too—where I walk—has been arbitrary, radiating out more or less from my home, with dotted-line boundaries I've created for

my view of Vancouver. In part because it's convenient and, for me, walkable, and also because I find the array of artwork and artifacts, history and stories, particularly rich where I live, here on Musqueam, Squamish, and Tsleil-Waututh land. But to give it parameters, I've focused my walks south of Burrard Inlet, west of Main Street, and, for the most part, north of West 16th Avenue. To the west, beaches blend with UBC and the sea, a scenic ellipsis in blue. I feel West 16th is a tidy yet flexible southern border, as it once served to delineate railway and city township lands. It was a muddy, forested ditch that became a tree-lined street where my nana and gramps made their home, so there's a personal tie-in as well. In a way, it's a stamp, an imaginary flag planted in dirt. Not unlike a posted map of the city I once passed along Granville; the layout was a bit vague, only useful if the viewer already knew the lay of the land. On the map, there was no dot or *X*, simply words: "You Are Here." Which I liked. And I thought, *Of course I am. Where else could I possibly be?* A reassuring statement of the obvious, applicable to anyone, anywhere, anytime.

Another reason I chose the roughly drawn boundaries that I did is because the area encapsulates a good cross-section of Vancouver neighbourhoods, museums, galleries, beaches, greenways, and walkways, and it incorporates the various "birthplaces" of the city's iterations from Gastown and Granville to Vancouver, acknowledging the fact this is all Indigenous land and bringing home the notion that history, artifacts, stories, and myth reside collectively in a ragged-edged quilt on this bustling crescent of forested seaside.

Going home is what I've done as part of each walk, peeling back city layers, meeting people, hearing stories, even writing a bit of haiku, a tone for each neighbourhood—maybe a nod to *The Odyssey* too—while maintaining the comfortable pace of a stroll. Several, in fact. I hope you enjoy my sharing the area in this manner, where it's nearly always a perfect day for a walk.

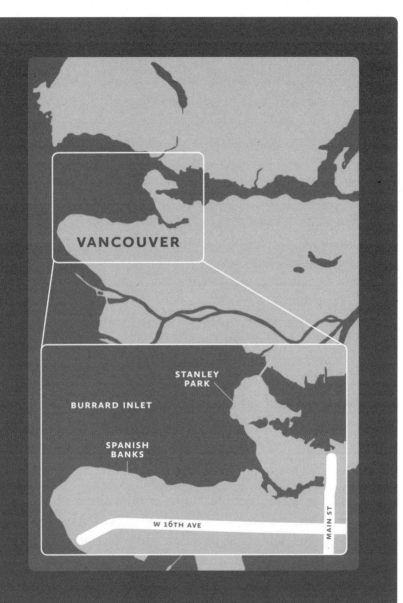

# INTRODUCTION

THE CROWS ARE in flight, reminders of omens and overcast skies. But this day is different, a horizon layered in gold as the birds start their day, crossing Vancouver from rookery homes in cottonwood trees and flying to parkland and seashore. I can gauge the day in their flight, I believe, with a glance out a window at sunrise. Are the crows flying high? Flying low? Flapping and tacking or gliding in ruler-straight lines? And no, I won't say "as the crow flies." Too obvious. Plus, I've seen them weave in meandering updrafts emitted by blacktop, the roadway curving the same as their flight path.

Beyond the black corvids, their very presence a measure of space and of time, this is a book about Vancouver, a place that I love because, and in spite of, its makeup. Visual beauty and grit, history as multi-layered as anywhere, all of it nestled in mountains and cuddled by sea. A high-rise pincushion of steel and glass needles tucked between bodies of water. Or, rather, a single saltwater body with a great many arms, a kraken embracing the metropolis, giving an extra good squeeze. The city motto? "By sea land and air we prosper."[2] Although it needs punctuation, the message is clear, a blend of optimism and aspiration. This is indeed a prosperous centre, abundant yet rife with lack. In other words, a city—thriving, striving, surviving, a conglomerate of culture and hope.

A few facts, to start: Vancouver is one of the country's most diverse cities, English *not* being the first language of half the population. Most of its residents are what the Government of Canada labels "visible minorities." It's laughable, at best ethnocentric when a majority is deemed a minority—in other words, not white. This sprawl of humanity continues to rank as one of the world's most livable cities, as well as one of the most expensive.

Search the city, online or in person, and what you find tends to loop, descriptors repeating in soundbites and slogans: scenic views, mild climate, unparalleled natural beauty, ocean and mountains and living outdoors. An online snippet I read poses the seemingly simple question, "Is Vancouver a good or bad city?" One reply in the chat makes me smile: "Yes it is." Another answer offers much more: "It's a lovely city, one of the world's most beautiful, provided you can afford to enjoy it." And therein lies a rub. *The* rub, perhaps, one of an endless array of puzzles and queries surrounding the city of Vancouver.

I've lived here for almost four decades. It's my home, here on Musqueam, Squamish, and Tsleil-Waututh land. And while I've lived in many of its neighbourhoods, much of it will forever feel new. Not merely new buildings, but a recurring burble of the unfamiliar fuelling a sense of discovery each time I step out the front door, as though I'm a tourist, an explorer, an adventurer here, where I live and work.

Exploration and discovery, however, unveil further questions. What exactly am I seeing out there? Who made it like this? Why is it this way? And what will it be like tomorrow? These questions drive me to examine this city, to better comprehend its "sea land and air," its scenic views and natural beauty—something I'm doing on foot.

I could rattle off quotes about the imperativeness of walking to truly experience a place, but that's neither fair nor accurate. A bus or a train may accomplish the very same thing. Mobility might vary. But for me, feet are a preferred mode of transport. Rousseau stated that he could only think when he walked. A part of me feels the same way. Novelist Flann O'Brien claimed that every step we take actually infuses some of the path we travel, an ingestion of places we wander. So for now, I'll be walking, slowing my pace to better absorb this city and see what questions I answer, what else I reveal here in Vancouver, my home.

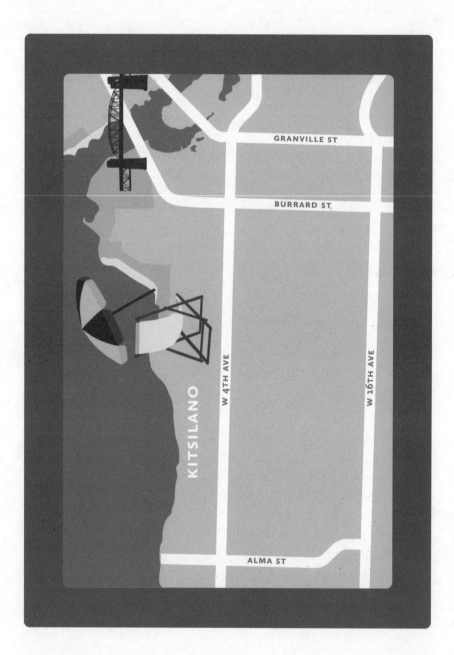

# Kitsilano

*sun rises and yawns*
*    as sea stretches, rolls over*
*        the crows start their day*

THE MORNING BRIGHTENS as I make my way north from the east edge of Kits, or Kitsilano, named for Squamish Chief August Jack Khatsahlano. Passing the retail of West 4th Avenue, I walk a few blocks to the mouth of False Creek, past the Vancouver Maritime Museum, where a leafy deciduous houses a bald eagle's nest. Most of the sticks overhead look like logs you might toss on a fire, the size of an arm or a leg. The large nest was moved a few years ago, having served generations of bald eagles where it perched in Vanier Park's highest tree, a towering poplar. According to local birders, a breeding pair also lived under the Granville Street Bridge, like two feathered trolls, but all I've ever seen in those high metal rafters are pigeons and slick black-dart cormorants.

Dogs are barking and splashing along Hadden Beach, a sandy off-leash space I can't help but see as an oceanside litterbox. We should be so lucky to have such a view from our toilets. But the furry friends are having a fine morning, as their owners stare at the water. And I leave them all to it, chewing on sticks and dreaming of life at sea.

Following the curl of the path, I walk to the end of a finger of land: Elsje Point. The promontory offers a panorama, west to east, east to west, a sweep of city and inlet. At the end of the point, there's a rock with a chain linked to an anchor, as though this slim spit of land is a lopsided vessel contemplating drifting away.

I trudge over grass that's slightly muddy and bunched into clumps to the *Ben Franklin* submersible that fronts the Maritime Museum. Something about it screams Jules Verne and a whole bunch of leagues undersea. The craft, a steel sausage in yellow and white, looks like a squat submarine, but I learn that submarines tend to be longer-voyage vessels, whereas submersibles usually have additional ship support, leaving us to imagine what the view might be like, peering through portholes deep in an undersea trench.

But this craft *did* have a crew and undertook a remarkable journey—not quite twenty thousand leagues, but still advanced for its time. Built in 1968, its role was to explore and research the Gulf Stream, the Atlantic current first charted in 1770 by Benjamin Franklin, thus the ship's name. The submersible's maiden voyage was from Florida to Halifax in the summer of 1969. Yes, Summer of '69. Song-worthy for sure, but tough to find lyrics that rhyme with *submersible.*

Notably, the *Ben Franklin* expedition was of interest to NASA, far beyond the data being gathered by the underwater team. The space agency was eager to know how a team of scientists would adapt to and endure a month-long voyage in a cramped workspace with sensory deprivation, as a crewed mission to Mars was being planned—still is, in fact, with the same Ben Franklin data gathered back then being used to this day.

The submersible's expedition went well, the craft propelling into Halifax a month after bobbing out of Florida. The news of the *Ben Franklin*'s success, however, evaporated almost immediately as *Apollo 11* made its historic moon landing at the very same time. Now, as I circle the vessel, I can see a last trace of that silvery moon fading in chalky blue sky, still snubbing this sea-salted ship.

With the show-stealing moon almost gone, I carry on, my view now a wispy cloud sky with the art deco loom of Burrard Bridge. For bridge

connoisseurs, this one's three spans with two truss types: a Pratt truss for the high midsection that boats pass beneath, and Warren trusses on the close-approach spans, that is, the end bits. Four concrete towers hold it in place, while two galleries connect both pairs of northern and southern towers. From these, two ornamental ship prows protrude, one topped by a bust of Sir Harry Burrard Neale, the other by a likeness of Captain George Vancouver, each sporting a respective initial: *B* and *V*.

The bridge now overhangs the Senáḵw construction site, at present "the largest First Nations economic development project in Canadian history," an expansive initiative slated for multiple towers and a few thousand new homes. According to its builders, Senáḵw translates to "the place inside the head of False Creek," literally placing it on the map.[3] For years, I would pass two cedar carvings—no longer here—on the south side of the bridge, just east of its trusses and towers. They were tall totems depicting *O Siem*, a traditional Salish greeting of welcome, with their palms held open, inward and upward. It's an expression of gratitude too, fitting in this coastal enclave, the inlet narrowing to False Creek, a watery entrance to the city.

No one seems to know where the totemic statues have gone. Maybe they wandered off, tired of the noise of construction. But the site will be a version of this for a decade, with cranes surrounding the bridge: new towers, latticed trusses in red-painted steel. The ground too is being reborn. I peer through a wire fence to a plummeting pit, which will eventually be a parking garage. Here the land is clay over sandstone and shale. A bit north, we'd hit granite, the metamorphic coastal expanse, igneous rock from bygone volcanoes.

I find the first of a series of plaques called Places That Matter, Vancouver Heritage Foundation installations I can use to plot a course across the city, a trail of bread crumbs through time. According to Musqueam First Nation historians,

> The area now known as Burrard Inlet is host to numerous Musqueam villages, camps, and transformer sites. It was connected by water ways, trails, histories, and genealogies to other villages throughout our territory ... Burrard Inlet was also part of our core hunting and

fishing area. Our families stayed at səńaʔqʷ [Seńáḵw] while hunting elk and waterfowl. səńaʔqʷ was also important for harvesting and processing salmon, sturgeon, and smelt that frequented False Creek and its many streams, many of which have been lost to urbanization and development.

The notion of historical trails, that infusion of paths that we travel, lingers as I deviate to another spur path tamped by a few thousand feet, what would have been shaded by totems now a small arboretum called Cultural Harmony Grove. The name alone induces a peacefulness. My pace slows as I weave between trees—cedar and maple, crabapple, windmill palms, even a monkey puzzle tree stretching and poking the sky. There's dogwood and birch, foxglove and snowbell, names that rattle into a poem. I retrace my steps and recite the flora, concocting a potion or spell. All I need is eye of newt for something a wizard might conjure.

By the pocket of park, a sign warning of coyotes sits next to a palm tree, a small gnarly spruce, and the buttressed wood end of what was a railway and trolley car bridge. A pair of crows have alighted where the two totems once stood, leaving me to wonder if they're related, placeholders perhaps, standing guard until the totems return.

The white noise of traffic hums from the bridge, a soft rumble of trusses and towers. Underneath are rock reinforcements in gabion wire and bricks made of stones, each the size of a crumbling Moai head. I've retraced my steps, now westbound, past a coast guard station that used to be here, then it wasn't, and now it's back once again. Different budgets and electoral promises.

Through a corridor of poplar and beech, an extension's being added to an L-shaped pier; a crane hoists huge floating slabs into place. Behind me is a transition of Vanier Park outdoor events. The Bard on the Beach Shakespeare Festival takes place here in the summer, with stage tents and flags that have the feel of a medieval fete. Now, a skeletal marquee is exposed, as though captured mid open-heart surgery, pried ribs gaping into the sky.

Out in the bay: no cruise ships today. Wrong time of day, wrong season as well. The inlet, however, is still busy with commerce; anchored

ships await their turn at the Port farther east. A songbird skitters through rocks at the shore, where a boulder is topped with a heap of cleanly scraped clamshells. Diners done with their feast, the rock is now an avian midden.

There's a heady aroma of leaves slowly mulching paired with the essence of sea. Behind me are the Museum of Vancouver and the H.R. MacMillan Space Centre, just a short stroll from the Maritime Museum, with its Beatlesesque yellow submarine. Sorry, submersible. I size up the ships in the bay: tankers, bulkers, freighters, some empty, some full. Waterlines telling their tale like long-distance trucks at a weighing scale, their profiles are an indicator of what each ship carries: goods in containers, fuel in tankers, ore in bulkers, ships with customized cranes to haul lumber. "By sea land and air we prosper." And I think of a quote from reporter Tom Zoellner: "If you want to understand the soul of a city, look at the economic reasons for its founding."[4]

The paddle and flap of a few waterbirds melds with the calls of seagulls and crows. Two geese fly away in a futile attempt at a *V*. Overhead, ducks flying west are shifting through letters—*U, W, J*—their flight path a tentative cursive. A high-pitched hum, a near whine, as two buffleheads pass. A pintail swallows a wriggling fish; silver flashes as the fingerling thrashes. Behind me, footprints traipse through wet grass.

I pause on the south side of Hadden Park, where the Centennial Totem Pole stood before its removal for restoration.[5] Carved by Kwakwaka'wakw artist Chief Mungo Martin, along with his son, David Martin, and his nephew, Henry Hunt, it was raised in 1958, commanding the space, a cultural beacon. Something used by a great many people as a landmark, it strikes me as a kind of sundial too, one measuring time immemorial.

Veering to the low rise of Vanier Park, my route becomes a circle in a spiral. This gusty point of land is a favourite for kite flyers. On the soft promontory is a massive steel sculpture: the outline of a square, but a square with a pried-open base. From a side, the installation resembles a walker striding the grass, geometry midstroll. The sculpture, *Gate to the Northwest Passage*, was constructed in 1980 by Alan Chung Hung.[6] It's a beast at over four and a half metres each side, the

split lower portion comparable to the twist of a splayed paper clip. The result, a blocky square arch, was designed to commemorate Captain George Vancouver's arrival here in the summer of 1792 in his ship HMS *Discovery*, along with HMS *Chatham*. Vancouver and Harry Burrard Neale, the captain's colleague and friend, are the two who are initialled on the multitrussed bridge beyond.

Gazing through the square of the sculpture from any angle, you can't help but see it as a photo or a window, yourself as a director previewing a scene, holding index fingers and thumbs in an outline, getting a mood into frame. Once again I circle the installation, admire the clean, simple shape, the soft corrosion of steel, with a knife of discomfort, knowing the results of that empiric exploration: decimation following the race to "Discovery," a grisly wake trailing those vessels.

I consider the welcoming carvings by the bridge, now moved on—relocated, same as the Centennial Totem. Another stab of unease, then I see the new growth of Senákw, carved land now in brilliant sun. And with it, a slice of renewal.

⟶

Methodically weaving through Kitsilano, I cross numbered avenues and streets named for trees: Cypress, Maple, Arbutus. Affixed to an oak is a commemorative plaque to Wong Foon Sien, the "Mayor of Chinatown." Born in China in 1899, Wong moved to BC with his parents in 1908, first to Vancouver Island and then to Vancouver. After graduating from UBC, he worked for the provincial attorney general as a translator, later becoming a journalist. Part of Victoria's Chinese Canadian Club and the Chinese Benevolent Association of Vancouver, Wong was instrumental in efforts to fight discrimination and to improve immigration and labour rights. Known as the spokesman for Chinatown, he's considered by many to be "Chinatown's most influential person."[7]

Chinese history goes back a long way around here. If I were to skip a stone to the west, have it leap the Salish Sea and Vancouver Island, it would strike Nootka Sound, where fifty Chinese craftsmen arrived in 1788 with Captain John Meares, their role to establish an otter pelt

trade from what's now BC to Guangzhou.[8] It would be a few decades more until the next influx of Chinese settlers arrived in 1858 with the discovery of Fraser River gold, workers looking to earn and send money to family "back home." Something that hasn't changed for a great many people.

Over wet grass, pea gravel, and dirt, squirrels lope between maples. Crows rake and flip leaves with their beaks. I see outlines of faces in burls on beech trees. Now I follow sidewalks through neighbourhood homes, past a bush of plump rosehips and maples in yards. Chickadees and towhees flit in a garden. The *scrape rattle grate* of a shuffling crow emanates from a house's eaves. A school is being rebuilt—seismic upgrades and earthquake preparedness. On a perimeter fence hangs a sign with "Every Child Matters" in bold orange letters. Underneath maple and oak along Walnut Street, a memorial stands to a neighbourhood dog.

A tall stately house fronts the street, with stairs to its weathered veranda on Maple near Cornwall Street: the home of Major James Skitt Matthews, who arrived in the city in 1898. A traveller, inventor, and collector, in 1911 he built this house, a space that still looks inviting. His acquisition of things would continue, this family home slowly filling with printed records and city legends. Today he might qualify as a hoarder, but back then the major's accumulated historical documentation was aptly seen as invaluable. In 1933, Matthews was named Vancouver Archivist, a role he filled for four decades, with his collection becoming the city's first archival holdings. According to historian Jean Barman, "Matthews is arguably the single most important individual in the history of Vancouver."[9]

Which brings me to the site of a neighbourhood mystery. Lumps in the street could pass for hastily buried treasure, like someone was desperate to hide something with asphalt. Which it does, in a way. This is one end of Kitsilano's "hidden" streetcar line, which ran on a diagonal through the neighbourhood to what was Greer's Beach and is now the sandy shoreline of Kitsilano Beach, with its volleyball nets, a few logs for backrests and seats, grass slopes, and picnic tables, all comprising Kits Beach Park.[10]

The streetcar came here via downtown, veering from Granville Street on the north side of False Creek and crossing the water on a low swing bridge, the truncated south butt of what I passed where the crows and two totems stood. The streetcar system was a leap for the city, electric trolleys taking the place of horse-drawn cars in 1890–91. The technology alone was cutting edge. The city not only introduced electric mass transit, but street lights as well. The *Vancouver Sun* reported the story, with two lines that still make me chuckle: "Expert electrical engineers say there is absolutely no danger of a shock while on or about a car. Employees often receive slight shocks while operating the cars, but thus far there have been no ill effects."[11] In other words, nothing to worry about, only the staff are being electrocuted. And even *that's* mild.

I remember my gramps explaining how, when he arrived in Vancouver following the First World War, he rode trolley cars to orient himself with the city, a rough series of squares downtown along Cambie and through Kerrisdale and Kitsilano, one sliver of which is buried under my feet. I imagine the jostle and vibrating hum. A sense of modernity, elevated and clean, no more dodging horseshit on streets. Maybe a curse from the operator following another mild shock. Aptly enough, a trolley bus careens by on West 4th, a hint at that past, as electric buses took over in 1948, expanding transit.

On West 2nd Avenue I come to the site of North America's first gurdwara, or Sikh temple, built in 1908 and run by the Khalsa Diwan Society.[12] A social, spiritual, cultural, and economic hub for Vancouver's growing Sikh population, the gurdwara served immigrants who'd been arriving in BC from India since 1903. The temple soon became a political centre as well, spearheading social justice campaigns brought about on the heels of the SS *Komagata Maru* incident.

The *Komagata Maru* was a vessel that sailed from India in 1914, the cusp of the First World War, transporting would-be immigrants to Canada, their destination: the Port of Vancouver. Those aboard, like those having come here since 1903, considered the relocation an uncomplicated emigration, citizens of the British Empire moving between colonial countries. But the shipload of South Asian passengers was turned away, disallowed to dock in Vancouver, reinforcing a

Eurocentric stand within Canada. Nonwhite immigrants were no longer welcome. The ship had no choice but to leave, taking families back to a violent and deadly state police reception in Kolkata. Government records indicate that as passengers disembarked, left with no other option, twenty-six people were killed. Witnesses counted seventy-five.[13]

Deeper into the neighbourhood, I see signs indicating not Kitsilano but Khatsahlano, acknowledging the area's ancestry. I bisect Seaforth Peace Park, which straggles Burrard Street along with the Canadian Forces' Seaforth Armoury, two sides of a complex and delicate coin. The park, which faces the armoury, has been a landmark for peace since the 1980s, with city-wide rallies coordinated here. Heightened Cold War concerns prompted a 1981 demonstration of a hundred thousand people marching across Burrard Bridge to fill the streets of Vancouver's West End.

In 1986, sculptor Sam Carter created *The Flame of Peace*, a bronze cauldron with a wick set on granite, commemorating the Hiroshima bombing. Its first ceremonial flame was lit by Hiroshima survivor Kinuko Laskey. Now a bronze bust of Laskey stands at the south edge of the park, gazing into the distance, to the future, perhaps. A few years later this space was renamed Seaforth Peace Park, a tie-in with Peace Parks Across Canada, an initiative to dedicate four hundred similar spaces. This included tree-planting ceremonies, with each national peace park planting twelve trees at the time symbolizing ten provinces and two territories. Fifteen years later, the peace parks each added an additional tree to represent Nunavut Territory.[14]

Past the peace park, I find more trees with historical plaques. One marks the former house of Banto Betty Gill, granddaughter to one of the first South Asian immigrants in 1904. The family developed lumber and logged along False Creek. Known for her generosity and for working three jobs, Gill managed to find time later in life to follow every hockey game of the Vancouver Canucks and was a symbol of community, hard work, and contribution.[15]

A flicker hammers a resonant tune from the top of a telephone pole, a metallic *rat-a-tat-tat*, and I like that the bird is making an actual call on a phone line. On the next block I learn the story of Ajaib (Jab) Sidhoo,

entrepreneur and founder of East India Carpets, a Vancouver retail fix-
ture. Sidhoo's father arrived from the Punjab, also working in lumber
and forestry, but on Vancouver Island. Along with the Woodworkers
Union, Sidhoo's father lobbied the legislature for voting rights, activism
that Jab would continue in Vancouver as a political pioneer in the prov-
ince.[16] As his carpet business prospered, Jab Sidhoo's initiatives skewed
to philanthropy, and in 1954 he also became one of the first co-owners
of the BC Lions, the city's first professional football team.

These historic slivers, combined with the unwavering perseverance
of South Asian and Chinese Vancouverites, helped spur this community,
to a great degree, from one of expulsion toward increasing equality.
Inclusive voting would be legislated in 1947, along with the country's
Immigration Act being amended, lifting restrictions and previous Acts
of Exclusion. At the start of that year, 1947, the Canadian Citizenship
Act came into force, recognizing those born in Canada as well as
naturalized immigrants, regardless of country of origin, as Canadian
nationals. Another shift toward justness.

—

Turning west on 4th Avenue, I flip another time-dog-eared page, this
one leading to the 1960s, the era of the *Ben Franklin* voyage and when
this stretch of neighbourhood was the centre of hippie culture, con-
sidered a northern version of San Francisco's Haight-Ashbury district.
Its acme, 1967, is known as the Summer of Love. And this, West 4th
between Burrard and MacDonald, was its epicentre. What made the
rise of free-flow lifestyle explosive was that prior to this, Vancouver was
conservative, a politically right-wing logging town: thick-frame glasses,
updos, and crewcuts. Then, suddenly, hair was abundant, paired with
loud rock 'n' roll and weed.

David Wisdom lived here—his moniker was "King of the Hippies"—
when he saw Jefferson Airplane perform at the Kitsilano Theatre in
1966, considered by many to be Vancouver's first rock show. He spoke
fondly of living just west along Point Grey Road, a place called the
Peace House, where musicians would party and "crash," most notably

members of the Grateful Dead, who were known for rarely wearing clothes, indoors or out.

Hair length became its own form of tattoo. A statement, social standing, and rank, all melded in windblown strands. Retail popped up that was deemed hippie friendly, inclusive, inviting, as well as coffee houses that weren't Seattle-based chains, with restaurants and record shops serving as venues for intimate readings, singing, and poetry, many offering up soft drugs and wine.

Broadcaster Lynne McNamara spoke of living here at that time, ahead of the Summer of Love. In an interview with CBC's Grant Lawrence, McNamara explained, "I remember beautiful, hot summers, the smell of pot in the air, lots of long hair, women swirling and twirling in long Afghan dresses, and everybody being stoned out of their minds. People were swarming here, especially from the States, and it made it all so exciting. From my experience, it was an open and accepting place for women."[17]

If Kitsilano was the hub of the hippies, CFUN was its heart on the airwaves, becoming the city's rock station in 1960. McNamara worked there, along with Terry David Mulligan and John Tanner, on-air personalities immersed in the scene and the culture. According to Tanner, "What was really incredible was that it happened so fast. Suddenly, by the early spring of 1967, hippies, flower power, and free love was everywhere."[18]

Influence travelled north from California, West Coast culture pervading national boundaries. The CFUN building was a transition as well: midcentury modern European design in light concrete, a breezeway with slender round pillars, an architectural depiction of radio airwaves fluidly fusing the world.

Just past the old CFUN site, ahead of me at West 4th and Arbutus, is the Russian Community Centre, known for years as the Russian Hall. When hippies were here, the Hall, a modest-sized venue, provided a one-two music and cultural punch, with the radio station a few blocks away. But both McNamara and Tanner referred to hostility that also arrived at that time from Mayor Tom Campbell, who took office at the peak of the Summer of Love. According to Campbell, *hippie* equated

to *peacenik*, considered the enemy of industry, commerce, and jobs. This resulted in a form of war being waged on the neighbourhood, mostly to quash marijuana, which the mayor saw as a cog in the culture he loathed. And for this, he employed enforcers, much like those portrayed by Costner and Connery in *The Untouchables*. But rather than conducting assaults on rum-running gangsters, here they raided houses, concerts, and coffee shops. The mayor's chief enforcer was a bully named Abe Snidanko, an RCMP sergeant and undercover narcotics officer. According to CBC's *As It Happens*, Snidanko was labelled the "hippie nemesis," making a name for himself in Vancouver's Gastown Riot, a violent police crackdown on a pot protest and smoke-in. Actor Tommy Chong added to the interview, remembering Snidanko. "He was the cop who would bust you for a seed or a joint or anything, you know? Abe was one of those guys back in the day that thought marijuana was the evilest drug on the planet, and he vowed to stamp it out any way he could." But Chong went on to admit his admiration for that kind of focus. "I really respected Abe because, you know, he was true to his craft. No one was a better narc than Abe."[19]

Ironically, former RCMP officer and radio stalwart Terry David Mulligan was also labelled a narc. No hippie would accept that a former cop could be anything but. Perception can disregard facts. Mulligan had to live with an aura of ostracization.

The more I drift through the neighbourhood, smelling wafts of present-day pot reminiscent of a controversial past, I'm acutely aware that each time I scratch at this community's past and its role in the city, Mulligan's name is ever present. A catalyst to the area's journalistic and cultural scene, the mislabelled narc and broadcaster's early career focus of discovering and playing new music and reporting on-air put Mulligan at the heart of a rapidly changing city that was witnessing a new iteration of Vancouver unfold. This is a voice I want to hear once again to shed further light onto where I'm now walking.

To connect with Terry David Mulligan, a.k.a. TDM, rather than walk, I've plunked myself in front of a mic and a screen, while Terry's done the same thing in his studio on Vancouver Island. Rather magically, where I

am located for our virtual visit is a one-minute walk from where he first hit the Vancouver airwaves, the station broadcasting from Kits.

I can't help but talk music with Terry. His was the voice that accompanied the songs and the bands I grew up with, not only via radio but videos too, bringing the artistic world to Vancouver while simultaneously sharing West Coast culture internationally. He also created TV's *Much West*, which brought Canada's music video programming to Vancouver.

"I said to the producer, you're calling yourself the nation's music station, and you're nowhere to be found in Vancouver," Mulligan says. "We're bringing home armloads of Junos, and you're missing out." This was Mulligan's foray into not only drawing attention to Vancouver but also fostering spotlights shining outward from here.

"What do you see in the city?" I ask. "Then and now, the changes and vibe of the place?"

"Well, each ten years was an entire shift. Like a new solstice happening. I lived there, on 4th. And it was like a zoo. People smoking joints, taking acid, sleeping on the streets, just sitting under lampposts playing music, taking over 4th Avenue. Which you wouldn't recognize now, because it's pretty trendy."

After four years of RCMP training and life in the Canadian Prairies, Mulligan returned to Vancouver, his home. He admits with a chuckle, "I walked into it with a very clear head and thought, *What fresh hell is this*? I found it interesting but could see damage being done, to people who were just taking whatever the current colour of pill was. And I lost friends along the way who simply died from overuse. Those were very dark years. Although the music was fantastic. LGFM came about from that, which was the first FM rock station in Canada."

"Tell me about that shift," I say. "From law enforcement to coming back here, trying to find your new tribe or community."

"Well, actually, my new tribe was being in Vancouver. I was delighted. I'd spent a couple of years in Alberta, in radio, at that point, then back to Regina, to that harsh weather. I said, I'm never going back there. I'm a West Coast guy. So everything I did was to get myself back home. Back to Vancouver.

"But even when a lot of the city was tough, I mean *really* tough, there was a buzz in Kitsilano. To be honest, things were moving at such a speed then. Some of it I only remember when I see the photos. Like being there, emceeing the first fundraising event for what was to become Greenpeace. I mean, special stuff. A privilege.

"The Vancouver that was there started to grow up. Every immigrant who came to Canada, to Vancouver, from elsewhere made us better. A better city. Better community. You could *feel* an appreciation of what was being stepped into and being experienced.

"Vancouver, now, people still rave about it. There's many, many, many things to like about Vancouver. But it's become 'What have you done for me lately?' or 'Get out of my way.' There's attitude, an *unearned* attitude, that I see a lot in the downtown core. An air of entitlement. I may be a little touchy about it, but I do see it, feel it, smell it, hear it. And it's disappointing. It's really disappointing. Because Vancouver had a beautiful heart and soul. For all of its dark scars and drug issues and homelessness and Indigenous rights being crushed, it *has* worked its way out of many of those holes. There are now teams in place to help people who were hopelessly lost. People still have to battle addiction, and thousands of people die each year. But now, Vancouver, I don't know what it's going to look like in ten, fifteen, twenty years. I have no idea. It may be the same shape and form. Maybe that's all in my imagination."

Mulligan shares a few photos, adding mixed media to our visit: black-and-whites, a visceral time warp, as though punctuating the era. Now he's off to record a new episode of *Mulligan Stew* while I'm back to the street, the place I just saw in monochrome. Only now, things are in modern-day colour, with Terry's former station transformed into fresh-mortared brick. Across the street, on the side of a bank, another black-and-white shot from that time: bathing-capped swimmers at Kits Beach, much like those owners and dogs occupying the Hadden Park sand.

Up the hill of West 4th, what was once hippie central, I stop at a Turkish bakery for strong coffee and a small twisted bread ring of simit, then head south to Broadway and west from MacDonald to the Kits neighbourhood unofficially called Greektown. Historically, this area

housed a dense immigrant population, with shops and restaurants supporting Hellenic and Mediterranean culture. This first influx took place when Terry and team were blasting out Morrison, Joplin, and Hendrix just down the road; Greek exiles arrived here in great numbers starting in 1967, fleeing the military coup and dictatorship of Georgios Papadopoulos. The centre of the growing Greek community was St. George's Greek Orthodox Church, built in 1930, until the current larger cathedral was constructed farther south on Arbutus. Both are commanding, with traditional Byzantine art and design, and the community still hosts annual celebrations and food festivals. Another stop, this time for a sticky triangle of baklava, and it's back to sauntering through time.

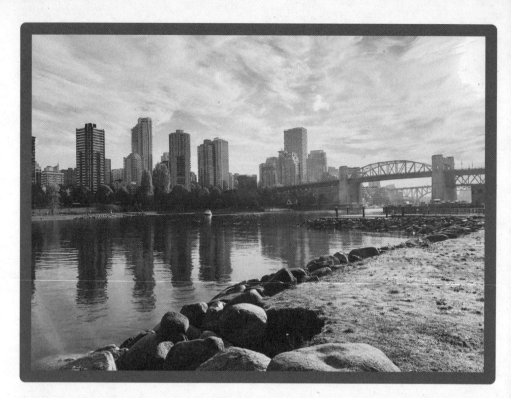

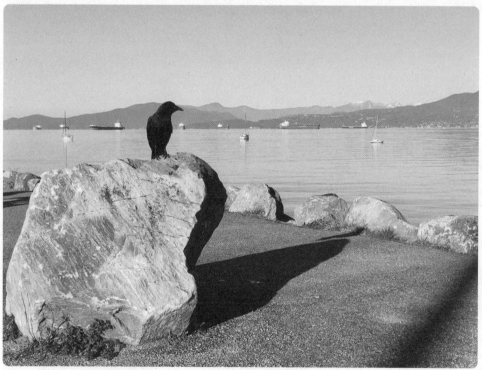

**TOP:** Burrard Bridge, looking east into sunrise. **BOTTOM:** sharing a north and west view with a crow on local granite, at Elsje Point. *Photos by Bill Arnott.*

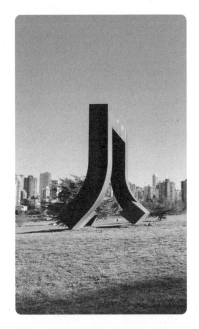
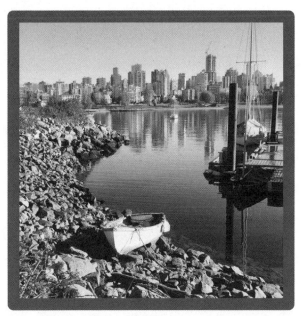
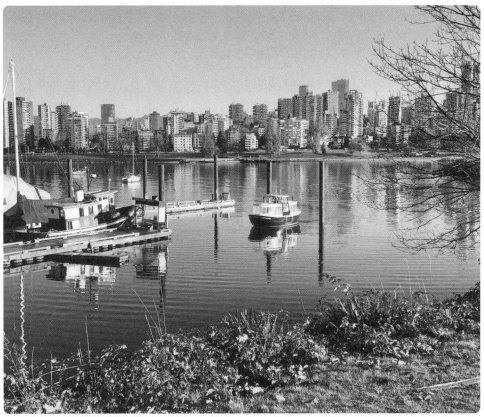

**CLOCKWISE FROM TOP LEFT:** geometry midstroll, the artwork *Gate to the Northwest Passage;* Elsje Point, looking north to Downtown; Heritage Harbour Marina, near the Vancouver Maritime Museum. *Photos by Bill Arnott.*

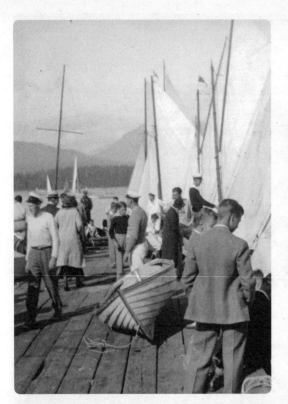
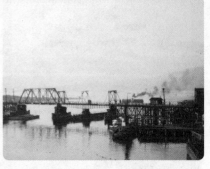
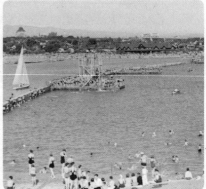
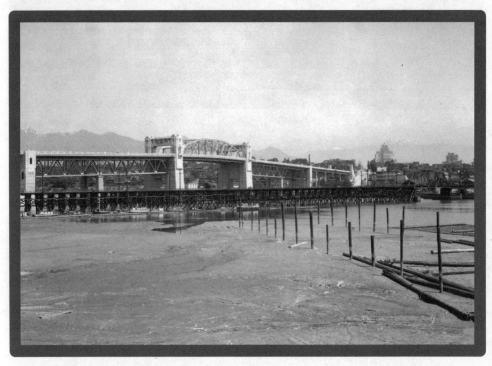

**CLOCKWISE FROM TOP LEFT:** Kits Yacht Club, 1935; CPR Kits Trestle Bridge, 1930; Kits Pool, 1932; Burrard Bridge and Kits Trestle Bridge, 1932. *Photos courtesy of City of Vancouver Archives.*

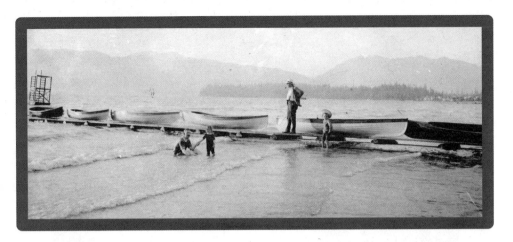

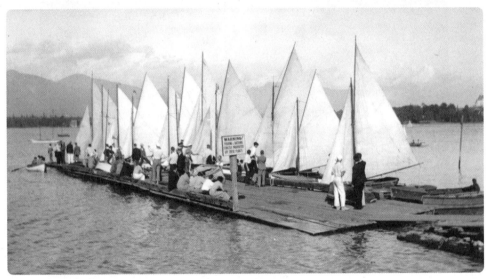

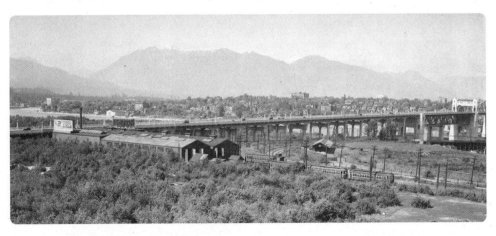

**TOP TO BOTTOM:** Kits Beach Boat Rentals, 1904; the pier at Kits Yacht Club, 1935;
streetcar sheds on *Senáḵw* land, with Burrard Bridge in the background, 1935.
*Photos courtesy of City of Vancouver Archives.*

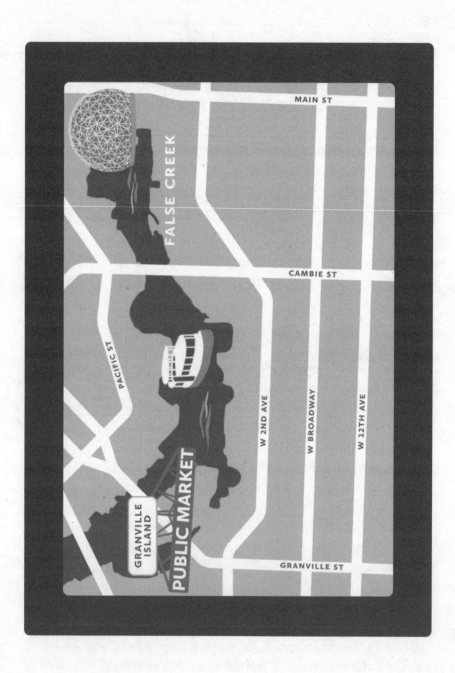

# Granville Island and False Creek

*haze of horizon*
  *dampens a still morning sky*
    *cloud curtains drawn closed*

MORNING FOG SLOWLY LIFTS, a bluster of crows cross a buttery sunrise, and vermillion lines the horizon—something I'd pay to see in a film. Burrard Bridge casts a shadow as I walk, once again, amid neatly spaced trees at Cultural Harmony Grove, poplar and beech standing lofty and regal, taking the place, in their way, of the carved totems in cedar.

Following the reinforced breakwater shoring the point, I head into rising sun. Ahead is Granville Island. Its own bridge, the Granville Street Bridge, yawns over False Creek in a flat, functional expanse. The walkway—sidewalk, footpath, cycle route—leading there serpentines in an inviting blend of cracked concrete and brick. Even a beeline feels meandering. Gone are the swing bridge, the trolleys, leaving the sense of a wall being removed, more open space, as though the CFUN architect put one final stamp on the place, embracing surroundings and sky. On the south side of the path, it's residential. Immediately north is the water, with the False Creek Fishermen's Wharf and Harbour Authority. Moored boats are a jostle of commercial trawlers and seiners, working craft harvesting tuna and salmon, Dungeness crab and spot prawns.

I follow the overhead snake of concrete and brick that is the Granville Street Bridge, landmark and history in one span. No sign of eagles, but a rickety cruiser resembling a pirate ship is tethered at a dock next to some paddleboats. Tourist energy simmers as a traffic thrum clatters above. The bridge support towers are decorated in posters advertising live plays, comedy, and music, all of it happening in venues around Granville Island. I bear north, slant west, and meander my way to the Public Market, a retail anchor in the midst of this land boat.

According to the Vancouver Heritage Foundation, "What's now Granville Island was once nothing more than two sandbars, that would appear and disappear with the tide."[20] Home to Squamish and Musqueam Peoples, original names for this area are Sen̓áḵw in the Squamish language and sən̓aʔqʷ in Musqueam. As settlers increased in numbers, a reservation was created in 1869, only to be dissolved with forced resident relocation in 1899. Now, Granville Island and its surrounds are a convolution of ownership: Indigenous, federal, and municipal lands, with layers of expiring leaseholds. Fronting the island are rows of townhomes and low condos, the same muddle of leases and property rights, reiterating, perhaps, that ownership is merely a notion.

At the moment, Granville Island's Public Market is wonderfully quiet, unlike what I experience here on a weekend or holiday, when shopping is a contact sport—not aggressive, just dense. Although I can't recall where I saw it, I once read a tourist statistic indicating that apart from Niagara Falls, Granville Island is the most visited destination in Canada. On those busy days, it's a stat I find unsurprising. Technically, I'm now in Vancouver's Fairview neighbourhood, the Island being, according to its media, "a magical escape within the city."[21] Which I get. It is a unique hub, much like Seattle's Pike Place Market. Fish tend to feature, along with restaurants, giftware, crafts, and artisans carving and forging and painting, a welcoming mess of industry, retail, and tourism.

This chunk of land's not so much an island as it is a peninsula, a spheroid of sand where Musqueam and Squamish fished for salmon, mussels, and clams. Late in the nineteenth century, Granville Street spanned the inlet, an earlier iteration of what's overhead now. A first

attempt by industrious settlers to shore up the land followed, with wooden pilings driven into soft tidal flats, much like in Venice. But the federal government stopped that construction, certain the ad hoc timber poles would hinder shipping. In 1915, a coordinated, sanctioned effort began, reclaiming land to develop an industrial centre. False Creek was dredged, and the "island" I'm standing on now was created. Its original name? Industrial Island. Which describes perfectly what this place looked like and the purpose it served. But, what with people getting here via that first Granville Bridge, Granville Island was what they called it, a name that adhered to the space like a buildup of saltwater silt.

As Indigenous anglers were shoved aside, the earliest tenants of the reinforced space were all part of heavy industry: mining and forestry equipment, barge construction and maintenance, and tin-making factories, one of the busiest manufacturing sectors leading up to the Great Depression. BC Equipment was Granville Island's first industrial tenant; its tin and wood–built machine shop is part of the structure now housing the market I'm gazing at. Within a few years, every space on the Island had been leased or built on, virtually all of it for heavy machining and industry.

Sawmills and logging track roads criss-crossed both sides of the inlet, yet something about the space, proximity, views, and sunlight made the south side of False Creek desirable. Land squabbles ensued. Local business, government, and the Canadian Pacific Railway (CPR) all had a say until a National Harbour Commission was formed to create a semblance of cohesive rules. The Seawall was built, dredging was coordinated, leases were drawn up. Vancouver Heritage Foundation records describe the area at that time:

> About 40 acres of leasable land was created and businesses, mostly factories and mills, were quick to move in, building post and beam structures clad in corrugated tin. It was called Industrial Island, and at its height in the 1930s, there were 1200 people employed by 40 industrial companies, which manufactured and supplied fibre, rope, chain, and materials for logging, mining and shipping.[22]

Across the water, the north side of False Creek became a booming community. Literally—there were log booms with sawmills and cooperage works, like where Banto Betty Gill's family grew their lumber and forestry interests. But when the Depression of the 1930s arrived, the False Creek labour community devolved into what were called "hobo jungles," shanty settlements made up of "shackers," or squatters. Somewhat ironically, survival among displaced workers required living in much the same manner as Indigenous residents had been for the previous five millennia; resource sustainability became essential as unemployed builders and loggers took to beachcombing, fishing for salmon and smelt, selling lumber at markets, and delivering offcuts to households for fuel.

Fifty years later, at the end of the 1970s, the federal government took a renewed interest, partnering with the provincial government to carve out the space that would turn into the market. In 1980, the Emily Carr College of Art and Design was created, an institution that has now expanded into a university and moved south and east to what's called False Creek Flats.

Skirting the market, I stop for an eye-opener (coffee with a shot of espresso), a sort of boilermaker for fans of caffeine. I feel it go to work immediately, no doubt dilating my pupils. I buzz my way to the north side of the Island, where wood reinforcements give the creekfront edge the look of an aging pier—which it is, in a way. There are newer pilings and ramps with a waterside dock where passenger ferries load and unload, shuttling foot passengers through the inlet. False Creek Ferries runs chubby blue-and-white craft resembling Theodore Tugboat, while somewhat larger Aquabus boats sport splashy rainbows. Presently, the federal government has additional plans to redevelop the Island, with new builds and zoning slated for 2040, much of it earmarked to utilize land where the Emily Carr school first stood.

A wide installation features a retrospective of VMF, or the Vancouver Mural Festival. Where painted murals were eliminated by construction and renos, replications have been recreated, images reimagined on banners and hoarding in colourful horizontal commemoration.

Enjoying the lingering caffeine, I take in my surroundings. A man walks a poodle. A busker in fingerless gloves sets up a small amp. The big yellow building of Tap & Barrel Bridges stands in the distance, a berth much like the market. There's a carving shed where trees are being transformed into totems. I pass a razor-wire fence; the visual is jarring, a reminder of property, real and imagined. The whole stretch on this side of the water is sectioned by bridges, lined in construction, restoration, repair. Again, a pondering of levels is involved.

Even in sunlight, the day's crisp, the water a cool stretch of teal up False Creek, where Science World faces this way, the glimmering dome of a pushpin. The sun's illuminating both bridges, Granville Street Bridge now agleam, while Burrard Bridge looks softened in angling light. The bright cube of an Aquabus putters past, while a False Creek Ferry toddles this way. A crow ambles by. Gulls chorus in yowls and cries. The moon's a slight smudge in gentle blue sky. Next to Fishermen's Wharf, a seal swims by, its slick head hovering through the calm. Vessels are moored in rows. Sunlight strikes high-rises in starbursts. And a witch bumps along in a forklift, getting on with her day, adorned in a sharp, pointy hat and a long purple cape. She nods. I nod back. Only now do I remember that it's Halloween.

⁓

A new day, onward from Granville Island, bearing east on the south of False Creek, where fog has enveloped the inlet. A blur of crows fly by in what can only be described as a Poe-esque sky. Here on the ground, it's very much Conan Doyle. Heavy mist on the ground. I can almost hear a hansom clop by, Watson and Holmes in a rush to unravel a mystery.

Starlings chitter above in synth-technopop from a phone line. There's a tall painted bear on a balcony, a memento from the Vancouver 2010 Winter Olympics. The day makes me feel like I'm out on the water, a thick fret, weather for woolens and scarves. Fittingly, the moan of a ship's horn emanates from the bay.

Another school is being rebuilt—more seismic upgrades. The blend of fog on slate water creates an acutely reflective surface today, the

same as a silver-backed mirror. At Granville Island Kids Market, a clown installation leers from upper-floor windows, animated and creepy. An enormous grey rabbit munches wild grass. By a pond, a lining of reeds and bulrushes, squat maples, cedar, salal, and a huge hedge of rhododendron. There's a woven twig fence, each tree clasping branches with the look of held hands.

I keep walking the south side of False Creek, Vancouver's downtown to my left, past a dock with outriggers and dragon boats. A black-capped chickadee hops in the undercanopy. I take a close-up photo of a plant as a rosebush tugs at my sleeve, imploring me to stay. I pass an ash tree where I once watched a beaver gnaw at tender green bark, the reminder of a fur-trading past with a glimmer of hope for the future. Mallards share the shallows with surf scoters and scaups. Someone is doing tai chi in the fog, a lone martial artist wearing a mist robe.

Just south of me, up the slope of Spruce Street at West 7th Avenue, is a patch of trimmed grass with an enviable view of the city: Choklit Park, a space imagined by Charles Flavelle, co-owner of Purdys Chocolates, in 1969. Part of the chocolatier's factory site at the time, the embankment and tight space made for difficult transport and warehousing.[23] Management petitioned the city to allow for construction of a wider circular accessway that would allow trucks to swing into their loading bays. Part of the proposal was the inclusion of a children's play space and park. The neighbourhood was largely light industry, and this area, Fairview Slopes, with its adjacent community of Mount Pleasant, was home to a growing population of children and single-parent households and had little to no parkland. Flavelle's proposal was approved, designed, and completed by a small group of workers in 1970, and it remains a green gem with a gleam.

South along Oak Street is the former site of Vancouver's Jewish Community Centre (JCC), built in 1928.[24] Originally located in the Strathcona neighbourhood of the Downtown Eastside, the JCC building resembled an aristocratic manor, with ivy clinging to exterior walls. It was a structure of heavy stone with a sharp slated roof and an abundance of windows and light. Following the Second World War, the JCC moved again, farther south on Oak Street to where, at 41st Avenue,

the city's trolleys and buses were serviced and housed—more linkage through roadways and cables.

If I did venture south, past the Choklit Park views, I'd arrive at VGH, Vancouver General Hospital, where a low wall still stands, framing a corner in stone. This was a boundary for King Edward High, the first secondary school south of False Creek, built in 1905.[25] The school also served as a college until 1907, when post-secondary classes were moved to create what would become the University of British Columbia (UBC).

But I've no interest in climbing the slope at the moment or revisiting memories of school, so I'll carry on here, by the water. Past a five-pier marina with sailboats and yachts, residential and commercial, a few floating homes and houseboats are tucked in the mix, reminders of shanties on stilts and the shackers that lived on the inlet.

Today a schoolyard's overrun with Canada geese, accompanied by two snow-white specimens. Snow geese, perhaps, doing their part to connect with my opening note? If so, I'm appreciative. Then again, they might be Ross's geese, but I'm not going to check, as that wouldn't help my story at all.

Beyond the marina, a flotilla of anchored sailboats shift in slow pendulum arcs. The movement and pulse of the fog makes each vessel look like part of a vanishing act, the magician unseen. I stop to take pictures of Habitat Island; the red, white, and black of rosehips and granite; and the wake of an Aquabus nudging the shore.

Another man's doing the same, taking photos midwalk, aiming his camera at fog. "It'd be nice to hear a foghorn," he says.

"Oh, they're going," I say. "Just heard a blast farther back, from across the inlet."

"Nice. I'll keep an ear open." He introduces himself: Gerry. And we carry on together, walking east, following the Seawall. He gestures at the swirl of the fog. "Every time I see weather like this, these conditions, I think of that song 'Into the Mystic.'"

I notice his ponytail, long and grey, and though I already know the answer, I ask just to hear his reply: "The Colin James version?"

He gives me a look as though I've passed him a turd. "*No.* Van Morrison. Of course." He pauses. "You local?"

I tell him I am. "Live just over there. And you?"

"Oh, yeah. Been here a long time. Arrived in Kitsilano in the sixties."

Placing him here for that Summer of Love. I guess his age, do the math, and ask him about hippie culture.

He laughs. "Yup, hippie central. I was one of them!"

Sure enough, he was here to witness its conclusion as well, not so much a transition as a needle-scratching stop. Many claimed that the death of those stars whom TDM had been playing—Hendrix, Joplin, Morrison—had ended the era. That and the crackdown on pot, combined with a shift by many to much harder drugs, overdoses, and increased crime.

"And now?" I ask Gerry.

"Now I live in Olympic Village. Moved in after the Games. In 2011."

"Must've felt pretty vibrant," I say.

"It was a ghost town!" he replies. "Took a long time to get busy. More people. Now it's too much. People stealing. I hate it. It's the drugs. I don't always feel safe out at night. Never know what people are up to."

I choose to simply nod, not wanting to delve or debate. We shake hands and part ways, Gerry to go home, me to continue exploring. Circling back to the neighbourhood's north-facing incline, I bisect Charleson Park, where the Laurel Street Land Bridge links Fairview Slopes to the Seawall and the water. The bridge is a means for pedestrians to pass over the busy flow of West 6th Avenue and the lines of what was the BC Electric Railway, which was revitalized for a short stint around the 2010 Olympics.[26]

At Charleson Park, a sign explains that this is a Wildlife Habitat Area: "This area is a seasonal wetland." This likely explains all the waterfowl. The expanse is an amorphous amoeba of green space: a reedy pond, trickle of water, a play area for families and children, an off-leash area for dogs, and space for soccer and tennis, all with pristine city views. A placard next to the walkway explains why the downtown vista from here survives. The plaque, its own installation, labelled "Protected Public Views & View Corridors," describes what I see from this spot: "View corridors are planning policies that limit the height of new buildings

within a measured sightline. This preserves the ability to see the mountains rising above the downtown skyline as the focus of the view."[27]

A small graphic accompanies the text, an expanding sightline radiating from where I stand, like an eye-exam chart outlining how optic nerves work. It has the feel of a spatial architectural exhibit, a trick Frank Lloyd Wright might employ—shrinking an entry or a doorway to make what comes next feel expansive. It's a neat method to maximize visual effects, optimizing space where physical limits are imposed, and it works. Here at the edge of the water, dogs running and fetching behind me, at a quick glance, all I notice over False Creek is the upright-dominos expanse of downtown. And yet, if I relax my eyes slightly, rather than seeing high-rises, sure enough, I can't help but see mountains beyond, as though *they're* the feature, centring a Vancouver skyline. Which I suppose they do, creating a corridor of amplification, a booster to bolster experience.

Resuming my easterly route, it's on to Habitat Island. The Board of Parks and Recreation offers a brief overview of this False Creek domain, another spheroid of land, a smaller version of Granville Island from above, but with a radically different objective:

Deep layers of soil have been added to the area to provide nourishment for new trees to grow. Boulders and logs commonly found along the coastlines in this region of British Columbia provide a home for plants, small animals, insects, crabs, starfish, barnacles and other creatures. Surrounded by water at high tide, the island is also a sanctuary for birds.

More than 200 native trees, as well as shrubs, flowers, and grasses that grow naturally in this region have been planted along the waterfront path and on the island.[28]

In effect, this is a grander version of Choklit Park. This whole area of southeast False Creek was developed in anticipation of the 2010 Winter Olympics. Olympic Village, to where Gerry was heading home, is a community of converted condominiums and retail that had temporarily

housed athletes for the international Games. Part of that redevelopment was dependent on ensuring sufficient green space—not simply building new residences, but creating a fully formed neighbourhood. There is more parkland, another play area for dogs, water with plants to attract birds, fish, and frogs, and flowering plants to draw bees, the small ecosystem designed for ongoing sustainability, a manufactured version of what may well have been here prior to development. And if the current array of plant life and fauna currently visiting and inhabiting the island is any indication, it seems to be working.

From the Seawall I hopscotch rough hunks of granite, a giant's causeway leading to Habitat Island. A gull tops a rock, watching me pass. The fog is still heavy but starting to thin. A tall stump holds a huddle of birdhouses resembling avian condos. I can't see what's inside, but splashes of guano on each entryway indicate that every little home is now occupied.

I identify a few plants and trees: red-berried rockspray, snowberry, green ash, milkweed with dewy white blossoms. A nurse log of what might have been cedar sits next to the path, mostly dissolved into sawdust. I dig out my phone, open a plant-finding app, and zoom in on the log just to know what it is. What comes up on my screen has nothing to do with the stump, but instead shows a dozen microflorae, mosses and lichens I can't even see—to my eye, it's just a patina of off-coloured wood. And yet another entire ecosystem is there in the span of no more than a metre, flourishing organisms in miniature. Another jolt of optimism here, on a manufactured reserve.

From the Seawall pathway, another sidetrack points south, this one cutting past the dog park and a wetland of reeds. A frog burps in the rushes as a red-winged blackbird adds harmony. A footbridge navigates the water and grass, then a few railway ties with a jungle gym, and I come to a historical plaque that states this is a former shipyard: "During both world wars the south shore of False Creek east of Cambie Bridge was home to Vancouver's shipbuilding industry." The plaque lists industry members: Coughlan's shipyard and West Coast Shipbuilders; steel manufacturers and bridge-builders Dominion Bridge and Western Bridge; and the Canron company, which fabricated structural steel into

the 1990s. The next part grabs my eye: "Two steel columns from the Canron Building have been re-used in the bridge crossing the wetland." What's now underfoot is a repurposed bit of that structure, a metal version of the nurse log on Habitat Island crossing a pond with tadpoles and songbirds, new life infused on the land.

Back on the Seawall, I'm still heading east, but I stop for a look at Cambie Street Bridge, the third span crossing False Creek, keeping company with the Burrard and Granville Street bridges. I still cringe a bit when I cross that expanse, for it was here I once convinced a young man not to jump. It was five-thirty in the morning. I was living in Yaletown, on the north side of Cambie Bridge. I'd just finished an early jog and was making my way home, crossing the bridge on foot. The city was silent, with no one around, so it seemed. No one, that is, but me and one other person: a young man on the wrong side of the railing, sobbing and contemplating the water, considering one more decision.

To be honest, what flashed through my mind was, *This bridge isn't high enough, friend, you'll only be injured or drown.* I've had a couple of suicides in my immediate family, both definitive: one, a leap from a height onto concrete; the other, a shotgun with one shoe removed. Neither was a plea for attention. This one—I wasn't so sure. It was unsettling, something I was completely untrained for. But I'd seen enough movies to falsely believe I might make a difference. And of course I had to try.

The next thought I had was, *Okay, this is happening.* And so, I began to talk with the pleasant-faced, crying young man clinging to the outside of the bridge rail. Spanish was his first language; our communication was halting and mostly one-way. I simply talked, not having a playbook, just conveying empathy, openness, and my small slice of personal experience.

"I'm just ... so ... tired," he managed to say.

To which all of us can relate at times.

After some time, some uncomplicated monologue, then dialogue, we knew each other—in some ways, to a limited degree, but in other ways, wholly. While we spoke, feeling gradual but growing encouragement, my new acquaintance chose to crawl back to my side of the railing. I suppose someone had made a call, because with mild surprise, we

47

both realized that a semicircle of six police officers were slowly, slowly, approaching, emanating patience. Not interrupting. Simply closing the gap.

Eventually, with tears and with thanks, we hugged and disbanded, the young man with a soft-spoken police escort to a hospital, me to head home for another quick cry. And, I suppose, another fresh round of healing.

Remarkably, following this, I happened upon a Squamish atlas of the area that gives traditional place names, which, much like *Senákw*, describe a locale based on notable landmarks or features, oral map-making by way of sensory and practical description. Some examples are *Ts'mts'ámels*, meaning "tool-sharpening rock," and *Iýeĺshn*, "a place of good footing." And what is the name of this part of False Creek now spanned by the Cambie Street Bridge? *Á7enmitsut*, which translates to "getting ready to commit suicide."[29]

⁓

I retrace my steps under that bridge to the Spyglass Place dock, a stop for the passenger ferries. For a long time, a piano sat out here, one of several placed outdoors around the city, like a musical library with one thing on offer, allowing passersby to play. The piano was painted in a mishmash of bright, garish colours, as though it had been tagged by every street artist in town. One memory still makes me smile. I was nearing the end of a run, tired and ready to stop as I approached this spot. But a person was seated at the piano, playing a fine rendition of "Chariots of Fire," the soaring instrumental echoing in concrete acoustics. I had to laugh and, of course, to keep running, albeit in slow motion.

Now, this space is Husain Rahim Plaza, an expansion of Seawall built into a round where an installation of carved metal, a form of industrial art, explains more.

Husain Rahim (1865–1937) was a member of the Shore Committee who, along with Gurdwara President Bhag Singh, took over the charter of the *Komagata Maru* after it arrived in Vancouver in 1914. One of

the first South Asians to challenge disenfranchisement laws, Rahim went on to found and publish "The Hindustanee," a South Asian, English-language newspaper in Chinatown.[30]

Another bridge constructed, linking not only shoreline but communities too.

I'm eastbound again. Rotting timber marks where old berths and a bridge once reached into the inlet and the bygone industry of logging and shipping. One high wooden truss has been spun into art, white letters spanning the crossbeam: "Should I Be Worried?" A question I consider unanswerable.

Another sign that faces Habitat Island offers more information on the Southeast False Creek initiative—"Bringing Back Birds, Brush and Barnacles"—with statistics about the volumes of cobble, gravel, boulders, and sand being moved to create this new space. This is one of the places that beaver has visited, along with a willow-clad shore at Stanley Park's Lost Lagoon. Unless it was more than one beaver I'd seen gnawing and felling young trees.

On the tall, naked stump with birdhouses, a lone crow stares at the water. The tree like a mast, the crow stands guard in the mist. Another pass round the island: granite hunks with slim firs and dune grass in chlorophyll green. Back on the Seawall, a few monstrous chairs have been placed, gleaming white respites for giants or groups. A footbridge leads to the heart of Olympic Village, where I stop for a cheese bun and some water, then continue. Along a boardwalk with tanker-sized cleats, a nod to a shipbuilding past, is another hybrid installation, an Indigenous maple leaf carved in steel and set onto stone, dual art with unlimited layers.

Next I pass two giant statues of sparrows, where City of Vancouver signage explains the transition of Southeast False Creek from the former industrial site into the Millennium Water Olympic Village. Self-congratulatory but informative. Next to this is more stylized art: laser-carved, burnished steel in a heavy vertical sheet, with Salish design in two dimensions, another hybrid, this one Asian flat art depicted in West Coast imagery, totemic insignia of what could be an eagle or raven,

a wolf or a bear, an orca, a beaver or a frog—nothing as clearly defined as the timber totems that stood near Burrard. These images could pass for Coast Salish ink blots. *Tell me what you see.* Everything, and nothing. Nearby, more plaques praise developers and Olympic ideals.

The fog's almost gone as I pass Village Dock, where a map on a sign instructs passengers how best to navigate the ferries and False Creek. A few rays of sun glint on the Science World dome, commonly known as "the golf ball." I uncover a summarized Vancouver Heritage Foundation history of the dome, in conjunction with the False Creek Expo Lands, former site of the 1986 World's Fair, or Expo 86.

> Vancouver's 100th birthday was celebrated by Expo 86, a six-month transportation-themed world's fair held on the northern and eastern shore of False Creek. Expo 86 was widely hailed for launching Vancouver as a global destination, transforming it from a sleepy town into a global metropolis. It attracted over 22 million people and remains the second biggest event in British Columbia history. It was the last world's fair in North America, and featured pavilions from 54 nations. It was the first time China, the Soviet Union and the United States exhibited together at a North American fair.[31]

Just as the Olympic rings, depicted behind me with dualist Salishan art, are the symbol of the international Games, the gleaming Science World dome I'm approaching remains the image of the Vancouver World's Fair, a futuristic beacon from the past.

> The fair's signature building, the shimmering "golf ball" Expo Centre, was designed by [Bruno] Freschi to serve as the visual anchor at the eastern end of the creek and mark the fair's main entrance. The geodesic dome—an iconic form invented by Buckminster Fuller … was built from 766 aluminum triangles and supported by an outer frame of white steel. It housed Canada's first (at the time, largest in the world) Omnimax theatre while the rest of the building was given over to exhibits on the future of transportation and technology.[32]

Freschi also added a visceral architectural twist, joining landmarks by way of this site, situated at the Georgia Street axis, thereby symbolically linking the hub of the fair (and Vancouver's one-hundredth birthday) with the city's Jubilee Fountain, the water feature commemorating Vancouver's fiftieth, located in Stanley Park at the western end of Georgia. Unbeknownst to Freschi, it also connects the two spots where I watched that beaver (or beavers) nibbling young timber.

Following the fair, Expo Centre, with its concave theatre screen and triangled dome, was repurposed to create Science World, the structure I'm circling now. But there is an additional nugget that acknowledges the legacy of Expo:

> Expo 86 created many infrastructure legacies including Canada Place ... BC Place, the Roundhouse Community Centre, the Dr. Sun Yat-Sen Classical Chinese Garden, SkyTrain's Expo line and of course, Science World—landmarks that have been integral to Vancouver's cultural and civic development. The experience taught planners and the public important lessons about placemaking, civic space and the use of density.[33]

I vividly recall days spent at Expo 86, which struck me as a grown-up theme park—informative, fun, everything shiny and new. Vancouver's SkyTrain was in its infancy, a novelty as much as mass transit, a People Mover like what passengers ride into Disneyland. I remember the season being sunny and hot every day, as though everything was in on it, ensuring the fair would succeed.

Signage announces a new park coming here, East Park, with a QR code for people to share what they want for the area, intended as collaborative space.[34] I find another sign, another request from the city—"What Are Your Hopes For This Place?"—with further explanation:

> The Vancouver Board of Parks and Recreation invites you to envision a new kind of park in Olympic Village and a renewal of a portion of the False Creek waterfront ... One that reinstates Indigenous values and stewardship, supporting a diverse ecosystem resilient to climate

change. A park that is welcoming for all and shares the rich stories of this place.

I jot down the info, take in the scene. A few boats at anchor front the Seawall and dome, a waterborne version of squatting, leaving me not only with an image of the past but of hope going forward for more green space, inclusion, and offering a bit more than the area might take.

As I circle the end of False Creek, now in brightening sun, one lonely cloud lingers over the dome. It could almost be smoke, a knot of nicotine yellow and grey laced with white, as though undecided what it might be: rain, sleet, snow, or simply a cloud undefined.

Now looming on the north side of the inlet is the spiky-topped dome of BC Place stadium. Not a sphere of Fulleresque triangled glass but a bubble of white fabric composed of a hub and spoke system supported by thirty-six masts made of steel. The roof is the largest of its kind in the world, built into three sections: stiff outer fabric, a glass ring, and a layer of translucent fabric to cover the floor, what becomes playing fields or concert seating. The dome is also equipped with an inflatable layer to retain its convex shape and to help slough off snow, something that resulted in the previous roof failing and having to be replaced.

Like so many public projects, it came in over budget—*way* over budget. From an original cost estimate of $150 million, the final repair and replacement exceeded $560 million and was the most expensive renovation in Canadian history, a headline that could spawn a reality show. According to the Vancouver Heritage Foundation,

When BC Place opened [in 1983], the area was still largely industrial; its neighbours at the time a sawmill, a cooperage, and the 1912 swing-span Connaught Bridge, replaced in 1985 by the current Cambie Street Bridge. For a time, the temporary buildings of Expo 86 occupied the nearby CPR railyards bordering Yaletown's old warehouses and, following the fair, Concord Pacific began the planning and redevelopment of the area with condominium towers ... Two and a half years after

being completed, BC Place hosted the Opening Ceremony of Expo 86, an event which featured 7,200 performers and 54,000 guests.[35]

The Heritage Foundation notes, as "Unforgettable Moments in BC Place History," visits from Queen Elizabeth II in 1983, Pope John Paul II in 1984, and Prince Charles and Princess Diana in 1986 (to which I'd add U2 in 1987, one of the best concerts ever); the Expo 86 inauguration; and opening events for the 2010 Paralympic and Olympic Games, with an estimated one billion TV viewers.

Following a swath of Pacific Boulevard that separates False Creek from the stadium grounds, I come to a patch of green, a stand of pines at the base of the giant white dome. It could pass for another peace park, although I don't bother to count the trees. Behind me is the Georgia Street Viaduct, a curved stretch of road lifting traffic from the elevation of the inlet into the city's central business district, the same ribbon of concrete the Expo dome architect imagined linking his shiny golf ball to Stanley Park's high-arcing fountain.

The Viaduct's arches of flared concrete now shelter unhoused residents, a current iteration of the settlements that once clung to the north of False Creek. I see tents, igloo-like structures of umbrellas, and octagonal domes of torn fabric reminiscent of golf balls and stadium roofs. Concrete sports graphic graffiti, splashes of paint like the piano that pumped out Vangelis.

At one time this was slated to be where the main highway would run, Vancouver being one of a very few major cities that doesn't have a high-speed thoroughfare bisecting its core. To learn more, I've arranged to visit with Gilles Cyrenne, president of the Downtown Eastside's Carnegie Community Centre Association. But our get-together won't happen today. For now it's back to False Creek, bearing west on the north side, where two smiling Jehovah's Witnesses stand with their wares along the Seawall.

A poster sits behind glass, its own advert and art installation. I've seen a few of these around town. A developer's city vision, an image of aspiration, the poster renders the green of the city as more lush than reality, the buildings more spacious and clean. A hot-air balloon

sails across the print as though everything's eco-friendly. For the sales team, I imagine some "hot air" jokes too, along with more Jules Verne visuals—Phileas and Passepartout admiring the city as they circle the globe.

The tide's high as I stroll through David Lam Park. At the foot of the green space, a concrete installation extends in a loop to the water, with curved pillars raised to the sky. Its inscription: "The moon circles the earth, and the ocean responds with the rhythm of the tides." I pass basketball courts, tennis courts, a field for softball or soccer, though no one's at play today. The wind picks up, a westerly funnelling under bridges, rippling False Creek and dropping the temperature at least five degrees. From here I have a view of Granville Island's huge concrete silos, spray-painted in a mural called *Giants* that's now desperate for a fresh coat.

*Giants* came into being in 2014. Created by Brazilian brothers Gustavo and Otávio Pandolfo, *Giants* is one of numerous Vancouver Biennale art installations around Vancouver and other munici-palities. The Vancouver Biennale is a non-profit organization that facilitates accessible art. Its objective is to exhibit unique, unexpected pieces—music, multimedia, sculpture, and film—in public spaces, effectively creating open-air urban museums. Funding for these proj-ects comes from sponsorships, donations, and grants, and many of the pieces are sold after exhibition, adding further funds to the program. *Giants* is one of the grandest examples, six towering concrete silos at Granville Island's Ocean Concrete manufacturing plant. Each silo mea-sures over twenty metres high, and the mural spans more than two thousand square metres.[36]

The Pandolfos go by the joint artist name of OSGEMEOS, Portuguese for "the twins." In an engaging video about the creation of this piece, the brothers explain, "It doesn't matter if I'm Gustavo and he is Otávio, or if he is Gustavo and I am Otávio ... And our art is the same. He can start, I can finish ... and [it will] become one painting."[37]

In their artists' statement, they add, "The connection between water and land on Granville Island, on the False Creek margins, also had a

lot to do with the choice of location—for us, the water acts as a vein, symbolizing life, and it is very present in our work."[38]

I take time to admire *Giants*, the colourful six figures variously facing north and south, and change my mind about their needing fresh paint. They're best left as is, much like Indigenous totems, not always designed for restoration but to simply return to the earth in the same melting as nurse logs, adding their essence to their surrounds. A Haida carver I spoke with explained the nature of cultural art in this way: "Maybe it stands for one year. Maybe one thousand. That's not for us to decide."

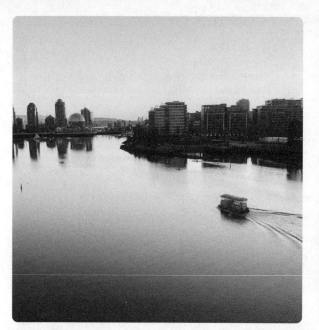

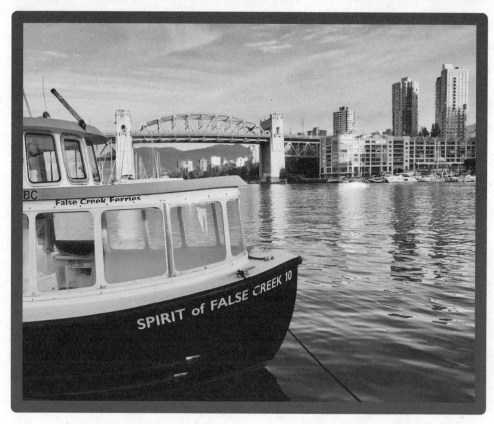

**CLOCKWISE FROM TOP LEFT:** an Aquabus heading east on False Creek; looking north from Granville Island, with Vancouver House on the left; False Creek Ferry and Burrard Bridge, looking northwest from Granville Island. *Photos by Bill Arnott.*

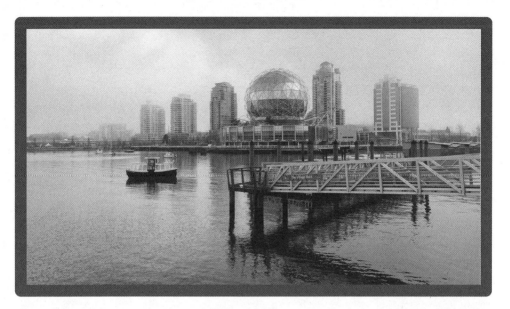

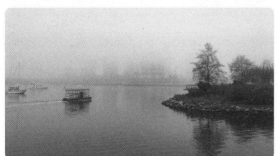

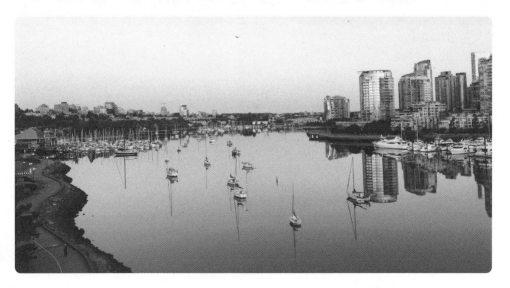

**CLOCKWISE FROM TOP LEFT:** Science World, through thinning fog; a foggy-morning kayaker on False Creek; False Creek at sunrise, looking west; an Aquabus in fog on False Creek.
*Photos by Bill Arnott.*

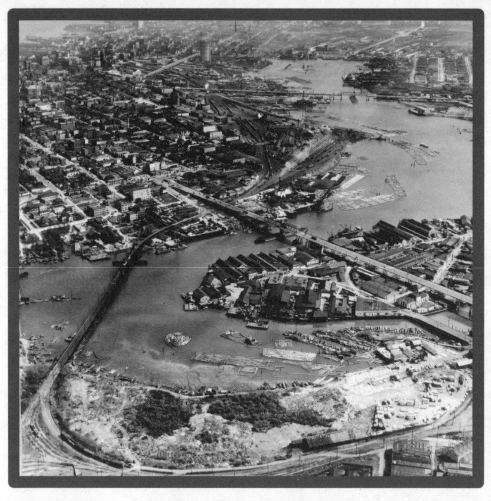

**CLOCKWISE FROM TOP LEFT:** False Creek and Granville Island, 1947; relocating a railcar by barge on False Creek, 1940–48; looking west along False Creek, 1946. *Photos courtesy of City of Vancouver Archives.*

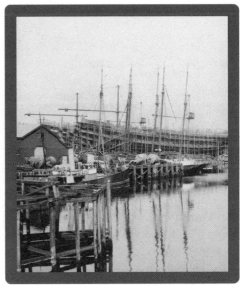

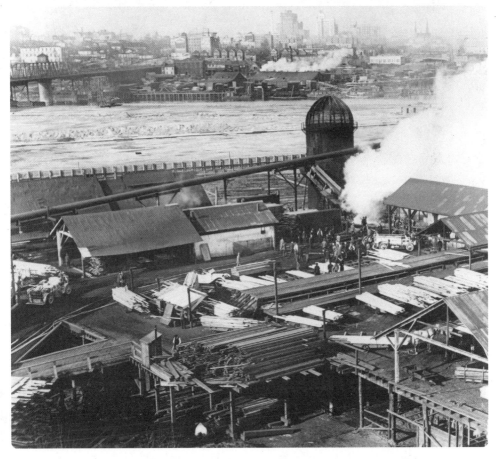

**CLOCKWISE FROM TOP LEFT:** rowers on False Creek, 1910–19; False Creek Shipyards, 1910–19; Granville Island, 1917. *Photos courtesy of City of Vancouver Archives.*

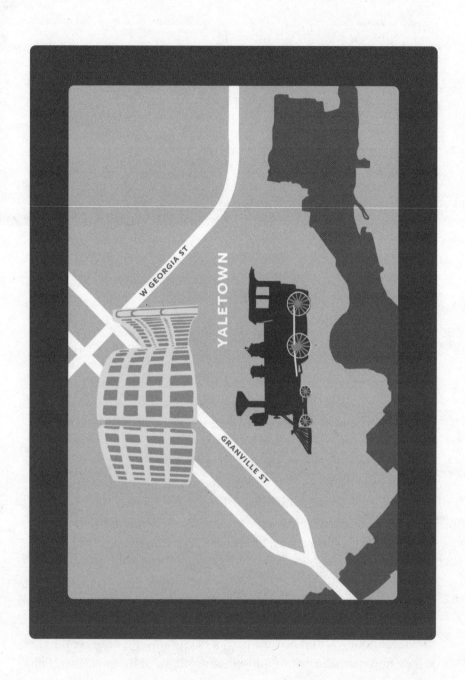

# *Yaletown*

*loneliness stories*
*shared among strangers and friends*
*eye contact, a smile*

THIS MORNING THE crows stand in formation, shoulder to shoulder, clinging to phone lines. Solid rows of parallel birds for almost two blocks, more than I can count. Eyes follow me, heads slowly swivel. One or two staticky blares sound in the caws like gameshow buzzers, as though I've gotten it wrong, making me oddly aware of each step, trying to remember how to walk forward.

It's lightly overcast with strong breeze and a promise of sun. And I've made my way into Yaletown, the north side of False Creek, just east of the downtown business core. I'm here for a new neighbourhood walk and to spend time with Vancouver Poet Laureate Evelyn Lau. We became friends when Evelyn was my instructor at the SFU downtown campus. A Vancouver native, Evelyn *knows* the city. An unbearable upbringing led to her leaving home as a young teen; she lived on the streets, in occasional group homes, and on the sofas of friends. Sex work provided money. Drugs became part of day-to-day life. Many of the stories we now swap revolve around substance abuse and dependence. Pills were her preference, whatever was on offer, an echo of TDM's sentiment,

"whatever the current colour of the pill." Writing poetry and prose were not only an escape, but inherently part of who Evelyn was and still is. She began winning writing awards as a child and received a nomination for the Governor General's Award for Poetry. Her memoir, *Runaway: Diary of a Street Kid*, became a bestselling book, eventually spun into a film starring Sandra Oh in the role of Lau.

Before we began our routine of taking walks together, usually along the north edge of False Creek, Evelyn had become a mentor to me, guiding my writing and shoving me past levels of comfort. Prior to this, I'd never been in a one-on-one session before, what writers might call blue-pencil coaching. Thirty minutes into that first session, I was crying, talking about my dead dad. Evelyn had tissues at hand, which should've tipped me off to the fact that writing consultation can be surrogate therapy. Had I known, I'd have asked for a sofa.

Invariably, our visits touch on travel, writing, and family, things ever present in both of our lives. Something I still enjoy when we walk is to stop by the Quayside Marina, its docks stuffed with yachts and a terminal for foot-passenger ferries. Immediately east of here is the Cambie Street Bridge, and under that, Coopers' Park, which was part of those lumberyards, log booms, and mills where shackers combed the shoreline for shellfish. If we were to walk east, we'd reach the Science World dome; west, David Lam and George Wainborn parks.

But here at the marina, atop a few stairs, is another informative plaque, this one featuring Evelyn, sharing a bit of her story along with a piece of her poetry. It's a good installation and enjoys a good view. For a while, there was a garbage bin here; we're both glad to see it's now gone. Evelyn's photographed visage faces south, making the most of the daylight. What I like about stopping here on our walks is that it feels like I'm watching TV while seated next to the person I see on the screen—a shift in perspective, dimensions, a fourth wall removed. Evelyn indulges me and, I suspect, likes knowing the sign's still admired and pristine. I make her pose for a photo next to her picture. A photo in a photo, you could say.

A shared smile, a hug, and we part ways for today, but there are still a few things I want to experience here. And so, I extend the walk into

Yaletown, which was my home for a while, back when I met the young man on the bridge. Some of the tidbits about this place I've taken for granted. Now I'm going slower in hopes of discovering things I likely missed in the past, the first being the name of the neighbourhood, a nod to the outpost of Yale, where CPR railyards were located east of Vancouver and just north of Hope.

South of where I am, under the Cambie Street Bridge, I now notice its pillars: blue paint in broad stripes, tones rising from dark to light hues. The work is *A False Creek*, created by artists Rhonda Weppler and Trevor Mahovsky. It doesn't quite have the grandeur of the cylindrical *Giants*, yet this art has a very clear message about the present danger of polar melt and rising ocean levels. An artist statement produced by the city explains:

> The Intergovernmental Panel on Climate Change projects sea levels rising between four and six metres as a result of the partial melting of the earth's major ice sheets ... [False Creek] is a site that provides an opportunity to reflect on the past, present and future of Vancouver's highly managed shoreline.[39]

The painted bands mark the midpoint of sea elevation rise estimates, that is, five metres. An ascension of blue softens into the same shade as the sky on clear days, when our planet's surface seemingly reaches the clouds. The effect is surreal, a calm in the sea paired with a rumble of imminent saltwater doom. I imagine the stripes as rungs of a liminal ladder, each step reaching not only new heights but new dimensions.

Ahead on the Seawall, still on False Creek's northern side, is a curving art installation by Henry Tsang called *Welcome to the Land of Light*. The work is unassuming but rich with interpretive design. A plaque in dandelion tones introduces the piece, while banister railings house the art: aluminum lettering spells out phrases in English and Chinook, pidgin used for a few generations in the Pacific Northwest. The jargon blends Indigenous Chinook with French, English, and First Nations Nuu-chah-nulth into language created for trade. I remember exploring Portland, Oregon, and learning that the Chinook–English dictionary

was the most common book in most city homes early in the twentieth century, when Indigenous merchants paddled through towns to conduct business in open-air, mobile markets. This language was never about industrialization but was instead succinct, everyday terminology used for commerce, like going to a store to buy goods when you're somewhere you don't speak the language.

Lit by the water's reflection, the words are aglow. The artist describes his statement in detail:

> *Welcome to the Land of Light* is a contemporary monument to the relationship between those who have lived on the False Creek waterfront and those who will arrive in the future to call this area their home. For the artist, this public art project is about the concept of home, the building of community ... the juxtaposition of English and Chinook Jargon functions as a metaphor for the ongoing development of intercultural communications in this region.[40]

Looping back, I turn at the T junction of Marinaside Crescent and Davie, bearing west. Ahead on my left is Yaletown Roundhouse. While the railway was securing and expanding passenger stations and destination hotels to the blocks north and east, the industrial grit of the railway yards was housed here: compass point tracks, an interchange turntable, loading ramps, cranes, and warehouses. A walking tour I once took started right here, a touchstone of Vancouver history from a settler and transport perspective and a literal landmark as well. A circle at the end of the line to punctuate an expanding nation like an exclamation point from above.

Many of the CPR buildings from the late 1800s still stand, buttressed and redeveloped into retail, residences, and restaurants. At a glance, the neighbourhood looks entirely made of brick at street level, with development rising in glass, steel, and concrete on top of the red brickwork.

I duck into the Engine 374 Pavilion, part of the Roundhouse Community Arts & Recreation Centre, a mixed-use space serving as history hub, community centre, and arts and performance venue. What

greets me is the black bulk of Engine 374, a steam locomotive. The engine's fully restored, crow black and shiny, eager to haul a fresh load of nineteenth-century travellers.

In 1883, as the CPR was nearing completion of its transnational line, the company began designing locomotives in Montreal. Two years later, the sea-to-sea rail was finished, the last spike driven at Craigellachie, now a bend in the Trans-Canada Highway between Sicamous and Revelstoke where signage instructs tourists not to hammer the commemorative spike.

Following this, the CPR constructed eight engines like the one I see here, each individually numbered, 371 through 378. In the summer of 1886, the first of these, Engine 371, pulled the first scheduled Pacific Express into Port Moody, making it the inaugural transcontinental rail journey. One year later, Engine 374, the locomotive in front of me, carried 150 passengers along the newly constructed train line extension into Vancouver, officially marking the nation's east-to-west railway connection. A black-and-white poster recaps that journey:

Engine 374. The first passenger train to come to Vancouver on May 23, 1887. The engine that linked Canada from Atlantic to Pacific.

Doubling back through exhibits, I give a zealous volunteer the slip once, twice, and take refuge among vertical banners, a timeline display with a dreamy, gossamer feel of moving through curtains while drifting through time. One of the banners informs:

When the construction of the Canadian Pacific Railway in British Columbia began in 1880, there were just over 30,000 non-aboriginal people in the province. It was estimated that the work of building the railway in BC would require several thousand men. The question was: where would the work force come from?

Titled Chinese Legacies, the series of hanging panels answers the question with historical snapshots of what the railway completion entailed:

There were up to 15,000 Chinese people employed along the railway line from Port Moody to Craigellachie between 1880 and 1885.

Work was contracted and conducted in crews, usually of thirty men, with a "bookman" serving as crew supervisor for tracking hours and language translation.

How many Chinese labourers died during railway construction? The estimates are between 600 and 2000 deaths, some as the result of landslides and dynamite blasts and other accidents, and some due to poor nutrition and illness.

The actual numbers are unknown.

The Chinese Consolidated Benevolent Society, concerned about the number of Chinese men who had died along the railway line without proper burial, hired workers to retrieve their remains and bring them to Victoria.

A Chinese cemetery was established in Victoria's Oak Bay, along with a "bone house" used to store remains for those being returned to China.

Once the railway was completed, most of those jobs disappeared, apart from a few crews who found occasional work servicing the line. For many, return fare to China was unaffordable. The result: unplanned immigration and a largely unemployed workforce. Labour shortages following the First World War did, however, provide a few jobs and wage leverage for former railway workers, but it would be many years before Chinese and white wages were comparable.

From the Roundhouse, I keep moving west to a whimsical patch of concrete and brick, a park with a floor: Bill Curtis Square. Spearheaded by the neighbourhood's BIA, or Business Improvement Association, the

space is best known for rotating art installations collectively known as *Suspend*. A gridwork of overhead wires forms the "canvas" from which colourful things are suspended. Parasols and umbrellas are frequent, in splashes of colour or palettes of a bright single shade. They do, in fact, shade the area. Other times, butterflies have flown here. Flowers as well. Today it's an eye-pleasing ceiling of inverted umbrellas in the warm orangey red of baked salmon.

From here I can take any street veering north and feel that the vista's identical: restaurants, retail, a few offices, patio pubs, a magnet for warm-weather tourists. But I'm not reading menus today, not planning a meal. Instead, I'm en route to the library. But first a short detour through a new urban space, Rainbow Park, a reimagined city block that's now public space. There's a coffee shop with neatly stepped concrete, an activity centre, trampolines, climbing frames, and hammocks. At the moment, a series of triangular flags overhead display Coast Salish art. A nautical feel in the cultural display, they could pass for an extra-large bunting of spinnaker. Although it's wired into place, there's life in the fabric, like the gentle movement of prayer flags on a calm mountain day, leaving me with a sense of meditativeness, of eagerness to delve into pages and words.

The Vancouver Public Library (VPL) has over twenty branches scattered around the city, each with a neighbourly appeal. Where I am now is the Central Branch, a place where Evelyn has her own dedication, part of the Yosef Wosk Poets' Corner on the library's ninth-storey rooftop garden. Flower-like steel installations "grow" from the garden, adorned with the names of the city's poets laureate. The building itself has a cultivating effect, history here as abundant as what's stacked on the bookshelves inside.

The city library got its start in 1869 with Hastings Mill, the Burrard Inlet sawmill seen by many as the area's first commercial operation, around which a non-Indigenous settlement developed into what would eventually become Gastown, then Granville, and finally Vancouver. Mill

manager J.A. Raymur instituted an employee meeting room and staff library. This became known as the Hastings Literary Institute, which lasted for over a decade. In 1886, a new reading room was established with a donation of four hundred books from the former Hastings Institute and became commonly known as the Vancouver Free Reading Room and Library.

By the turn of the twentieth century, the Free Reading Room had outgrown its space, a YMCA building on West Hastings. Enter steel magnate and philanthropist Andrew Carnegie, then in the process of doling out most of his fortune to "improve society" through education and research initiatives, including the construction of libraries. A *lot* of them. Over twenty-five hundred, in fact, across North America and beyond.

Which triggers a money memory. When I was barely an adult, I inherited a few thousand dollars. I figured I'd invest it, use it for school. So, I went to an investment firm, where they booked me an appointment with a stockbroker. I put on my suit and went for our meeting, feeling terribly grown-up and sophisticated. We discussed my "investment comfort zone," when I'd need the money, and so on. And on the advice of the broker, I bought a convertible bond in a steel company, a company that was once a competitor to Carnegie's firm. To give the stock broker credit, it would have been an excellent investment, had I invested a hundred years earlier. However. With student loans and two jobs, I got by. And yet, in a circuitous way, I still get to enjoy the rich dividends of that industry, albeit through Carnegie's library donations.

In 1903, Vancouver's Carnegie Library was built at the corner of Main Street and Hastings, and it became the city's main branch for the next fifty years. The library then moved to Burrard Street, in the shadow of the current Hotel Vancouver, where it stayed until 1995, when what I'm staring at now was completed: VPL Central Branch, a hundred-million-dollar undertaking. Cheap, I suppose, compared to a puffy white stadium roof. Now part of Library Square, this real estate occupies the entire block between Robson and Georgia, set between Homer and Hamilton streets, and was then the largest capital project undertaken by the city. Following a competition and survey of

public opinion, the design work of DA Architects and Moshe Safdie & Associates was selected, described as "unique, imaginative, interesting and exciting."[41] The office tower, with a long-term federal government lease, facilitated financing in conjunction with securing the land. It took two years to complete. With retail and food offerings, as well as extensive public education and events, Library Square's traffic of book borrowers and sightseers mushroomed from its previous activity.

From here I can admire the building's distinct features, connected by breezeways and glass. There is a corner office tower, its winged extension curving like a sail in breeze, and the primary library sits in a smooth oval. Exterior walls are heavy with colonnade, the ellipsis resembling an amphitheatre from Rome, space where gladiators might race chariots. Along the library's streetside curve, black-and-white photos adorn an east-facing wall, a family album of sorts, snapshots of the library's evolution from the Free Reading Room to the Carnegie building, a hopscotch through the city and time, each frame a step toward here. Inside the high vaulted atrium, interior glass looms on an open concourse and foyer, a piazza created by a rounded wall within a rounded wall. This could be a pedestrian walkway in any urban centre in Europe, blending architectural vision, functionality, and welcoming accessibility. Two different people are napping at tables. If I had to guess, I'd say one is a student, with somewhere to go after this. The other, I'm not so sure.

Inside the branch, I browse books on Vancouver, curious to see what others have seen in the places I've been. Searching through local sources, I find a well-researched list of key turning points in the city in a book titled *Everything British Columbia*.[42] The first is the creation of reserves for Indigenous Peoples in 1869, the development of unceded land, with treaties *not* being negotiated. The second is the CPR's moving its Pacific terminus from Port Moody to Vancouver, hot on the wheels of Engine 374. Coal Harbour was chosen, the result of government dealings in which provincial authorities granted two thousand hectares of land to the CPR, land occupied by Indigenous Peoples.

Next on the list is the establishment of streetcars, their route system creating and delineating neighbourhoods, labelling the gridwork of roadways and paths I'm now walking.

Following this is the anti-Asian riots of 1907, in which a white mob destroyed much of Japantown and Chinatown, attacking citizens and looting. When the riots finally ended, every window in Chinatown had been smashed. In a bizarrely dualistic government response, Asian merchants were compensated while, at the same time, immigration restrictions were increased, limiting Chinese and Japanese migrants.

According to the book, the next wave of regional change can be pinpointed to 1929, when the city expanded through the absorption of municipalities, specifically South Vancouver and Point Grey, making Vancouver the country's third-largest city with a few pen strokes. The significance of this goes beyond population and area, because for the first time, the city would include diverse socioeconomic groups in distinct geographical areas. Working-class residents tended to live east and south of downtown, while wealthier locals were generally inhabiting properties in the west- and north-lying regions.

A blend of technology and behaviour is cited as the catalyst for the next wave of change: the accessibility of cars from the 1930s through the 1950s reinvented the city once more. No doubt we'd find facets of this anywhere, but in Vancouver, it was even more so, one reason being the extensive system of serviceable streetcars. Transit was good, making cars less essential. Compared to other large cities, Vancouver was slower than most to embrace automobiles. The lay of the land was a factor as well. Rivers and inlets created a need for bridges, in this case, no longer simply for railcars and trolleys, but eventually for cars as well. The construction of the Lions Gate Bridge in 1938 accessed Guinness family land in what's now West Vancouver. Being able to drive directly from the North Shore into downtown eliminated the need for ferries crossing Burrard Inlet, while the paring down of the streetcar system in the early 1950s contributed to more cars and created a further need for bridges.

The next major change began in the 1960s, when the federal government reversed discriminatory immigration laws. The result was an influx of immigrants, particularly from the Pacific Rim. The book's researchers also refer to that turning point of the Summer of Love, considered the "long decade" of the 1960s. Social change was at a zenith,

with civil rights movements, peace protests, and a backlash against consumerism and material possessions. The civic plan to construct a highway through Chinatown was quashed, largely due to grassroots efforts. In 1972, further upheaval ensued as a development-driven council was voted out in favour of more moderate city policy-makers focused on creating social, family, and cooperative housing, much of that being what I walked through on the south shore of False Creek.

Rounding out the list of the city's turning points is Expo 86, that springboard for adolescent Vancouver's becoming a grown-up, I'd say overnight, but it ran from May to October that year. I think of the billboard, the one with the hot-air balloon in a still-growing development where the fair had been held, a reinvention of self for the city, its investment and infrastructure. And I think of graffiti I saw there as well: a skateboard park, art burbling from the street in a shake and a hiss of spray paint. Pleas and shared anger, another "last spike" being driven, this one in alternate steel.

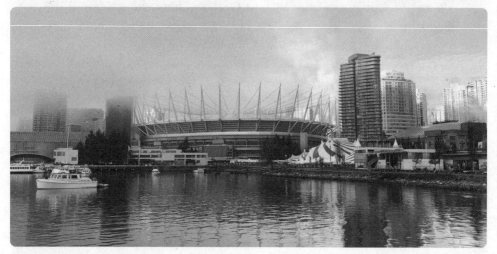
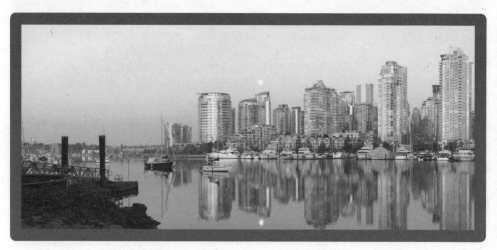

**CLOCKWISE FROM TOP LEFT:** a full moon over Yaletown, looking east over BC Place; Vancouver Public Library, Central Branch; BC Place stadium, touching low cloud; downtown Vancouver, from southeast False Creek. *Photos by Bill Arnott.*

**TOP:** the False Creek view corridor in 1905. **BOTTOM:** Cambie Bridge, looking north to Yaletown and downtown, 1946. Note the Marine Building and the Hotel Vancouver. *Photos courtesy of City of Vancouver Archives.*

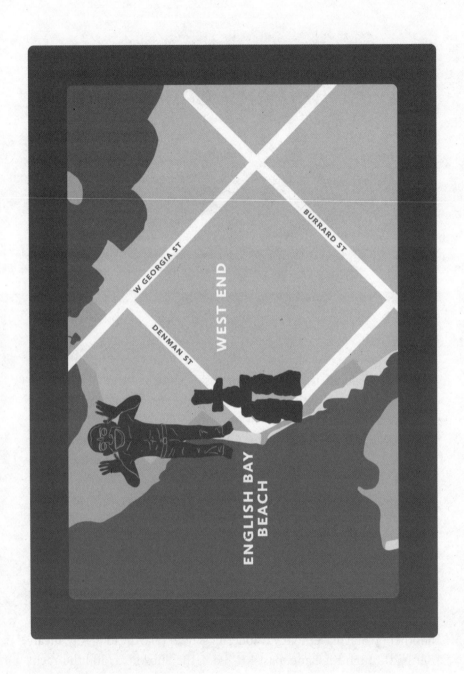

# West End and English Bay

stories of streetscapes
 etched into granite and steel
  fade softly with time

A NEW DAY in ebony shades, wet and cold. I can barely make out the crows in the gloom, their feather smears flapping in charcoal. I consider changing the name of the book, then the next cup of coffee kicks in and with it, a promise of daylight. For now I cocoon to see what the weather provides and pick up a travelogue from my bedside table. Skimming the text, I discover a quote that could mesh with my own exploration, a merged narrative from Bruce Chatwin, who in turn quotes the Buddha. It's almost a time-bending game of Whispers, voices in hushed private tones, in this case roving the world. No doubt the words readjust with each telling, but the quote goes something like this: "You can't travel a path until you *become* that path." Words that could well be intended for me at the moment, a gentle reminder or a cuff to the head. So I put on rain gear, pull on a hat, and venture out under circling crows.

Today I'll explore Vancouver's West End. I've arranged to visit with another pivotal player to my wanderings. But I take the long way, meandering through Kitsilano, past Kits Pool, the Showboat, and the Yacht Club. The pool—seasonal, accessible, outdoor—has become a city icon,

one filled with its own splashy stories. I even have a stylized print of it on a wall in my home. In the picture, it's always sunny.

Kits Showboat is an open-air stage, with rows of benches that rise in an amphitheatre of nautical blue. For those in the seats, the view to the stage faces north, with Burrard Inlet and the North Shore mountains beyond. Featured acts tend to be local: music and song, mixed performance and dance, some famous, many new to the stage. Shows are free, and the energy is invariably warm. When I saw a friend performing here, singing his original folk rock, all I could think was how tiny he looked on the stage. I was more nervous than he was. The space, however, remains one of those places where the venue itself is the headliner.

The long wooden pier of Kits Yacht Club reaches into the water just west of the Showboat, where sailors, rowers, and paddlers ply the bay. The club's been here since 1934 and keeps the water busy through the summer with white hulls and sails. Following the sand of Kits Beach, I'm among joggers, dog walkers, parents and caregivers with strollers, children on swings, and swimmers in a shivering clump. I hear the coo of a pigeon as an eagle sails by, scolded by seagulls and crows.

I pass a commemorative plaque set on stone honouring George Burrows, "guardian of Vancouver beaches and pools." There's another Biennale installation, a series of steel chairs, but unlike the Showboat bleachers, these seats aren't solely for sitting. Collectively, the chairs are called *Echoes*, sixteen stainless-steel seats created by Canadian artist Michel Goulet in 2005. The original exhibit was displayed across the water at Sunset Beach, on the northwest shore of False Creek, past the Elsje Point outcrop, before being moved here in 2010.[43] The chairs face compass points: north, south, east, west. Each chair is carved through, inscribed in both English and French, with aphorisms in dreamy prose bubbles. On a sunny day, the chairs throw shadows of words on the grass, soil, and sand, their projection, when strung together, creating a free-flowing poem with the flavour of a beachside bilingual *Odyssey*.

I make my way northeast. At a bend in the path, a half-buried rock could pass for a rune stone or a cairn. Here's another art installation, a poem not reliant on sunshine or shadow, but etched in a boulder of salt-and-pepper granite, an isosceles with a Himalayan look. Called

*Vancouver in the Rain*, it's poetic prose by Regan D'Andrade and captures the mood of today. In her piece, the poet feels that same sense of gloom that I did when I woke, only to realize, as I did as well, that the day still holds wonder, proffering a less obvious internal brightness. A reminder to not grumble and that this is, in fact, another perfect day for doing just this.

I cut through avenues and streets, where an art drop of painted rocks peers from under a hedge: petite faces on stones, a range of expression in the eyes, a mouth gaping in wonder. Next to this, a Little Free Library: a cabinet set on a stand with levered doors holds a selection of used books inside. People take and leave what they want, no cards or overdue fines, very much sharing the word. I open the small doors, today misty with condensation. Mostly novels, with a stack of Jack Reachers, some Clancy and Gabaldon. Even one of my own, near the back and suitably thumbed.

Curving back past Senákw, I cross Burrard Bridge and turn left, following the inlet's northern shore westbound. I'm now at Sunset Beach, where a plaque describes this sloped expanse: "Sunset Beach Park, established in 1959, completed the dream of a continuous strip of public waterfront between Stanley Park and the head of False Creek." Prior to this, the shoreline was a mishmash of seasonal cottages with a few apartments and an aging public pool. But in 1941, George Reifel traded the last strip of "private" land at what's now the foot of Bute Street to the city in exchange for property elsewhere, enabling the establishment of this continuous beachside park.

I'm on a slight elevation. Behind me are mid-rise apartments and condos, and to the south, I see Vanier Park, the museums, Hadden Park, and a bit of Kits Beach. To the east is Burrard Bridge and a passenger ferry heading to Granville Island. An outdoor fitness class is using a sliver of park, while a few huffing folks inline-skate on some concrete. In the bay are a few ships, as a Zodiac buzzes from the coast guard station. The metronomic *tick tick* of a metal-tipped cane approaches, and the woman using it smiles as she passes.

Two more Biennale exhibits stand before me. At the water is a piece titled *217.5 Arc x 13*, thirteen weathered-steel arcs, their ends pointed

toward the sky.[44] The upturned U shape is reminiscent of that partially deconstructed marquee, something open and almost completed. This installation is by sculptor Bernar Venet, designed using precise math to convey the beauty of raw steel and its natural fit with surroundings, curvatures depicting the interconnectedness of people and nature. It not only looks but feels like a paired bookend to the big open square across the water, *Gate to the Northwest Passage*, which comprises part of a circle and most of a square in heavy steel, with the stabilized rusting effect known as corten creating a coarse ochre-brown surface.

The next Biennale piece is another of giant proportions. This one, *Engagement*, sits up from the water on grass circled with trees in a lop-sided loop, its own quasi–peace park called Huntington Meadow.[45] At a glance, the art needs no explanation. The two enormous engagement rings, each nine metres high, are the creation of Dennis Oppenheim. The rings are rolled steel and aluminum, with "diamonds" made of plexiglass in oblique pyramids that light up at night. Oppenheim's work is pop art, the repurposing of familiar or everyday items into evocative new iterations. These rings appear slightly squashed, a commentary on the delicate or precarious balance inherent in relationships, institutions, and commerce. Much like OSGEMEOS, Oppenheim rarely explains his own work, leaving interpretation up to viewers. The depth of this piece is easily overlooked, as it remains a popular photo spot for the newly engaged and married. Where I am now, looking west to the inlet and bay, the vista's ideal for a photo, particularly at sunset. Having grown up in a household of jewellers, however, I see extra layers: the industry of gemstones and mining, oppression and power, and institutional flaws, not to mention the burden of symbols and cultural weight. But yeah, it's a beautiful setting.

Leaving the sculptures behind, I keep walking west, and it occurs to me I haven't yet needed the little umbrella I packed in a pocket. It's actually starting to brighten, while over my shoulder, Oppenheim's rings are even emitting a slight shine from their bands.

Another landmark ahead, cresting a round point of land: *Inukshuk*, the work of Rankin Inlet artist Alvin Kanak.[46] Traditionally, inukshuks, or inuksuit, were landmarks, navigational aids, and spiritual conduits.

This one, composed of eight granite boulders, was commissioned for the Vancouver World's Fair and adorned the Northwest Territories pavilion at Expo 86 before being moved here the following year. The rock statue, decidedly humanoid, commands the headland and north edge of the water, keeping an eye on the bay. I wonder what it makes of the George Vancouver blocky arch to the south and what a window from here might reveal.

The beach is a jumble of driftwood and logs broken from booms— who knows where, who knows when. This whole stretch of Sunset Beach back to Burrard Bridge is made up of reinforced beaches scalloped in a series of shallow, tide-breaking lagoons. With prevailing southwesterlies, things tend to accumulate here, one being a breakaway barge shoved shoreward during a storm in 2021. For a while it appeared the leviathan was going to slam into the bridge. The road and the bridge deck were closed, traffic diverted. But the barge lodged itself safely next to the beach, between the two Biennale exhibits, becoming its own installation and reigning supreme with the Instagram crowd.

I check the time. I'm still ahead of my meeting, so I dawdle as I bear west and north, coming to the wide, sandy swath of English Bay, where another plaque grabs my eye. This dense urban beach surrounded by high-rise apartments, restaurants, patio pubs, and paddle-board rentals once housed a cottage, a modest one too: the home of Seraphim "Joe" Fortes, a Black Caribbean immigrant who arrived in 1885, when the city was not yet Vancouver but Granville. Fortes worked in forestry, rowing supplies across the inlet between logging camps, and came to treasure the beach and the bay. The plaque shares his story:

> Joe defied the prejudices of the time, endearing himself to Vancouverites as the city's first Official Lifeguard. He also patrolled the area every night as a Special Constable of the Vancouver City Police. Thousands paid tribute to Joe at his civic funeral on February 7, 1922. His small cottage stood on this site from 1905 to 1928.

From the beach I turn north, sidestepping to Morton Park at the corner of Davie and Denman, where perhaps the most famous Biennale

exhibit now stands, Yue Minjun's *A-maze-ing Laughter*. Fourteen burnished bronze statues each depict the artist having a laugh; some are hysterical, some farcical, some simply wear grins of enjoyment. Says the artist, "My intention when making this series of sculptures was to use art to touch the heart of each visitor and to have them enjoy what art brings to them."[47] Strolling through the extra-large men all having a very good time, I can't help but smile, even chuckle. Infectiousness captured, conveyed in copper and tin. All on a small wedge of land with sea view surrounded by windmill palms, their finger-like fronds adding half-hearted applause.

Farther north, on the pedestrian scurry of Denman Street, I pass the Joe Fortes Branch of the VPL, another nod to the man and his influence. A short detour east brings me to Barclay Manor and Roedde House. The manor now serves as a community centre, the house as a museum. When I lived in the West End, the manor was a place I visited frequently. I'd lied about my age, adding a decade, and bought a fifty-five-plus senior's pass to join a writers' group: poets, novelists, memoirists, encouragement and sharing. No one questioned my age, which convinced me that I needed to take better care of myself.

The manor building is in soft lemon tones with a wraparound veranda, a brick chimney, and a tile roof. The first part of the house was constructed in 1905, with additions added in 1909.[48] For a period it served as a hospital, then as a women's residence called Rosary Hall. In 1925, it took its current name, Barclay Manor, becoming a boarding house. Although known as a respite for naval officers, the manor also served travellers, wanderers, and short-term residents. Two daily meals were included, providing a sense of shelter, a pilgrimage inn serving a wider community. Bought by the city in 1970, the manor was rebuilt in 1988, restoring its Edwardian design. In 1990 it melded with the West End Seniors' Network and Community Centre Association.

Occupying the same block, with a lush garden, a gazebo, and benches, Roedde House sits like the manor's better-dressed sibling, completing the citrusy palette in two shades of lime. Built in 1893 by Matilda and Gustav Roedde, the house is the design work of architect Francis Rattenbury, designated a class A heritage building.[49] Of

particular interest to me, Gustav was the city's first bookbinder. His printing business, G.A. Roedde Bookbinders, was a half-hour walk from here, in a three-storey brick building on Homer Street, the tallest structure around at the time. One of Roedde's unique offerings was marbled paper; colour was applied by aqueous transfer, giving the paper the look of textured, smooth stone, a process still popular in bookmaking design.

Now I'm almost late and have to hustle back for my meeting, a coffee date with Lorenz von Fersen, a City of Vancouver cultural planner who was instrumental in creating the historical stories and plaques leading me across the city. We settle in at a West End coffee shop to the *grind whirr* of espresso and the aroma of freshly ground beans. I've read a description of Lorenz as lanky, which is accurate. Tall and fit, he folds himself into a seat for our chat. From an artistic and cultural perspective, his résumé is a snapshot of the city's most recent decades: the Vancouver Folk Music Festival, the Vancouver Writers Fest, the City of Vancouver Portrait v2k Millennium Project. Innovative, enduring legacies Lorenz has either created, run, or helped to ensure the success of.

Portrait v2k is what I want to learn more about, the city stories that have been revealing themselves on my walks, a combination of heritage, history, and storytelling—intangibles I want to understand better. I ask Lorenz to explain.

"v2k is the sharing of oral stories about Vancouver. Not history, but *stories*. We thought the plaques would last for five years, but they're still there! A hundred and fourteen plaques, with ten other stories on boulders."

Stories that are shared not only as a means of imparting knowledge but also of facilitating the invocation of experience, bringing to mind a Thule term I once heard, *isumataq*—that is, a storyteller who "creates the atmosphere in which wisdom reveals itself,"[50] akin to Socratic learning.

I ask Lorenz about the rocks the stories appear on, granite as captivating as the words being shared. He smiles. "When city works projects take place, road repairs, etc., they're always left with a few pieces of granite. Some get saved. And we went shopping."

The best-looking rock hunks were embossed with narrated stories, becoming v2k installations. Following the success of v2k, Lorenz then spearheaded centenary celebrations for Kitsilano, putting in place a historic microscope with new installations, more regionalized stories, and the addition of photos, an extension of what I've been seeing on light standards and poles.

Our conversation moves into travel, the interpretation inherent in movement, the flora and fauna we encounter. Lorenz picks up the thread. "Plants tell the story of a place, where it's come from, what people value. An example being laurel hedges, what Vancouver's known for."

Something I realize I'd taken for granted.

"Greenery, gardens, share an element of *why* we look the way we look. Plants and trees tell us about our city's state of health, the health of the neighbourhood, occupancy, pride of place, all of it. Back lanes as well. You know, some are still unpaved! And, of course, architecture, what lessons we've learned."

I consider the notion of lessons learned, the importance of stories, flashing back to a conversation with Evelyn Lau, the idea that a poem is simply a stylized story. And despite how we differentiate stories from history, we can appreciate the fact that historical lines have been blurred more often than not. History is written with objectives, distorted by perspectives and time. I recall a presentation in which the speaker delineated the difference between truth and *TRUTH*—written as such on a whiteboard. The latter is the version on offer, for sale, the hot-air variety, maybe wailed from a pulpit or proclaimed on a campaign trail. The former is simply the way things are or were experienced by those who were there, with no motivation to skew fact.

Lorenz and I chat a bit more about stories in conjunction with plaque installations. When he worked in the midst of collaborative efforts between the City and the Heritage Foundation, he explains, things were rarely easy, due to strong and differing personalities, to say it politely. But the Museum of Vancouver facilitated, acting in a negotiatory role and enabling things to get done.

"What I saw, what we saw," Lorenz adds, "was that v2k was an investment in the future, following the particularly bloodthirsty

twentieth century. These were portraits, volunteers meeting and interviewing people to learn their stories. Of course there's an ethical element—collecting oral history, factors including remembering. Not to mention ownership of stories and art. Highly ethical issues. Although historical plaques were in place, this was the first civic infrastructure of stories by citizens."

I recall a research paper by Diana E. Leung, "Recovering Evicted Memories," that speaks of the v2k program, using the words *storytelling* and *oral*, with a description of the initiative as "a kind of collective memory bank."[51] My mind conjures time-capsule imagery, composed not only of objects and words but aural depictions and sounds too.

Lorenz asks about my walks, what these days of discovery look like. And I explain that as I walk, I often make voice recordings, articulating my thoughts in real time, adding my own oral story. To a degree, I'm leapfrogging the process of rewriting, a straight line from narrator to narrative.

Lorenz smiles in reply, understanding, and our chat shifts to composition and sound, what he calls environmental acoustics. "When you record something, you hear things you don't when you're walking." He refers to the subtle nuance a microphone often captures. Another grin. "The politics of noise. Much like 'memory walks,' areas and buildings: nostalgic but insightful. It can also be a slap in the face. They're gone, let it go!" he adds with a warm smile, as though bidding farewell to close friends.

—

Coffee's done, and Lorenz is off to trounce friends on the pickleball court. I resume my walk, looping once again through the West End, stopping first at the neighbourhood library for a title Lorenz recommended: *A Hurricane in the Basement and Other Vancouver Experiences*, a summary of the Portrait v2k project and the neighbourhood plaques I've been sourcing. Going through the book, I see passages contributed by Lorenz about placing quiet, personal experiences of storytellers on plaques in the hopes of bringing "a softer, more humane feeling to our

bustling urban streetscapes." He describes the city works granite and its transition into story stones, referring to these as "glacial travellers," the remains of a previous ice age—which I see as slow-rolling stones, samples that *do* gather moss, in the form of collected, accumulated stories. He concludes by summarizing the intent of the project, a hope that the triggering of memories will "add another layer of meaning to our sense of the place called Vancouver."[52]

Another passage in the book resonates: a contribution from Henriette Koetsier, reflecting on what she refers to as this "small town, big city."

> This is a city that strains for world-class status, like a prescient teen-ager in a wealthy family, yet lacks maturity. Earnest, yet slightly heartless. It is part of us, yet apart from us. We can transcend it, yet it will eclipse us ... Tracing roots to First Nations, there exists a veritable United Nations in every block of Vancouver. We don't know how it works but it does. Albeit, the most we will ever have in common with each other is the desire to live here. In the end, we take the best and give the best to this part of the world we call home.[53]

Two voices out of maybe two million and both views that I share, leaving me wondering as to the overall extent of the overlap in collections of stories that are truly collective. Maybe *that's* the story unravelling here: a story of stories spread on a map of the city. An atlas of not merely two dimensions but an off-kilter gridwork of avenues, laneways, and streets where dimensions are utterly endless. A conglomerate of experience in as many stories as souls.

With these thoughts of humanized spreadsheets imparted upon roads, I refuse, for the moment, to choose only one. Instead, I veer through back alleys, each buckled stretch an introduction to people, stories, and lore. Here in the West End, laneways not only have names but are personalized, deepening a sense of community.[54] I mimic a chess piece moving forward and to one side, now the other, box-stepping to navigate monikered lanes.

The first I encounter is Maxine Lane, named for chemist and entrepreneur Maxine MacGilvray. Her business, the Maxine College of Beauty

Culture, was located here on Bidwell Street in 1930. Six years later, Maxine replaced the structure with a Mission Revival–style building, updating her business to Maxine's Beauty School. Although the building has been redeveloped, the facade's been retained, something that would fit in Sonora, with the yellow of desert scrub, featuring red Spanish tiles, Gothic arches, peaked windows, and rafters. Additions include a Baroque gable and a mission bell, which makes "Hotel California" play in my mind. From here, looking south, I can make out Kanak's *Inukshuk* and the rings of *Engagement*, the grassed slope and the water.

Now I'm at Pantages Lane, dedicated to Peter Pantages, founder of Vancouver's Polar Bear Club. Following the First World War, Pantages came to Vancouver from Greece ahead of countrymates who eventually found homes in Kitsilano and Greektown. After working at his uncle's theatre on Hastings, Peter owned and ran the Peter Pan Café, a successful glass-fronted restaurant on Granville Street. But he's likely best known for his daily dips in English Bay, irrespective of season or weather. Friends gradually joined, and the Polar Bear Club was created, with celebratory public swims still happening every New Year's Day from the beach by *Inukshuk*, where I like to believe that, for a season or two in 1920–21, Pantages and Fortes, Peter and Joe, might've had a swim or a laugh together.

With two turns, left and right, I find myself at Stovold Lane, named after Kay Stovold, advocate for seniors and people living with disabilities. She co-founded the West End Seniors' Network, the community service I benefitted from as a writer, and Kay's Place, situated in Denman Place Mall, which is a drop-in space for seniors to visit and access an array of resources and services: information about and assistance for housing, subsidized rentals, landlord and government issues, and residential care and support. Many needs stem from isolation and illness, loss and depression, a legacy that knows no age limit.

Next I find Ted Northe Lane. Northe was a pioneering LGBTQ2S+ civil rights activist and drag queen who advocated for the decriminalization of homosexuality through the 1950s and 1960s. In 1958, Northe led his first protest at Vancouver's court house, dressed in full drag. Incredibly, the law required men to wear three pieces of "qualifying clothing," those

being "men's" socks and underwear—which Northe did for compliance, cleverly (and effectively) stuffing men's undies and socks in his bra. He followed this with a multi-year letter-writing campaign, gradually garnering attention and support from politicians and lawmakers. Finally, in 1969, former justice minister and then prime minister Pierre Elliott Trudeau passed bill C-150, decriminalizing homosexuality in Canada.

Farther along, I find familial lanes, by marriage, at least: See-em-ia Lane, for Squamish matriarch Mary See-em-ia, granddaughter of Chief Capilano, and Eihu Lane, for the Hawaiian settler Eihu. In what was a common-law polygamous marriage, See-em-ia had a second husband, Joe Nahanee, another Hawaiian, and the three spouses resided at Kanaka Ranch, now Coal Harbour, directly north of where I am now. The ranch-settlement was a blend of Indigenous Coast Salish and Hawaiian Peoples, a polyethnic Pacific infusion.

Through the 1800s, many Hawaiians arrived to find work in fishing and fur trading. Hudson Bay ties were part of the connection, as well as Hawaiian salting facilities, which drove North Pacific fisheries in advance of industrial refrigeration. The Kanakas were a widespread family group from around the Pacific, *Kanaka* being a Polynesian term to define people or humans, but every Kanaka to come here was a native Hawaiian. These local Hawaiian First Nations roots began a lengthy inheritance, a spliced family tree of temperate forest and tropics.

On to Rosemary Brown Lane. Brown was the first Black woman elected to a provincial legislature in Canada, becoming a professor of women's studies at Simon Fraser University before being appointed commissioner of the Ontario Human Rights Commission.

Another squared loop, and keeping to my chessboard analogy, I no longer know if I'm winning or losing, not to mention what piece I might be. Now I'm at Jepson-Young Lane, named for Peter Jepson-Young, a medical doctor diagnosed with AIDS in 1985. Jepson-Young educated the public about HIV and AIDS through his weekly video series, the *Dr. Peter Diaries* on CBC; the sharing of his story was informative, impassioned, relatable.

Heading south once again toward the water, I've come to Jung Lane, commemorating Vivian Jung, the first Chinese Canadian teacher hired

by the Vancouver School Board. Part of Jung's teacher training required her to complete a lifesaving certificate. But in 1945, the "public" Crystal Pool at Sunset Beach, near what's now the corten-steel U installation, disallowed Jung from entering. In a draconian reversal of what Joe Fortes accomplished, nonwhite swimmers were restricted to one day of pool access a week, with no mixing of Asian or Black bathers with whites, a rule enforced when the pool opened in 1929. However, Jung's co-workers and students refused to get into the pool without her; their show of support resulted in the elimination of segregation at the facility. Jung completed her training and taught in the city for thirty-five years.[55] I can almost hear that domino drop, one in a series of *clatter clack clacks* that ends in a splash, with applause and a cheer from Jung's students as she jumped in the pool, in what I hope was a cannonball.

Shifting my route north and east along Robson Street, each conversation I hear is in something other than English: Russian, Farsi, Japanese, Arabic, with Persian pop pumping from a stereo. Food options: Korean, Japanese, Chinese, Filipino, Thai, Vietnamese, with lineups for ramen, bubble tea, cakes, and fried chicken. A culinary globe, with loitering sweet, spicy smells.

A side street has a low ceiling of strung lights, the look of a chandler's loft. A one-legged man wheels himself in a chair, inching, inching up a steep street. A few roads are blocked off to traffic, with tables and chairs of painted concrete under maple and oak. There's a square empty lot overgrown with grass, halved in two tidy triangles, the bisecting diagonal the result of footprints, the residue of people taking the most direct route, like bipedal ants heading home. I consider the shared walkways that we follow, possible ley lines or pedestrian pheromone trails, shortcuts known as desire paths.

Last time I was here, it was sunny and warm, and a lone goose occupied the trail. Two perfectly good patches of grass, and yet this chunky bird chose to plunk itself squarely in the footpath, forcing everyone else to walk around, half going left, half going right, breaking new trail to create a wow on the point-to-point line.

In the heart of Davie Street Village, at Davie and Bute, I follow a rainbow crosswalk to Jim Deva Plaza. Deva, activist and advocate for the

LGBTQ2S+ community, founded Little Sister's Book and Art Emporium. The bookstore, now ahead of me, surfaced in international court cases pivotal to reinventing publishing and censorship laws, building on what Ted Northe had accomplished. A heritage plaque here shares more:

> The blocks of Davie Street between Burrard and Jervis became the heart of Vancouver's gay community in the 1970s. A streetcar strip of shops like many others in the city, it began to attract gay-friendly businesses in the years following the first demonstration for rights by the Gay Alliance Towards Equality, in 1971. The first gay pride event was held the following year and soon became a major parade each summer.

Kitty-corner from where I'm standing is QMUNITY, "BC's Queer, Trans, and Two-Spirit Resource Centre," whose former executive director, Dara Parker, describes Davie Street Village as the "most visible example of queer culture" in the province.[56] In addition to Little Sister's bookshop, more institutions became symbols of gay liberation: a gay community centre, a gay press, and openly gay nightlife and clubs. One of the most notable of these is Celebrities, housed in the heritage building I'm now approaching, where another plaque offers an overview:

> Architect Thomas Hooper designed the Lester Dancing Academy in 1911. By the 1940s it had become the Embassy Ballroom, one of a number of genteel dancing clubs in the city. A sign of the times, in the 1960s it became a rock club called Dante's Inferno, then the Retinal Circus, hosting psychedelic bands from all over the West Coast. It has continued its reputation for contemporary entertainment since 1982, when the Kerasiotis family renamed it Celebrities Nightclub and welcomed a diverse clientele from the gay, lesbian, transgender and straight community.

Ron Dutton, founder of the BC Gay and Lesbian Archives, sums it up with a quote, aptly enough, from the archives: "Celebrities has always been on the cutting edge of whatever was trending in club entertainment

in this town. It was never the staid place to go—it was the place to be seen and to socialize with the city's most progressive clubbers."[57]

Zigging and zagging my way north, I'm completing not so much a loop as a quotation-mark route, now into skyscraping new builds of glass tinted coral and pea green, with unique architecture as well: cantilevers, sharp angles, high-rises in swoosh slopes and rounds. One appears to be armoured with metal plates that could pass for an armadillo's thick hide.

Sidewalks are closed alongside construction, forcing more zigs to my zags. Well-dressed office workers smoke and vape under eaves, scrolling their phones. The disgruntled moan of an electric car in reverse adds a weirdly industrial score, as though I've bypassed another fourth wall, this one in a Fellini film. There's a retail glitz on the east end of Robson, Alberni as well, with high windows, bright lights, and bracket creep: Jimmy Choo, Cartier, Tiffany, and Louis Vuitton.

Overhead, triple-A real estate: offices, finance, hotels, and exorbitant homes. Despite a hum of activity and a range of side streets, I've seen no unhoused people on this walk. Not yet, anyway. A lone woman, bundled up and wearing a surgical mask, sits on a bench at Christ Church Cathedral at West Georgia and Burrard, reading a fantasy novel. Beside her is a stone Celtic cross next to a small wheeled trolley stuffed with her possessions. I turn south and, for the first time today, see someone bedding down on the street. A two-person tent is pitched on the sidewalk in front of a diamond exchange. Another layer to the rings of *Engagement*.

To my left are the sharp copper roof of the Hotel Vancouver and a neck-craning mural, ten storeys at least, in the colours of the Vancouver flag, something I've seen only once, recently. The flag is a field of wavy white and blue stripes depicting the ocean and the harbour. The left part of the flag is an elongated green pentagon representing the forested land where this settler city was founded. Inside the green shape is a gold city badge, and inside of that, a mural crown with a paddle and axe acknowledging the founders' traditional industries of fishing and forestry. Visually, the design is attractive, despite its components being neither inclusive nor representative. But maybe that's the point of a flag; it's a stamp made by someone elsewhere.

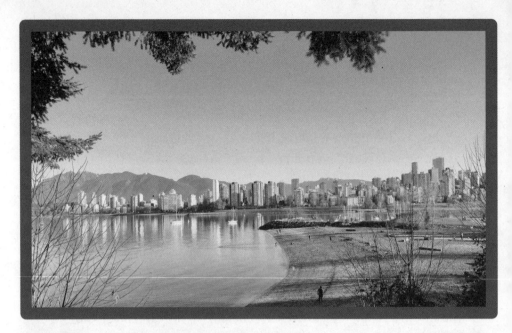

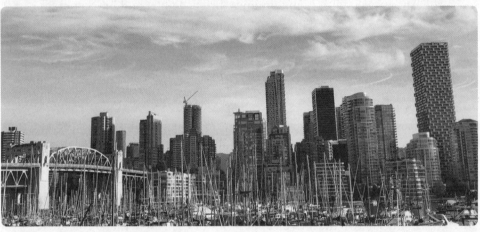

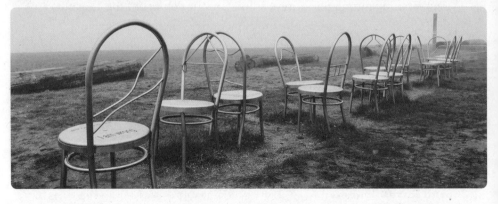

**TOP TO BOTTOM:** looking north from Hadden Beach to the West End; looking west toward downtown and the West End; the poetic Biennale installation *Echoes. Photos by Bill Arnott.*

**TOP TO BOTTOM:** looking east along English Bay, 1930–39; English Bay, looking northwest, 1931; the West End and Stanley Park, looking northwest, 1927. *Photos courtesy of City of Vancouver Archives.*

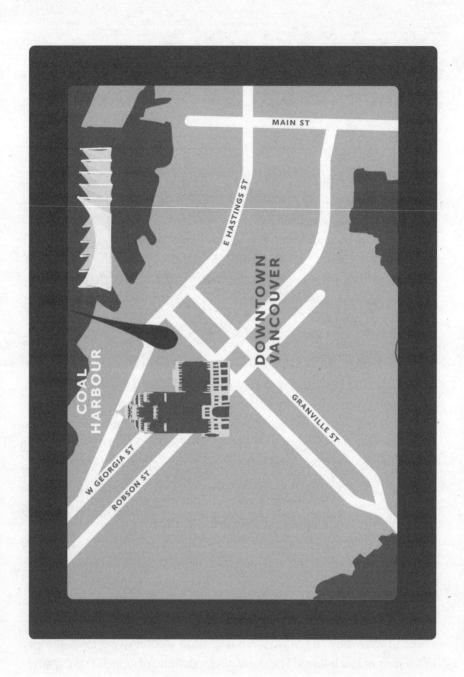

# Downtown and Coal Harbour

*stories strike shoreline*
*surging in sibilant sounds*
*a pulse on the blue*

A MORNING OF colourful chill, with today's crows under cherry-red sky, where bare branches sprout blossoms of skeletal nests. I'm walking northwest, Granville Island behind me, through downtown, toward Coal Harbour. Arctic air's passing through—snow in the forecast—and each step is a coarse crunch of salt on the concrete. No view corridor needed from here; today the mountains are popping, icy peaks against luminous sky, an illusion of alpine skyscrapers.

A man with a heavy blond beard muscles a shopping cart piled with gear, the wheels wobbling through grit. Behind him, a Salvation Army sign reads, "Giving Hope Today." A mobile crane rumbles by, double rows of fat tires, with the look of a tank on its way to the front.

At the south end of Burrard Bridge, huge silos at an old brewery are begging for paint and some artistic twins. Sen̓áḵw still hums: beeping of trucks on the turn, scaffolding, and I-beams of steel. A cyclist stops for a photo of snow-dusted peaks as an e-bike and a scooter whizz by. Rooftops belch mist in low billows. The sky is now a slashing of amber. I spin a slow pirouette and count nine hoisting cranes at six projects nearby.

English Bay is particularly blue, almost lapis, as I veer north onto Hornby Street. A couple in camouflage print scan the ground for salvageable cigarette stubs. Ahead, buildings stand in a juxtaposed cluster: a government building in brutalist concrete, support housing at the red-brick Murray Hotel, and the gleam of seven-figure townhomes. I've seen unhoused locals camped on the steps of these condos—necessity, or perhaps a statement.

St. Paul's Hospital is in the process of moving; its stodgy brickwork is tired and worn. Out front, a complex community of patients, residents, and unhoused people are in shuffling transit, a mosaic of movement. Along Hornby is a polish of live-work spaces, micro-retail, trades, and professional offices. Strands of white lights add a festive appearance. A squat bank by a lofty hotel and more city homes, a mishmash of short- and long-term, where an ESL school fronts a building of blue glass and steel.

In the midst of the law courts and the Vancouver Art Gallery, I'm immersed in a webbing of history, politics, and design. The expanse flows north-south, with Robson Street bisecting the space in a pedestrian belt to the garment. Robson, running east-west, was named for John Robson, BC premier in the late nineteenth century, although at the time people called the street "Robsonstrasse," as Eurocentric retail dominated storefronts: continental boutiques, patisseries, delis, and restaurants.

Early in the 1970s, BC's Social Credit Party intended for the province's highest building to stand here, fifty-five storeys of office and commerce. But in 1972 the government changed, with the BC New Democratic Party coming to power, scrapping the skyscraping plan and commissioning re-envisioned design. Enter renowned urban planner and architect Arthur Erickson, considered by many to be Canada's most influential designer. His vision? To fell the proposed tower, quite literally, and lay it out laterally instead.

Nicholas Olsberg, Erickson's biographer, shares what might be the architect's most famous quote: "Arthur came in and said, 'This won't be a corporate monument. Let's turn it on its side and let people walk all over it.' And he anchored it in such a way with the courts—the law—at

one end and the museum—the arts—at the other. The foundations of society. And underneath it all, the government offices quietly supporting their people. It's almost a spiritual progression."[58]

Which is more or less what I see. Quintessential Erickson in three blocks of grey concrete, still blending government, education, and art. I find a summarized version of this on a plaque:

> Seen as an urban park for the centre of the city, Erickson's design re-imagined the old courthouse as the home to the Vancouver Art Gallery. An integral part of the scheme was the sunken plaza under Robson Street which was to serve as the access to the rapid transit system ... When transit didn't materialize, the space was converted into an ice rink. Erickson wanted Robson Square to become Vancouver's largest public space and its design was intended to offer "an introspective view of the city."

Sure enough, in the chill of the concrete, a man's lacing skates to start his day on the ice, while UBC students loiter and lawyers in dark robes drag cases on wheels. For a few years, traffic drove here along Robson, truncating Erickson's vision. Now it's returned to the original plan, with this block of Robson Street closed to vehicles, re-establishing the open flow of the law courts and the art gallery—where, at the moment, an art installation is pulsing above me.

Entitled *Canopy*, the assemblage of strung lights, shifting in colour, has the draping effect of a hammock or of sails unfurled.[59] The display is a collaboration of Vancouver's BIA and Tangible Interaction, purveyors of art and design. A striped sign at one end explains more:

> "Canopy" aims to bring light and inspiration to the darker days of the year. Comprising nearly 3,000 controllable lights suspended above the street, the installation serves as a beacon of warmth and wonder. Drawing from the natural world, the lights are programmed to emulate the mesmerizing movement of salmon swimming upstream and the awe-inspiring spectacle of the aurora borealis.[60]

Even now, in bright sun, the overhead lights draw me in, a succession of natural tones, the same blue-green and icicle white I can see all around as I walk through downtown. Ahead of me, atop the Vancouver Art Gallery, compact ships ply a high, invisible sea: a small trawler and a mini destroyer, the latter the same yellow as the *Ben Franklin*. Street corners too have a decorative look, with hydro boxes painted in cartoon designs, joining the showcase of art. Grey and brown pigeons strut by, pecking at nothing. At the east end of Robson is the BC Place dome, with Terry Fox statues limp-running this way by the Sports Hall of Fame.

From the plaza on the north side of the art gallery, I admire the Canadian Pacific hotel, now rebranded as a Fairmont, specifically, as the commanding Hotel Vancouver. It was a railway hotel, with their lore of mystery, hauntings, and trysts, not to mention deep-seated industry, particularly through mountainous terrain, where the CPR laid track through the Rockies to here. Steep grades made the dead weight of dining cars excessively costly, so the creation of eatery stops was essential, not to mention lucrative. Remote stations and restaurants became destinations. Lodging encouraged longer stays, the journey itself an attraction. With scenic locales, the railway route was its own tourist trail. Combined with clever lobbying to put national parks around their hotels, the railway effectively created a new traveller monopoly, but on a gameboard where you *could* put a hotel on a railroad and manage the money as well.

What I'm looking at is the third iteration of the Hotel Vancouver. Prior to this, the CPR hotel with that name was two blocks east, part of an ambitious initiative to anchor the transnational rail with grand accommodation, a showcase terminus at the west end of the tracks. The Canadian National Railway, or CN, was doing much the same thing, including building Pacific Central Station directly behind what's now Science World's mirrorball dome. That former CPR hotel opened in 1916, the CN station the following year.

Fast-forward a decade, and CN was building the hotel I'm looking at now, in classic Chateau railway style. During that process, the Depression struck, devastating infrastructure financing. But rather than halt construction, CN partnered with CPR in a joint-management

venture, and the new hotel was completed. Part of this agreement was the planned demolition of CPR's former Hotel Vancouver, the one situated two blocks away. This allowed the current Hotel Vancouver to open in 1939, thanks to previously out-of-work locals being hired in a frenzy of make-work construction. Over time, a game of ownership hot potato ensued, with CN taking full ownership in 1962 and CPR buying it back in 1988.

It's easy to see the appeal of this place; the hotel is still grand. It does feel like a destination. For years, the hotel's Panorama Roof ballroom was a city hot spot, featuring Dallas (Dal) Richards, the King of Swing, conducting his live band, an eleven-piece jazz-swing ensemble, with Juliette Cavazzi on vocals. CBC Radio broadcasted the performance in a show called *The Roof*, airing it live from the ballroom.

Although surrounded at the moment by the white noise of downtown— a car horn, a truck rumbling at a traffic light, the compression-brake hiss of a bus—part of my mind holds an echo of Dal's brassy band, an auditory time machine, partly real and partly imagined. But I realize I *can* travel there, in a manner—using virtual reality and a project called *Circa 1948*.

A few years ago, I dedicated a month to attending as much as I could in the city, an event or two every day: galleries, museums, art installations. Some I paid to attend, most were free. One in particular resonated: *Circa 1948*, a National Film Board of Canada production, collaboratively designed using university research and city archives and created by artist Stan Douglas.[61]

The feature is an augmented reality program, a live-action movie in which you take part, navigating old city buildings and streets, every-thing historically accurate, with exquisite detail. Two Vancouver locales were recreated: Hogan's Alley, by Main Street, and the former Hotel Vancouver, what the CPR tore down to co-create the green-roofed chateau. When I first saw the exhibit, the technology impressed me. Augmented reality, or AR, was fairly new to me. I hadn't played any AR games; the apps on my phone at the time were quite basic. *Circa 1948* was truly immersive. Wearing wraparound goggles, I stood on a pressure-sensitive floor that "read" or sensed physical movement.

All I had to do was remain in one compact spot, "walking" more or less like a mime. This enabled me to "move" through the recreated simulated terrain, in this case, the Hotel Vancouver, with its lobby, café, and rooms. I could ride the elevator, even eavesdrop on conversations. The technology has been around for a very long time, but like anything one experiences anew, it feels like discovering treasure. Which I did, in a way, jumping on an artsy bandwagon with its nucleus here and tapping historic veins in a fairly young city, veins that pump with intrigue.

Now, *Circa 1948* is an app you can download for free. Still engaging, but far from flawless. Regardless, I take a moment, load it, and time-jump back to that instant, a recollective rest stop as I recall that room with the foot pads and the goggles, then my destination: decades ago, when stories layered in these places relaid the foundation of what would be built. A quick stroll from the "new" Hotel Vancouver and I'm back where the former one once stood, as though I were en route to that railway station, a steamer trunk stuffed with my gear in tow.

The app starts up with a jazzy bebop that could well be the Dal Richards band, conga percussion with the wail of a trumpet in high octaves. Next, a black-and-white aerial view of the city, a few clouds shading downtown. I can tell by the streets that the image is accurate to the late 1940s. Now I've a choice to make: teleport to Hogan's Alley or visit the Hotel Vancouver. Because of where I am, I choose the hotel and deposit myself to this very spot the better part of a century ago.

Text appears on the screen:

*A rain-soaked city, caught between the ruins of an old order and the shape of things to come. Where what is right is not necessarily what is good and where what is wrong can exist above and below the law.*[62]

A bit hardboiled, but informative and mostly fun, as I slide into a *Dick Tracy* mood and enter the Hotel Vancouver in 1948. In the lobby, there are revolving front doors, marble floors in off-white and coral, carpet in faded, thin stripes, and a bank of phone booths to one side. There's wood panelling, crown moulding, and plain chandeliers providing dim light.

A bell on the front desk is aglow, indicating that it will advance the story. I touch the bell, imagining a *ding*, and a conversation ensues. A female guest is looking for a number, for a person, in fact. The male receptionist does his best to assist, offering a phone book, a map, an air of mystery, a whiff of danger. We are left to imagine its source and its outcome.

An unseen radio broadcasts news stories: hosiery is now available at department stores, where barricades have been set up, just in case. Unhoused veterans are taking part in a peaceful demonstration, asking for reasonable accommodation; veteran pensions are sixty dollars per month, less than half the national average wage. One possible policy being discussed is the assurance that no more than one-fifth of household income be spent on housing, the cost of which should be calculated and charged not by square footage, but ability to pay.

I move through the lobby, where it's now evident this whole building will soon be condemned. Flooring is missing, stairs are blocked off. Steel buckets catch drips. A mattress leans against a wall, and I may have just spotted a rat. The hotel is only barely functional. Every resource has been shifted to support the new venture, the lucrative one two blocks down. Anyone living here is in transition or a veteran with nowhere to go, hoping their lot will improve. I take a side hallway to the hotel café, where I hear but don't see a cashier serving a patron hot coffee. The young woman serving lives here with her unemployed husband in a small room upstairs. Her customer, a beat cop, is fuelling up for his shift.

I take an elevator to the tenth floor, where I hear a veteran moaning in his sleep, PTSD a term no one yet knows. I overhear the husband of the woman downstairs muttering and cursing, blaming the system. In the telegraph office, a man is desperate for money, willing to bet, to transfer an IOU. His plea sounds like a scam.

I decide I've had enough of this space, having gotten a general feel. The research was clearly thorough as the storyteller created this stylized art. Again, there's that question of interpretation, of the nuance and lenses we peer through, hearsay colouring history.

Before I leave to escape this old building ahead of its demolition, I want to see where I am. Not on a map or a satellite view, but what's

around me right now, here in this spot, in 1948. So I make my way into as many exterior rooms as I can, corner units and high-windowed hallways. A few open curtains let me take in the streetscape, the night vista, from ten storeys up.

Now I realize I'm not at the top; there are another five storeys above me, a total fifteen floors of Italian Renaissance styling. For a thirty-year-old building, it's exceedingly tired and clearly ignored, with an appearance of dereliction. What catches my attention is how the surrounding art deco buildings, by contrast, look new. Trees are smaller. (Yes, I realize that from up here, they're farther away.) I imagine the cars on the street are all Plymouths and Buicks, with the occasional Studebaker or Packard. Peering down, I almost feel dizzy; the realism, combined with my willingness to mentally be here, is vivid.

Like Marty McFly, I want to get back to my own time. Yet, I feel an obligation to complete this faux journey in a manner befitting the art. So, I return the way I came, back down the hall, taking the elevator to the lobby, and past the front desk to the revolving front door. Only now do I feel I can suitably exit the program and leave the 1940s behind. One last blast of big band, and I drag myself to the present, where the Hotel Vancouver looks much like it did in a photo I found of when it was built: clean exterior stone, flags snapping in the breeze. The only things that have radically changed since the hotel relocated to here and now are the cars. That and the fact that everyone has a smartphone. I wonder how many others have apps that can transport them through time.

Back to walking the present. At a coffee shop, I recharge my phone. I'm now in the north end of the downtown financial district, at Howe Street and Hastings. Early in the twentieth century, a flurry of construction happened here, where art deco abounds next to finance. Here, in an area of comparable size to the Erickson showcase I've just come from, the buildings were all banks. And they still are; Canada's largest financial institutions have marquee offices here, buildings with pillars known as temple bank style, imitations of those in the northeast us that were in turn derived from Templar design, statements of power and wealth.

The Vancouver Stock Exchange Building, still here, is now a hotel. Traffic is light, so I test the knowledge I gained on another tour a few years ago, conducted by senior students at the Architectural Institute of BC. We wandered downtown to identify various design features: colonnades, cornices, crestings, and cupolas, brackets and corbels and dentils. We compared what we saw to what else was built in that era—New York's Empire State Building, for example. Before it was scaled by King Kong.

A nugget of information I've retained is that, when standing in the middle of Hastings Street, facing west, the Marine Building is pretty much all you can see. It cements one end of the thoroughfare, a pillar among pillars. As the columns of banks flank the road just behind you, the Marine Building looms like a beacon. (Unless you have excellent insurance, don't stand in the middle of Hastings for this view like I did. Wait for the lights and enjoy a quick glimpse.)

Something else we were taught, which I presume to be mostly true, is that this streetscape has roots in the Roman Empire. In the same clichéd manner that "all roads lead to Rome," early urban planners determined that *this* would be the city's new heart, at the end of Vancouver's most influential roadway. Unapologetic with imperial pride, the Marine Building would be its anchor. From a developer's perspective, as with the railway station and Hotel Vancouver, this was marking the end of the line with an architectural exclamation.

But, in abysmally unfortunate timing, the completion of construction coincided with the start of the Depression. People couldn't afford the twenty-five-cent admission to enjoy the observation deck lounge. Business investment was scarce. Shop owners moved to cheaper locations. And this structure, which of course came in over budget, costing two million rather than one million dollars to build, was snatched up for less than a million by the Guinness family. It did, however, result in new office opportunities. Short-term leases with flexible financing were introduced. Many professionals were then able to afford prime real estate, the result of the market correction. So, as shackers were combing for mussels on False Creek, here a resurgence of white-collar jobs would gradually revitalize the area.

I take some time around the Marine Building, this culmination of what was envisioned as a Romanesque road. The structure does conjure maritime imagery. There are seashell designs in the exterior features, as though this whole slab of art deco thrust itself out from the ocean, its husk encrusted with fossilized bits of seabed. Where I am now, the north side of the structure, was precisely where the city peninsula ended and the shoreline began. The design optics of the Marine Building were intended to act as a visual breakwater, a skyscraping lighthouse. Now, two more city blocks stretch to the north, reclaimed land to extend the downtown.

Passing through brass-framed doors, I'm overwhelmed by nautical architectural tweaks and design bric-a-brac of mermaids and ships. Everything is busy, extravagant, and excessive. I'm reminded of train stations or museums constructed at times when money was seemingly limitless, designers adding and adding to maximize features and flair. Never *or*, only *and*. Despite its excessive detail, this is a building I like, a scaled-down Empire State, dowdy, yet proud. Call me a sucker for art deco. Or maybe the historian in me likes that it's roughly a century old. Or the fact that it does feel like it's risen from a watery lair, an inverse Atlantis.

Next door, more or less, I enter the Vancouver Convention Centre, where a huge spinning globe adds another waft of imperialism, as though the world is entirely here, and it's ours. Or perhaps this is its hub, a newfangled Delphi, a navel to the planet. A security guard smiles, is pleasant and professional, but makes it clear I'm not entirely welcome. I move on to circle the centre's perimeter, where a towering water droplet stands at a rakish angle, an installation by German art collaborative Inges Idee.[63] Geese bicker on the water as I read its story on a plaque.

Thrust into the waters of Burrard Inlet, *The Drop* playfully invites the viewer to reflect on our relationship with this precious commodity of water, and by extension, on the history, complexity, and future of our waterfront. *The Drop* pays homage to the element of water and

the untameable forces of nature which are omnipresent in Vancouver. The slender, elongated sculpture balances as if a huge raindrop were on the verge of landing on the sea walk.

A few people stop for photos. The view from here faces north, Burrard Inlet runs east-west, and the sails of Canada Place (considered Convention Centre East) with its cruise ship moorings are immediately to my right. The North Shore mountains are scarved in ribbons of mist, their slopes white on green, and below, berths are ready for ships from elsewhere, more vessels and people in transit.

By sauntering this section of Seawall surrounding the convention centre, I'm faced with a new wave of stories, more installations and plaques, like another album flipped open. I might as well be on a sofa sipping tea with an Elder, learning recalled memories as I work my way west. One plaque reads:

The panels on the seawalk around the Convention Centre West tell many stories, and one story. True stories—each one a piece of working history ... About people who dared to venture to what was, for them, the most remote corner of the earth. Who carried with them their skills, their families, their languages—and their prejudgements ... Remember, for all but First Nations, everything was new: the forests, the animals, the sheer size of the place ... In a remarkably short time, these not-so-common people laid the foundation for the culture of innovation, education, tolerance, and common human decency we strive for today.

I have a discombobulated walking-on-water perspective as I stroll an invented landmass to read the next plaque on display, describing the Marine Building, perched on the former tide line behind me.

Towering behind the convention centre stands the most famous building in Vancouver, once the tallest building in the British Empire and one of the great art deco buildings in the world ... Perched on a bluff in the water's edge (before the railway tracks were built), the Marine

Building was designed to resemble a huge, ornate crag, encrusted with starfish, crabs and other marine life, topped by a flock of deco Canada Geese.

That echoing of geese, resonating by the gargantuan droplet of water, suddenly takes on new meaning. Their presence is nearly as persistent as that of crows through the city, honking rather than cawing, having more heft and more colour, and being a symbol of national pride to some—a camp I'm not part of. Maybe I spent too long in an apartment a few years ago that two geese decided was theirs, occupying a water feature at the front door and paving our sidewalk with digested green. But I admit that in flight, in a chevron, they're attractive.

A seal plies the water as cormorants air their wings, and a seagull rides a lone drifting log with the look of a lumberjack navigating the strait. A SeaBus trails a wide wake, burbling north, its twin heading this way, while a tugboat, a musclebound version of those squat False Creek Ferries, turns toward Canada Place. I imagine the view from the wheelhouse, looking upward to here, as I read the next plaque, another peeling of layers.

First Nation, First Union

Workers from the Squamish nation have worked as longshoremen in Burrard Inlet since the 1860s ... Chief Joe Capilano worked as a foreman on the docks, which helped pay for a trip to England and an audience with Edward VII of England, to discuss land claims. In 1906, Squamish longshoremen established the first union on the Burrard Docks – local 526 of the Industrial Workers of the World ... Despite its First Nations leadership ... members included Englishmen, Chileans and Hawaiians.

A nod to Kanaka Ranch, which stretched along here, the early days of a Pacific-culture mosaic, and another connection, this one of labour and land drawing lines beyond maps. I walk a bit farther as sun gleams on the water to brighten the royal blue of *The Drop*. A seaplane roars

in for landing, a bump on the wake of the SeaBus. I hear the grate and squeal of a train just out of sight. There's a confluence of tracks to the east—commuters and freight—another Romanesque terminus, this one in cold steely lines.

I make a note of this neighbourhood name: Coal Harbour. It comes from navy surveyors sourcing coal seams between here and Stanley Park, by what's now the Royal Navy Military Reserve and Deadman's Island, another reclaimed football of land.

Here by the convention centre, plaques are keeping pace with a natural soundtrack and visuals, as though this jaunt through the north and the west of downtown has been choreographed in unplanned mixed media. The media, in this case, being history and stories, a watery expanse where things overlap, the splash and collision of high waves in strong tides. The next plaque I read speaks of the grind of steel wheels on rails.

Taking It to Ottawa

On the tracks east of the Convention Centre began the On to Ottawa Trek, one of the greatest labour protests in Canadian history. During the Great Depression in the 1930s, 30% of the labour force was out of work. One in five Canadians depended upon government relief for survival.

Ottawa established military-style work camps for unemployed, home-less men. Poor food and backbreaking work for as little as 20 cents a day led one worker to describe these camps as "civilized slavery." In 1935, 1,500 striking camp residents gathered in Vancouver, demand-ing better conditions. When officials failed to respond, 1,000 strikers vowed to confront the Prime Minister, demanding "work and wages." They boarded freight cars on the national railway, completed in 1885 and stretching across Canada. But the On to Ottawa Trek never made it.

In Regina, police, on orders from Ottawa, blocked the strikers from re-boarding the trains. Instead, 8 men were sent to Ottawa to meet with the Prime Minister.

Nothing happened.

Meanwhile in Regina, RCMP squads moved in to arrest strike leaders, resulting in a bloody confrontation that left one policeman dead and many Trekkers injured.

Prime Minister Bennett was defeated in the next election, and the hated camps were closed.

There's no way I can pick at the past without finding more patches of dark. But from this event, positive change did occur, future benefit arising from preceding effort.

I keep walking and reading; every few metres, new lessons. I consider the wording involved, the depiction of stories. How writing itself skews a tale until stories unfold into history. Hearsay is normalized, myth becomes fact, like waves reaching shore in collisions of ebb and flow.

A stop for a second breakfast, where I charge up my phone at a table with a view of mountains and inlet. Another seaplane roars in by a criss-cross of SeaBuses, and thuggish gulls brood for take-away scraps. Looking west, I see Stanley Park, where the Lost Lagoon fountain imaginatively links to old Expo lands. Between here and there is a marina with houseboats and yachts, once the site of the ranch where Mary See-em-ia and Eihu and Joe Nahanee raised their kids, lumbered timber, and fished from this shore. Eventually the CPR forced them out. See-em-ia was vocal, articulate, but buildings were burned and land was taken once more. For the sake of their safety, See-em-ia moved her small global family to the north side of Burrard Inlet, where her lineage began, living the remainder of her life with a view of the former home that she had built.

Back to the seawalk, fabricated land in a broad jut of concrete, a touch of Erickson styling. Under my feet, beneath the convention centre and under the water, another ecosystem has found a new life. In a similar vein as Habitat Island and the reedy ponds of Charleson Park and Olympic Village, here, too, new wildlife terrain was created. At sea level, where tide finds its way among concrete and pilings, exposed reaches encourage mussels and starfish and crabs to make homes with their saltwater companions, which explains the healthy population of

water birds, cormorants, seals, and gulls—not because of new building, yet not in spite of it, either. It's a blend of planning, design, and implementation, aiding and abetting in the very best sense, helping not only to restore but also to springboard nature on its doggedly positive path.

One more plaque stops me. Both a story and cautionary tale, it joins everything I've read on my way here, acknowledging workers, safety, and know-how, a literal blast from the past.

Right in front of you is Canada Place – site of CPR Pier B, and the worst disaster in Vancouver Port history.

March 6, 1945, 11:15 am:

The *Greenhill Park*, a 10,000 ton merchant freighter, was taking on cargo which included 7 ½ tons of signal flares, 94 tons of sodium chlorate (for bleaching wood pulp), and barrels of over proof whiskey – all in the same hold.

3 volatile ingredients, waiting for a spark ...

In an instant, 4 explosions tore apart the vessel, killing 2 seamen, 6 longshoremen and injuring 26 more, including 7 firemen ...

Downtown, the shock wave shattered thousands of windows. Glass and cargo rained on the streets for 15 minutes.

Meanwhile, tugboats towed the blazing vessel from the pier, but only as far as Brockton Point, fearing that another explosion could destroy the Lions Gate Bridge.

The investigation, with no evidence, blamed longshoremen for smoking on deck.

Nobody told them they were working on a floating bomb.

I have a tough time with this one, am compelled to take a moment of silence, even take off my hat. This is *not* an example of hearsay morphing into history. When lives are lost, it's just fact, wrenching and raw. Hopefully, lessons were learned and with them came healing.

I cross town once again, this time to multi-layered new sounds. I experience an inversion of noise as I hear and *feel* a SkyTrain zoom by underfoot. Here, trains that loft over the Science World dome dip below ground to enter this part of the city, tunnelling under the streets I've just walked. It's as though commuters have founded a new Rome in the form of Burrard Station, a five-minute saunter from that yesteryear terminus of the Marine Building. Walking above a train line named for the sky has me feeling like I did at the seawalk, strolling atop water. Yes, I'll say it: borderline biblical.

But along with that less common feeling and sound, I hear something as familiar as songbirds and crows: the long, moaning hoot of the Heritage Horns sounding noon, a sound now as much a part of the city as mountains and rainfall and sea.[64] Ten cast aluminum horns let out their six-second, four-note blast every day, the tune being the opening notes to Canada's national anthem. The horns, designed by sound engineer Robert Swanson, were built by BC Hydro as part of a 1967 centennial project. For two decades, the horns were on the BC Hydro Building downtown, every day doing their thing at noon, more or less. I say more or less because the horns were originally set with a mechanical timer that wasn't precise. Eventually the Hydro building was repurposed to condos, silencing the horns for a while. They found a new home at Canada Place, where they sit on the roof of the Pan Pacific Hotel, re-equipped with a precise electrical timer. I can't be the only one, but for me, the blast conjures a Pavlovian response, and I find myself wanting a midday meal. Maybe the timing's ideal, as I'm due for a lunch date a short ways away, and for a series of neighbouring neighbourhoods.

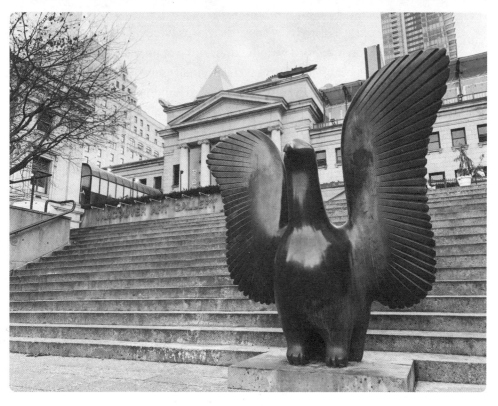

**CLOCKWISE FROM TOP LEFT:** the Marine Building, from the southeast corner; SFU Harbour Centre; Robson Square and the Vancouver Art Gallery. *Photos by Bill Arnott.*

**CLOCKWISE FROM TOP:** the Hotel Vancouver; the Hotel Vancouver, with Christ Church Cathedral in the foreground; a tugboat approaching the Canada Place sails; the Vancouver Art Gallery, north side, with a nod to the Lions. *Photos by Bill Arnott.*

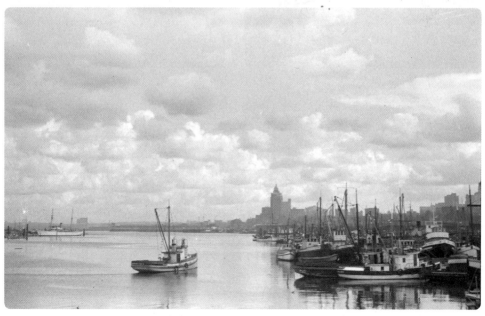

**TOP:** CP Hotel Vancouver, 1923. **BOTTOM:** Coal Harbour, looking east toward the Port of Vancouver, 1938. *Photos courtesy of City of Vancouver Archives.*

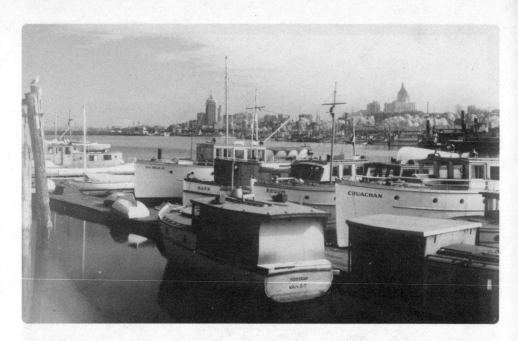

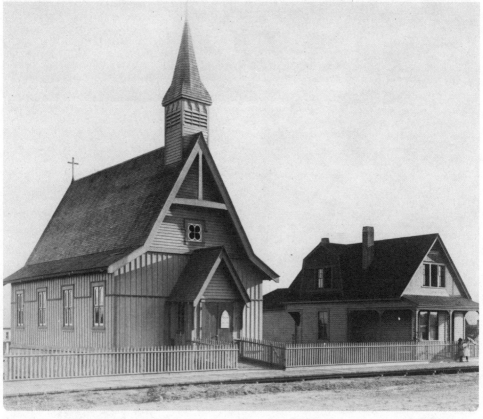

**TOP:** looking east to downtown, 1936. Note the Marine Building and the Hotel Vancouver dominating the skyline. **BOTTOM:** St. Paul's Church on Hornby Street, 1889. *Photos courtesy of City of Vancouver Archives.*

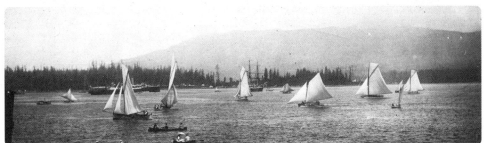

**TOP TO BOTTOM:** the Vancouver Courthouse, 1915, prior to its being the Vancouver Art Gallery; Coal Harbour Regatta, 1890; looking over Coal Harbour from Stanley Park, 1940–48.
*Photos courtesy of City of Vancouver Archives.*

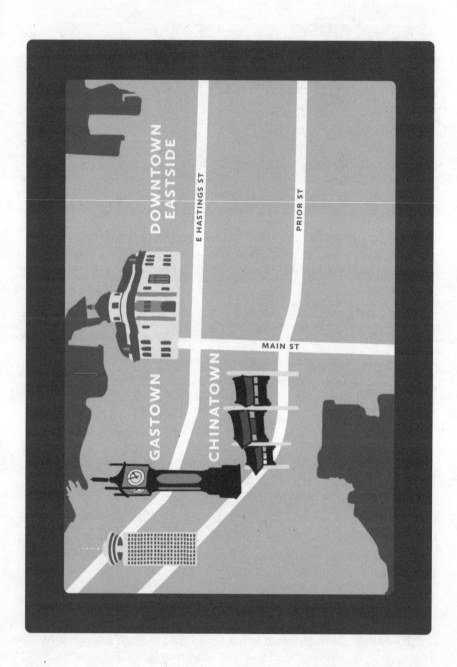

# Gastown, Chinatown, and Downtown Eastside

*a new world appears*
  *needles and faces and scars*
    *despair paired with hope*

FROM DOWNTOWN'S CENTRAL business district, bearing east, the neighbourhood shifts into Gastown. Its tagline: "Old Soul. New Spirit ... Vancouver's first downtown core."[65] Which it is, more or less. Later the settlement of Gastown was known as Granville, prior to the city's becoming Vancouver, when that first rickety bridge spanned False Creek and lumber mills whined on the shore with tinworks and railway lines. Now Gastown may be best known for its whistling steam clock, galleries, retail with a tourist flair, brick sidewalks, and Victorian buildings. A bit farther east is what was Japantown and is now rebranded as the Railtown district, with more studio space and art displays, residential and retail bleeding into Chinatown and the Downtown Eastside.

In front of the red-brick facade of Waterfront Station, I stop at *Winged Victory*, a bronze sculpture put here in 1921, created by Montreal artist Coeur de Lion MacCarthy.[66] The installation was commissioned by the CPR to commemorate employees killed in the First World War, over a thousand deaths. Similar pieces adorn railroad sites in Winnipeg and Montreal, MacCarthy's hometown. The statue, also called *Angel*

*of Victory*, depicts a winged spirit hoisting a fallen soldier skyward. A tapered base flows from a plinth, adding to the visual of flight and departure. The sculpture is strikingly lifelike, somber and ethereal.

Stepping back, I take in the building itself, the city's third CPR station. Opened in 1914, it wouldn't look out of place beside the central library's colonnades, another hint of old Rome at the heart of an empire imagined. Prior to this, the station was one block west, at the foot of Granville, built in the Chateau style reminiscent of railway hotels in cities and national parks. And before that, it was a bit south and west, at the corner of Hastings and Howe, that first terminus being a long wooden structure with extended railcar coverage where Engine 374 chugged to a stop in 1887.

From the feet of the angel, I follow the street north and east, with views of train lines through fencing. Another block, another turn, a short flight of stairs, and I've arrived for lunch and a visit with another community pillar, Gilles Cyrenne, president of the Carnegie Community Centre Association in Vancouver's Downtown Eastside, or the DTES. A gifted writer and poet, Gilles is a vocal activist for fighting houselessness and the area's aggressive gentrification.

Over sandwiches, with a view of the tracks and of Burrard Inlet, we discuss the community, which we simply can't do without touching on addiction, trauma, and healing. I could say that about anywhere, but here it's particularly evident and less hidden.

Without having planned it, I learn that Gilles's story dovetails with some of my previous visits, as he too arrived in Vancouver for the Summer of Love.

"I grew up on a farm in Saskatchewan. Durum wheat, alfalfa, some cows. Then went to teachers' college and was teaching a class before I was twenty," he says with a smile, shaking his head.

The cow reference transports me to when I first met him at a DTES poetry reading delivered to a full house in a Vancouver Film School location, the event a collaboration with the Carnegie Community Centre. Gilles read a poem of his called "Bringing Home the Cows," which evoked visuals of a prairie upbringing. The memory is a bridge to where we are now and what we can see on the street.

"We all suffer from trauma. The booze, the drugs—that's our medicine," he continues.

I nod understanding. Show me a person, a family, in which trauma is not present, and I'll show you a person, a family, in denial.

Gilles speaks with pride about the neighbourhood. "The DTES has the most diverse population in Canada, I think. It's like a mini UN each time I ride the bus." An echo of Henriette Koetsier's quote, something I see and hear too when I choose not to walk but take transit instead. "After my teaching stint, I hit the road. Made it as far as Alberta, then was hit by a blizzard. Had to spend all the money I had on a motel. Went to Manpower Canada and got a job right away. Part of a seismic research team in the Arctic, up in Inuvik." He grins, recalling his luck. "Horseshoes."

From there, Gilles returned to the road: seasonal work, hitchhiking, relationships, travel, exploring the North American West Coast, and eventually arriving in Mexico.

"I was back in Vancouver for the late sixties and seventies. Started drinking. Then moved to Bowen Island for the next twenty years. It's a good place to be a drunk," he adds with a chuckle. The gulf island is one of the province's highest per capita liquor consumers. And yet, it was there Gilles stopped drinking, returning to Vancouver a teetotaller. Another twenty years of working in construction ensued, with a transition to community involvement, directorships, and activism.

He hands me a magazine, a glossy program of the Downtown Eastside's Heart of the City Festival, something he's actively involved with in his role at the Carnegie Community Centre. He compares the annual event, much like the neighbourhood, with his childhood home, a prairie farm in a small community: it's a place where it seems like everybody knows everybody.

"We care for our neighbours, share, help, celebrate, and *know* one another. There is someone I know almost every time I get on one of the local buses, and if not, people I don't know often start a conversation. That's rarely happened to me anywhere else in Vancouver. When I sit at a table outside my studio to write, everyone who walks by says hello,

or at least nods. We aren't inhibited about being friendly. I'm more at home here than I've ever been anywhere else.

"This community is creative electricity, with shocking street scenes, homelessness, addiction, and emotional and mental challenges. We work to meet those challenges; we're rich in connections that protect, feed, and shelter people—not enough, but we keep working at creating that ground. Our activism challenges governments to do better. We like making *good* trouble," he says, quoting American congressman John Lewis.

After lunch, we part ways with a hug. And I pick up my walking, meandering from Gastown to Chinatown, where a park delineates a vague neighbourhood border in mugho pine, maple, and willow. The Sun Tower stands as a century-old backdrop, scaffolding wrapped to its cupola dome. This was the Pacific Press building, home to the *Vancouver Sun*, an icon of shared information, like a transmission tower. Only now it could be a *transition* tower, a vintage car dumped in a field.

Prior to my walk, I reached out to a friend at the *Sun* and asked what she thought of the city. I reached her at home, from where she reports most days, chasing news sources and conducting interviews via phone or videoconferencing. Once part of a large team, now she's the entire department.

A sigh. "The city? All I can say is it's busy." Then she laughed. "And hard to find parking."

I told her that wasn't news, but signed off with a smile. She knows what she's talking about.

Here on the street, a man wheels a large HVAC unit balanced on his rolling walker, reminding me of that book set in Ireland about a guy hitchhiking with a fridge. Next to this, a line of schoolbuses murmur in an idling row, awaiting their cargo. And two tiny men stand in front of the Mr. Big & Tall store. I wonder if they know they're ironic.

A scatter of education and art lies ahead in acronymic signage: SFU, VFS, VCC. Up the street, the QE, CBC, and VPL.

SFU, Simon Fraser University, is a campus extension of where Rosemary Brown taught women's studies. VFS is Vancouver Film School, where Gilles shared his poem. VCC is Vancouver Community College,

where I trained in their culinary school, my class another mini UN. The QE: the Queen Elizabeth Theatre. The CBC: the station where Peter Jepson-Young shared his diaries. And VPL is, of course, the Vancouver Public Library, with its poetic, steel-flowered garden.

Where I'm standing, the SFU building has muscled its way centre stage, with one of its stories on a street-level plaque. Now called Harbour Centre, the art deco facade was part of a department store for most of the twentieth century. It started as Spencer's when David Spencer expanded his Victoria-based business here in 1907. Spencer, a Welsh immigrant, arrived in BC in the 1860s, part of the rush for gold. A stringent retailer, he began with the sale of dry goods. His policy was cash and carry, no credit. As his business grew, he bought this piece of land, most of the block, to build his nine-storey flagship store. Five additional storeys extended beneath the street, creating a vast indoor shopping space. Comfy chairs next to the elevators became one of the store's trademark features. A toyland drew families, and cafeteria lunch specials were considered the best in the city.

The store steamed along in this spot until Spencer sold operations to Eaton's in 1948, which carried on until 1972. It was Sears for another two decades. Then portions of the building were torn down, others restored and expanded to create what I'm looking at now: Harbour Centre Mall, which includes an office tower, SFU's downtown campus, and a rotating rooftop restaurant. The whole resembles a good-looking but unflightworthy spaceship. Its plaque explains further:

Now known as SFU Harbour Centre, this building was a department store built in 1928 by David Spencer Ltd., a firm established in 1862 in Victoria which expanded to Vancouver in 1907. Spencer's eldest son, known to his loyal employees as "Mr. Chris," ran the business for many years before selling to the Eaton's department store chain in 1948. The building became a Sears department store during the 1970s–80s before its conversion in 1989 to a university campus.

When I was an SFU student studying at the Burnaby campus, the occasional course that I took was held here, at the downtown campus.

Coming to town was a chore but exciting—the bustle of traffic and offices, the people in suits. A glimpse, perhaps, of what many of us were working toward. Bright lights, to a degree. As students, we joked that when you saw a classmate in a suit, it could only mean one of three things: an interview, a court appearance, or it was laundry day and everything else was unwearable.

I stop in a high office tower of pink-tinted glass, find a chair, and have a sit. Water burbles behind me in a slate waterfall. There's a faint aroma of bleach, some potted tropical plants, and it feels like a greenhouse, humid and close. The slanted ceiling is four storeys high. Zipping into view, sussing its surroundings at the top of the atrium, a hummingbird taps at the glass from inside. It must've come in with the slow-closing automatic doors. The space is enormous, the door comparatively small. I don't like the bird's chances, but I hope and watch for a while, determine its colour, its species. Rather magically, it's an Anna's hummingbird, the official city bird of Vancouver.

Back to the street. I've crossed most of the city's peninsula, west to east, following Hastings from Coal Harbour through the financial hub to Gastown. I'm now aiming for the Downtown Eastside. A cluster of buntings chirp from a sumac, nibbling at things I can't see. Couriers are coming and going. Office workers tote take-away dishes and boxes. A few sleeping bodies stir under mounded blankets positioned on vent grates sending gusts of warm air from below. It's overcast with a dim, nondirectional light.

Two men approach, having just risen from a stint sleeping rough.

"Excuse me," one asks, "is this morning or evening?"

A fair question, the light's *that* weird. I smile, tell them the time. They thank me and move on.

Now a reverse time warp unwinds, as though I'm adding discarded pages to a calendar; the buildings show more age with every block I walk east. I think of an actor seated at a mirror at the end of the night, slowly removing makeup, exhausted yet stoic. A few crumbled bricks,

mosaics on street corners, tiled stories in flat art. I pass a sword-fighting academy with pictures of cutlasses, épées, and scimitars, as a man on the corner cleans his teeth with a stick.

I pass the red brick of the Woodward's building, a structure from 1903. This was Charles Woodward's second retail outlet, the first all-in-one department store: groceries, fashion, a food floor, items unavailable elsewhere, with professional services too, and a place to book travel. The store was known for having the finest window displays, particularly at Christmas, attracting shoppers and browsers with lavish decor, festive lights, and animatronics. It was considered the heart of the city's shopping district, bookending these blocks with Spencer's. Woodward's continued to grow, expanding to twelve storeys, its landmark red W revolving on top, its base a faux Eiffel Tower. I take a photo, which blurs. I wait for the W to rotate, take a new shot, move on.

Across the street, Victory Square is home to a nine-metre obelisk of granite, a cenotaph that could pass for grey concrete. Flags droop from the sides, wreaths sit at its base. The park, a slope facing north, connects intersections in a wedge—Hastings, Pender, Cambie, and Hamilton—and is considered a keystone to the city, securing this peninsular arc into place. The lopsided patch is now a repository for passersby, students, some unhoused people, and others on lunch. This was also the site of the city's first courthouse before its being rebuilt on Georgia, what's now the gallery at one end of Erickson's expanse of law, academia, and art.

Another facet of the block's keystone persona is that this is where pre-Vancouver Gastown, or Granville, abutted the CPR townsite. A linchpin to planning and construction that would result in the terminus station and subsequent hotels, this is what some consider the founding of the present-day city. In 1886, still surrounded in forest, the space was called Government Square, and it was here the first survey stake was placed to begin the laying out of streets.

Another landmark, the site of the city's first hospital, sits a short distance south, where a plaque tells me more:

Vancouver's first hospital facility was a tent destroyed during the great fire of 1886 which was replaced by a hastily erected 9-bed wooden structure. In 1888 the first City Hospital was built of brick on this corner lot between Pender, Beatty and Cambie Streets, on land acquired from the Canadian Pacific Railway.

The City Hospital grew to a 50-bed compound of brick buildings with open wooden balconies, surrounded by picket fences and gardens. It was replaced in 1906 with the newly built Vancouver General Hospital. The original buildings on this site were demolished in the 1940s.

According to historian Michael Kluckner, "For a tiny little city of just a few hundred or a thousand people, this was really the beginning of organized medical care in the city."[67]

Still moving east, farther into the Downtown Eastside, that imagined actor removing makeup is looking more pained. On the street, there is open substance use, with crack pipes and meth, a few needles. Three men fetally curled into commas punctuate the sidewalk. A man dressed like me—tech jacket, backpack—steps to the street as an Uber pulls up, pauses, hits the gas, and keeps going. "Hey!" the guy yells, in disbelief over what just happened. Unfortunately, I can believe it.

From the huddles of pipes being fired, I weave through a market. No roof or walls, apart from the building exteriors fronting this space; it's a true open economy. Some vendors have lanyards with licences to sell, others have canopied tables. A few have goods on the ground, assorted electronics and clothing. A woman holds up a top, puts the garment next to her shoulders. "You got this in medium?" she asks, as the seller searches through boxes and bags. Upbeat reggae pumps from portable speakers. There's haggling and laughter. Apart from the weather and the architecture, this could be anywhere in the world.

Another woman wheels a trolley filled not with possessions but with sandwiches, cocoa, and coffee, which she offers to each person she sees. "Would you like something to eat?"

"You got grilled cheese?" one man asks.

Exchanges and smiles. Munching and slurping. No money involved. A food bank, perhaps? A community centre nearby? All I know is a great many people are getting a meal. If she weren't so busy, I'd find out, but she's gone in a moment, her trolley empty, before I can start a conversation.

A grey-haired woman smiles as I pass, makes eye contact, says, "Have a nice day." I return her serve, pleased with the volley.

Tatters of cardboard serve as damp groundsheets, a slim separation from sleeping rough. Some of the cardboard is charred, marked with ash from previous nights, spurts of warmth in the cold. A low fire still burns in a shallow aluminum pie plate.

There's a slight but distinct dip in the street, in the sidewalk. I descend and then climb. In that modest expanse of two blocks, at best, is a microcosm, a neighbourhood inside the neighbourhood. There's a shift from tobacco and pot into meth and crack at the base of the dip, then a transition back to cigarettes, hand-rolled and industrial. A few guys are swapping stories of the best prices they've gotten reselling cartons in singles and packs.

Along the sidewalk are more mosaic designs, splashes of colour in tiles set in rounds and then framed by squares. It's part of the DTES Footprints Community Art Project, begun shortly after Portrait v2k was unveiled. Footprints is a series of over thirty installations in the neighbourhood, the work of local artists coordinated by Marina Szijarto. Each mosaic serves as a plaque, but unlike what I've been tracing and reading from Heritage Foundation and City sources, these pieces share artistic imagery; tones and design leave more room for a viewer to decipher, are less directive, more interpretive. *Conceptual* is a word often used to describe this initiative.

Artists were hired to direct the conceptual development and production of mosaic and banner markers and a guide book that together capture historic events, natural history and cultural stories from the rich history of the Downtown Eastside. Artists worked with participants from the Carnegie Street Program in a storefront studio over a

six week period to research, design and produce 31 mosaic markers and 100 banners that mark the Old Vancouver Townsite.[68]

Another hopscotch of stories, in this case through emotive and engaging concepts in colour. From street corner to corner, I construct a jangly visual poem, stylized lore in the artwork. *The Heart of the Community* depicts a fern with new growth, a plant sprouting a rosy red heart. Next, the red, white, and black of Coast Salish design in *The Raven Created the World* ..., the trailing ellipsis as evocative as the story it heralds. Another image has the look of broken glass with a plank of lumber. Titled *1907*, it's a depiction of the anti-Asian riots that took place down the block in that year. Now I'm at a piece called *Vancouver Corner*, depicting what looks like a worker, husky and hatted and holding what might be a shovel or railway tie. He has an industrious, industrial appearance—not as political as proletariat propaganda, but a hint at the importance of labour.

Each tile mosaic is framed in four compass points, making it nearly impossible to be directionally challenged around here. When I first moved to the city, I remember receiving geographical advice from everyone. "The mountains are north. Just look for the mountains." But with terrain undulations, tall buildings, occasional dark rain and fog, those unobstructed view corridors don't always present themselves. Alternately, I recall exchanges with friends who moved here, much like Gilles, from the prairies. "I get lost!" they say. "I'm hemmed in. There's no space and no sky!" To which I have to admit I only get lost in those open flat spaces, fields with no discernible landmark or hill. A matter of perception, perhaps, or of internal geography, of places that instill a sense of home.

On Keefer Street, rows of oak trees direct me to Chinatown, past a slate-tiled white building. On Columbia Street, the Chinatown Memorial Monument stands like an artistic directional sign, as though I've arrived at a central throughway. The installation is by sculptor

Arthur Shu-ren Cheng, commemorating railway workers and soldiers in the world wars.[69] This piece was not commissioned by the CPR but the local community. Two workers in bronze hoist their gear, one with a wheeled barrow, the other a rifle. Between them, a central column branches in two, both extensions joined to the main pillar with a crosspiece. It has the look of a mainsail with spars and forms a stylized depiction of the Chinese character *zhong*, which means "middle ground," "moderation," and "harmony."

Behind this is another Biennale exhibit. Unlike others I've seen, this one is simply words in white neon—"let's heal the divide"—created by Canadian artist Toni Latour.

> *Let's Heal the Divide* was originally installed on the facade of Vancouver Community College from 2015–17. It marked the physical and perceptual divisions between the Downtown Eastside, one of the most impoverished postal codes in Canada, and one of the wealthiest commercial and financial districts that borders it.

> Reinstalled in December 2020, the artwork is located in Vancouver's Chinatown, a neighbourhood confronted with gentrification, class inversion, and the threat of cultural displacement from urban developers and city rezoning.[70]

It's another linchpin, buttress, or line, something that divides while it strengthens. The words stand out clearly in any light, any weather, in simple, blocky letters of lowercase text. I imagine that ellipsis in the mosaic *The Raven Created the World* ..., only here the words aren't so much introductory as conclusive, a statement, a call to action, a plea. Maybe a future historical touchstone as well.

Roadways curve and meet in another wedged streetscape, bearing a physical likeness to where those first survey stakes were jammed in the soil, or the transition I felt in that dip in the sidewalk, the shift from free-market tobacco to needles and pipes. Of course, it could be a function of who's in this space at this moment, but I spend lots of time in these neighbourhoods. Not always looking for interpretation, mind

you, but seeing what else I might find. Who's to say what it will look like later today or tomorrow? I suppose I just need to continue, to compare and contrast as I go.

I pass aromatic displays of produce and dried goods at greengrocers and convenience shops. On the street, a singer has set up an amp and a mic and is now singing with gusto, with the feel of karaoke, occasionally in key. Clothes pegs hold his sheet music in place.

On to Dr. Sun Yat-Sen Classical Chinese Garden, where a city worker is trimming bamboo, a leafy bushel of green at his feet. Everything in this compact space feels significant. Which it is, culturally, historically, geologically, artistically—a discombobulation of nature tucked into the urban. Dr. Sun Yat-Sen, born in 1866, has been labelled the father of modern China.[71] Completing his education internationally, he returned to his home country to form the Nationalist Party, his objective to "unify and modernize" China. The party he created toppled the Qing, China's last ruling dynasty. Being sought (or hunted) by the Chinese Empress, the doctor came to Vancouver through the late 1890s and early 1900s. Not only was Sun fleeing the Empress's supporters, but he came here to raise money as well, fundraising for ongoing campaigns. A few buildings nearby, giving off the raw crackle of political subterfuge, housed the doctor as he worked to better his home country. Vancouver's Chinatown raised more money per person for his cause than anywhere else on the continent.

Here in the garden, any sense of intrigue or urgency vanishes. Though it's another space like the Cultural Harmony Grove or Seaforth Peace Park, it's also unique, the first full-scale classical Chinese garden created outside of Asia. Completed to coincide with Expo 86, it was inspired by the Ming dynasty gardens in the Chinese city of Suzhou. In a tidy chronological tie-in, this is also considered the site where Chinatown began, a version of that survey stake being planted, in this case, at the northeast edge of False Creek, which extended to here at that time.

Immediately south, a curve in the road bisecting Andy Livingstone Park marks the spot where the proposed city highway extension was slated for construction, intended to eliminate much, if not all, of

Chinatown—a disturbing pattern consistent with similar initiatives in major centres across the continent. Only here, it was thwarted by citizens through that "long decade," and the land was transformed to this green space, eventually acknowledging the doctor, the culture, and the neighbourhood, with another whiff of revolutionary salvation. Where I am now is a small portion of that earmarked locale. Dr. Sun Yat-Sen Park is due east in this block, while the pristinely manicured space is the Classical Chinese Garden. The combined area covers one hectare, with the garden taking one-fifth of the overall space.

What I'm strolling through triggers each of the senses, precisely what classical Chinese gardens are intended to do. The manner of design, planting, and maintenance is equal parts science and art. Traditionally, there are three types of classical Chinese gardens: imperial, monastery, and scholar's. This is a scholar's garden, its design consistent with those created for Ming dynasty imperial advisors known as "scholars," high-ranking administrators who had private gardens like this adjacent to their homes, places for contemplation and meditation.

The space represents landscape architecture in its purest execution. Nowhere can you see all of the garden at once. Each step reveals a new vista or scenescape. The premise is to recreate a rolling exhibit of artistic design, like strolling through a gallery, one in which all the pieces are integral to nature. A series of footpaths unfurls, undulates, and turns gentle corners, forcing a slowing of pace while simultaneously keeping unwanted spirits at bay.

By delving into the history of classical Chinese gardens, I learn that all samples hold primary elements: architectural design, calligraphy, plant life, water, and rock. Each facet draws from Confucian and Taoist principles, yin and yang with the positive harmonic energy flow of chi all present while striving for balance. Perhaps another example of *zhong*.

Past the *whsh whsh* of the worker raking bamboo, there's no way not to see it all playing out as intended. The dark and the light of white-stuccoed walls with their dark-tiled roofs. Smooth stones next to coarse porcelain. Soft plants and hard rocks. The stillness of earth with the trickle and flow of cool water. Even the overall park. To the north,

rounded curves of the yin. To the south, sharper lines and distinct edges associated with yang. Opposites reaching for harmony.

In design details I see good fortune represented in the depictions of bats on door features and tiles. There's a Moon Gate, a symbol of perfection and heaven, and what are called leak windows lighting the garden while providing seclusion and privacy. The walkway edges a pond, climbs small hillocks in "false mountains." Rocky cracks invite and contain welcome spirits. There's limestone brought here from Lake Tai in Suzhou: transplanted chi.

The pond is not only a painting-like image but a mirror as well. Constructed with an opaque clay liner, its calm surface is a perfect reflector. I can see buildings beyond—the "rest" of the city—inverted and flat on the pond. Their clarity is stunning. I start taking pictures and can't stop. I have a sensation of doing a handstand, seeing familiar landscape turned upside down. I see jade in the rockwork as well, a symbol of purity and prosperity, a stone I've actually sought around the Pacific, each shade of earthen green its own regional story.

Interestingly, the number of plants is quite sparse. This, I learn, is part of classical Chinese garden design, greenery used not to feature but to complement groomed natural space. More symbolism as well. Here a judicious balance of local flora is displayed with traditional Chinese arrays: maple and pine next to bamboo and ginkgo, indicators of renewal, resiliency, and longevity. There are even a few little bowls of penjing plants, the greenery art form predating bonsai.

Elegant calligraphy adorns garden features, poetic contributions from a number of Canada's premier Chinese scholars. The translated words speak not only to the ethereal nature of the garden but also to the drawing together of people and time. Sections of garden are designated with fitting names: Garden of Ease, and Cloudy and Colourful Pavilion.

The garden was even created using authentic tools and construction methods virtually unchanged from those of the Ming dynasty, the late fourteenth to early seventeenth century. Authentic components as well: actual Chinese ginkgo, camphor, and fir, and tiles of riverbed pebbles shipped here from China. I wonder what the Empress would have made of the rocks' emigration.

A Heritage Foundation plaque offers a succinct overview:

This Suzhou-style scholar's garden home built by craftsmen from China without the use of nails, screws or glue, was the first of its kind built outside China. The site of this unique Canadian museum was once home to buildings including a sawmill, brothels, opera house, opium factory and train station. The Dr. Sun Yat-Sen Classical Chinese Garden is an important bridge between cultures.

Aptly enough, I read this from a bridge, a small one over a pond, but a bridge nonetheless, another span between politics, culture, and time.

Leaving the garden and park, I pass signage on East Pender where Chinese characters outnumber English lettering. Two pedestrians are helping two more on the street, both surfacing from a trip gone awry. There's discussion to determine whether an ambulance might be in order. Next to this is a pile of white and grey feathers that look as though they've burst out of pillows. A stooped man spots a small square of foil with a trace of oily brown residue, a hint of an old hit. He snatches it up and moves on.

At Main Street and Hastings, I've arrived at that former main branch of the library, now simply known as Carnegie Centre. A library's still here, although somewhat small and tucked in a corner. I imagine it feeling much like that original Free Reading Room. According to the City's Parks, Recreation, and Culture department, "Carnegie Community Centre—often referred to as the living room of the Downtown Eastside—provides social, educational, cultural, and recreational activities on-site and nearby at Oppenheimer Park. The programs serve low income adults with the goal of nurturing mind, body, and spirit in a safe and welcoming environment."[72] In a way, it's not unlike what I've come from, the mindfulness inherent in the multisensory flow of the classical garden. Only here, everything is inside. Yes, there's a buzz of community out front, busy with bus stops, street

transactions, interaction, and socializing. But the objective of creating an inclusive community space has clearly been met.

The manner in which I'm walking the city, or at least this north-western portion of Greater Vancouver, puts this Carnegie building in the northeast or upper-right corner of my wanderings. It makes a good cornerstone. Designed by George Grant, the structure's design is Romanesque Renaissance, with a mansard roof and domed portico. The foundation granite is local, quarried just north of here, with sandstone in the walls sourced from Gabriola Island. Not quite the trans-Pacific providence of those pebbles from Suzhou, but still grade-A rock.

The central feature inside is a three-storey spiral staircase of marble supported with iron and steel. Multipanel stained glass sheds soft rainbow light, the effect of a dyed towel draped over a lamp, a colour-ful version of the garden's leak windows. Adding a scholarly tone to the space, stairwell windows are inlaid with English literary notables, the etched faces of Shakespeare and Burns, Milton and Scott. When the building was new, fireplaces warmed every floor, like in a very grand home.

On the second floor, I stop for a fifty-cent coffee, charge my phone, and eavesdrop on a conversation happening just over my shoulder. "I got stabbed in the back." And I think of money dealings and relation-ships gone sour. Only this isn't metaphor.

"Really?"

"Yeah. Seven times. Hit everything but the vitals."

At another table, a guy eats Doritos and plays chess by himself, methodically gauging each move, white piece, then black, yin and yang in sixty-four squares.

A younger couple are here for a meal, planning their day. One of them has an interview, the other is making a list and budgeting groceries.

I scribble notes and make my way to the third floor. Navigating the stairwell, I find, takes concentration. The spiral is slightly askew with a tilt, reminding me of vertiginous climbs on steep slopes where I'm unsure of what lies below. At least here there's a core of steel holding things up, I believe. I keep climbing and trust in the builders and old makers of steel.

Today, the DTES Writers are getting together. It's a drop-in session for anyone from anywhere, at any stage of their writerly journeys. Our score at the moment is the sound of a passing siren rising, then falling. Fiona Tinwei Lam, retired lawyer and Poet Laureate for the city, is leading today's group. She too has a steel flower in white with her name at the VPL Poets' Corner, keeping company with Evelyn Lau's and others.

I ask Fiona for her take on the city.

"I've been in Vancouver for fifty years and have seen the city change a lot in that time. More so since the pandemic. There's a greater intensity."

I'd like to probe further, but our session's begun. It does, however, bring to mind a visit I had with Evelyn, as though recollection is triggered by laureate visits. No doubt scribbling haiku at the moment is fuelling the memory. It was a sunny outing, again following False Creek, and Evelyn and I were enjoying newfound freedom following the lockdowns of COVID-19. She relayed more than one story of being yelled at during the pandemic by racists motivated to verbal abuse—madness that became, for more than a moment, disturbingly common.

Back to my writing. The room is quiet with concentration and artistic creation. My mind drifts to a previous time sharing stories around this table when I had a visit with Toni, a talented writer, funny and raw. Transgender for many years, Toni made a living through sex work, and she shared a couple of stories from the street.

"My most embarrassing moment? Falling asleep while giving a ... well, you know. Dozed off right there on the job." With a laugh, she continued. "The second most embarrassing moment? Waking up after falling asleep while giving a ... well, you know." She laughed again, then blurted, "God, I hope I didn't snore!"

Other stories revolved around addiction, recovery, and relapse. A soft-spoken man named Mitch was here with his partner, Heidi. "Been clean a long time now. I'm forty-five. Never dreamed I'd make it to this age." He smiled and put his arm around Heidi, the same way I grasped at the railing, trusting the stairwell to get me to here. "Having a schedule helps," he added. "And writing." Another shy smile, as though he'd already shared too much.

Our writing session wraps up, people disperse, and I'm back to the street, heading north past the DTES Community Market, which looks like an all-in-one flea market. Past a police station and firehall, I take in graffiti in concentric swirls of deep blue and white, with pink and fiery orange. At Hastings and Main, pillared banks anchor the corners. Toward the Port of Vancouver, I pass a plaque at the former site of a city hall:

> Since 1886 Vancouver City Hall has had four locations around the city after moving out of the tent erected after the Great Fire. 125 Powell Street, 425 Main Street, 16 East Hastings Street were all home to civic officials until the construction of City Hall at 12th and Cambie after the amalgamation of South Vancouver, Point Grey and Vancouver in 1929.

A city hall tent was the result of Vancouver's Great Fire. The fire that destroyed the new township was actually two separate blazes, both started in order to clear more of the peninsula. This took place on June 13, 1886, a few weeks after that first survey stake was wedged into the slope by what's now Victory Square. The city had just changed its name from Granville to Vancouver, the ink barely dry on legislative documents. Forest was still thick over much of the area, and while big trees were felled for the mills, burning was simpler for clearing deadfalls and scrub.

One fire was started toward what's now the West End and the second in Yaletown, to make space for construction of the CPR Roundhouse, future home of Engine 374.[73] A few factors played into the resulting inferno. It was a hot and dry spring, and buildings were constructed largely of lumber cut from freshly felled trees; much of the wood was still sticky with resinous pitch. The aroma of new builds would've been lovely, but the town was essentially tinder and fuel.

Shortly after the fires were started, intended as controlled burns, an intense gale blew from the southwest, fanning flames in violent, hot gusts. Embers leapt between buildings, engulfing the area almost

instantly. Within a half-hour, the city was decimated. The amount of damage can only be estimated. Approximately one thousand buildings were destroyed, and about two dozen lives were lost, although many suspect it was more. As the fire grew, residents fled to False Creek and Burrard Inlet, but still the heat was too much. People were forced to swim away from shore, some clutching belongings, others jammed into boats, while many clung to anything that could float.

From across Burrard Inlet, near Mary See-em-ia's village, Squamish responded immediately, launching canoes and paddling toward the blaze, hauling people aboard and saving countless lives. One of the Indigenous paddle songs that was heard during the rescue is still sung at traditional Squamish ceremonies and celebrations of life, oral tradition sharing cross-cultural history—another rebirth of the city, this one set to song.

Within a week of the disaster, Vancouver was mostly rebuilt: tents for essential services, a wave of new trade, retail finding footing in old ash. *Phoenix* was one of the street mosaics I passed to get here, the mythic bird rising from flames in Coast Salish design; the visual takes on new meaning, leaving me to imagine that heroic paddle song. Following the blaze, a fire engine was brought into the city, with more new builds shifting to brick.

Continuing north along Main Street, I can see some of that brick-work, although most of what I see was more recently built to conform with vintage and heritage buildings. This reminds me of a recent visit I had with an engineer friend, part of the team responsible for refurbishing the Spencer Building, where David Spencer expanded city shopping with his cash-and-carry retail model. The refurbishment was very much artisanal. Yes, there were structural integrity considerations and rainscreening, but visual optics were of equal importance. New owners insisted on keeping the appearance of the overall structure true to its initial architectural design. Original bricks were reused. In spots where that wasn't an option, new bricks were designed and created with customized terracotta concrete virtually identical in look to the hundred-year-old samples, not unlike restorers doing touch-ups on museum paintings, often using traditional egg wash and horsehair, but

in this case, combined with reinforcing structural integrity. The result, the building exterior I walked by and admired, is now indistinguishable from the original. More art and science executed with a great deal of passion.

There's a curve and a rise in the road as I cross the railway tracks, making my way to that stretch of shoreline where much of the fire rescue took place. Now the Port of Vancouver looms to my right: ships with containers, gargantuan cranes, even a rusty white cruise ship, which I assume is here for repair.

I pass a man with the look of a very rough Santa, his woolly beard streaked with amber nicotine. He's smoking two-fisted: in his left hand, an unfiltered cigarette; in his right, a long, pungent joint. He takes long, contemplative drags, alternating between left and then right. Left and then right.

A train rumbles through, echoes of a CPR past in the present. The raised walkway hoists me in a sloped curve to CRAB Park at Portside. This north-facing shore, much like False Creek, was a prime fishing and shellfish-gathering spot for Indigenous locals, Burrard Inlet being an active throughway for transport, hunting, and trade. That sense of roadway on water remains. Prior to bridges and SeaBus sailings, ferries shuttled settlers back and forth, taking the same route as Salish canoes. The first ferry service began operations in 1866, run by John "Navvy Jack" Thomas, a North Shore gravel merchant.[74] Where I am now was one of the passenger stops. But by the early 1900s, ferry services were taken over and run by the City of North Vancouver. Now, the SeaBus loads and unloads at Waterfront Station, that third CPR terminus building.

With a shudder and cringe, I imagine the Great Fire raging. Chaos and heroes, a crack in the egg of that phoenix. From above, this swath of parkland resembles a diving orca. Where I am is the tail. Walking west, I'm approaching its dorsal fin. Just as that curved stretch of green in the Chinatown heart was saved from a proposed motorway, this park too has a story of modern-day saviours.

In 1982, a proactive group of DTES residents led by Don Larson proposed this community-binding green space, which at the time was

unused federal government land being leased to the Port of Vancouver. The collective formed a committee and chose a name. In the same way many Salish place names describe physicality or logistics, the group's moniker, the CRAB committee, stands for Create a Real Available Beach. Stated Larson, "Our purpose was to create a public park in a park-deficient neighborhood on the central waterfront of Vancouver. Since June 1982, we worked five years, and against all odds, succeeded to create what is now known as CRAB Park at Portside, a seven-acre waterfront public park."[75] Five years of lobbying, protests, and sit-ins ultimately resulted in the success of this park, which opened in 1987. Some, however, consider the catalyst of CRAB's efforts, which in part defined future city legislation, to have taken place in 1984, with a free concert and open camping, effectively taking over this space for nearly three months. The public and lengthy protest resulted in the Port and each level of government solidifying the agreement to turn this beach into parkland.

But in 2016, the Port proposed an expansion, something many felt certain would negatively impact the park, and the CRAB committee stepped up once again. In 2018, however, a project permit was issued, leaving the view that I now see, the relative quiet I'm enjoying, in jeopardy. In a visual reminiscent of that 1984 protest and camp-in, the west side of CRAB Park is home to a semipermanent tent city, Vancouver's only legal encampment. Part of this legalization came about as a result of unhoused and temporary residents being relocated from elsewhere in the DTES, perhaps most famously from along Hastings Street, where police and city workers combed blocks full of unhoused residents, gathering tents and belongings and dumping them all into garbage trucks, compactors, and bins.

What I see here feels like a respite, a sense of renewal. Or hope. Even a hint of *zhong*, of finding middle ground. There's a play space, a jungle gym, public washrooms, and more monuments: a dedication garden to Yokohama, Japan, Vancouver's sister city, as well as the DTES Missing Women Memorial Stone and a mosaic commemorating the *Komagata Maru*.

Away to my left are the sails of Canada Place, the Vancouver Harbour Heliport, and the Spencer Building—now Harbour Centre, with its rotating top, a restaurant with slow-moving round-city views. I can just make out the Woodward's *W*, emblematic of the past, hoisted in red like a very old win.

Signs for self-guided walking tours adorn lampposts, more stories and snippets of history. Between here and the white peaks of Canada Place sits the tent city, a sprawl of tarpaulins and shelters on the promontory, the head of the orca. It's a jerry-rigged village where the displaced and unhoused have established new residency, temporary housing with no end date.

A thick chunk of Portrait v2k granite sits by the path. This one is heart shaped and called *Urban Indian*. It's one that Lorenz von Fersen described, yet I can't help but see a slight blur in its reference, not only with the Vancouver millennium initiative but also the term "voice to skull," auditory mind projections associated with harassment and pain, often depicted in the media as "v2k." Maybe it's not so much a blur as it is clarity.

A horn shudders the water as a tanker bears west, and the clap of railcars coupling gives a thunderous boom. I keep walking through the growing knot of tarpaulins and tents, garbage bag shelters, handcarts, trolleys, and shopping carts. There are conversations and transactions; life carries on. Ivy creeps up the trees. And a Helijet rotor roars through, symbolizing a chasm of economic dichotomy.

The grind and squeal of the rail breaks my own train of thought as boxcars rumble by, hauled by two locomotives. Doubling back on the footpath curving over the rails, I spot another commemorative plaque. This one is not about builders or soldiers or angels, but the strikers taking their fight to Ottawa during the Depression, when logging and cooperage shackers packed the shores of False Creek. It's consistent with the Taking It to Ottawa story and plaque that grabbed my attention as I circled the convention centre, working my way through that timeline.

Now I have a view of Gastown from the north, where signage on the back of a building reads, "Chandlery, Boom Chains, Steam Fittings." More of the past on display in the present, a museum in obstinate brick.

I'm returning to where I began, but via different streets. The growth of gentrification is startling—restaurants, retail, an increase of tourism. I imagine Gilles in a Sisyphus role. The Hotel Europe, built in 1908–09, faces the street with a clinging of old airs. On the sidewalk there is amethyst glass in the concrete, a form of underground lighting indicating passageways, labyrinths below, a Minotaur to pair with Sisyphus.

The steam clock puffs as I pass, hooting off-key to mark the half-hour, the asthmatic huff of a pan flute in need of cleaning. At the Scientology centre, there's a case of books on the street, every volume an L. Ron Hubbard. A big truck gives a honk as it turns in reverse, easing a long trailer into a slender garage, its load: steel trusses and joists.

The temperature is dropping. Clouds are moving in. Away to the north, snow is low on the mountains. The aroma of cold and imminent precipitation seems to pulse in the air. Bearing south, I wind up my day between brutalist buildings in concrete and the tail end of that previous alphabet—VCC, VPL, CBC—while the BC Place crown holds its lofty dome high. Here on the street, sponsorship bricks surround tree roots, hornbeams, and nettles in red-lettered blocks. I see them as a blend of fundraising, philanthropy, and self-funded walk-of-fame stars. The sidewalk resembles a flat trophy case, memories and neighbourhood pride on display.

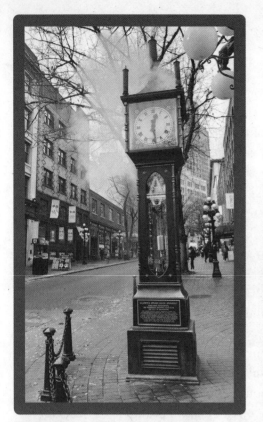

**CLOCKWISE FROM TOP LEFT:** the Gastown steam clock; the Chinatown Memorial Monument; CN locomotives by CRAB Park at Portside; Maple Tree Square, considered by some to be the birthplace of Vancouver. *Photos by Bill Arnott.*

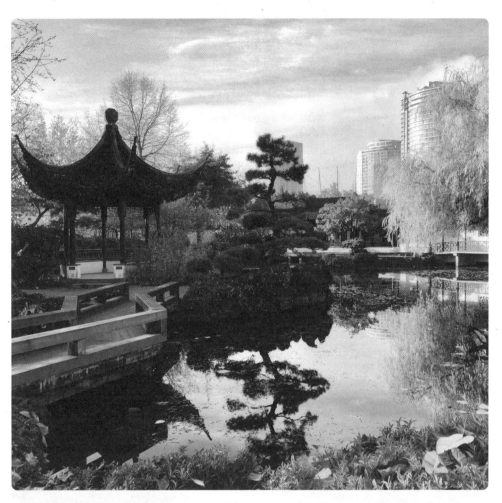

**CLOCKWISE FROM TOP:** Dr. Sun Yat-Sen Classical Chinese Garden; a bust of Dr. Sun Yat-Sen; the Woodward's *W*, rotating atop a faux Eiffel Tower. *Photos by Bill Arnott.*

**TOP:** after the Great Fire, at Carrall and Cordova Streets, 1886. **BOTTOM:** CPR Engine 374 being trucked to Kits Beach, 1947. *Photos courtesy of City of Vancouver Archives.*

Water, Cordova, and Richards Streets, with a flatiron building and streetcar, 1912.
*Photo courtesy of City of Vancouver Archives.*

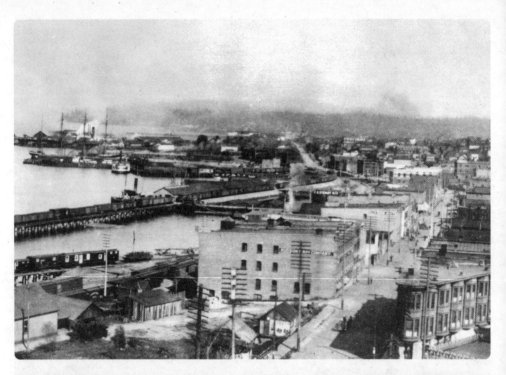

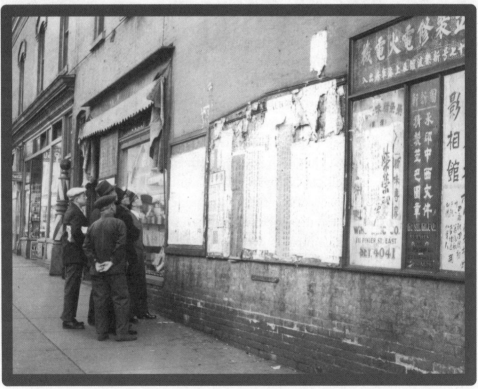

**TOP:** the Port of Vancouver and Water Street, looking east, 1901.
**BOTTOM:** Chinatown bulletin board, 1936–38. *Photos courtesy of City of Vancouver Archives.*

# Snow Day

*the world is on mute*
  *bundled in blankets of snow*
    *as steps disappear*

SURE ENOUGH, SNOW has arrived, and the world is on mute as the crows start their day, a movement of black on white. I dig out snow pants and an extra-thick toque and plunge into the snowfall. My eyes water, and my tears start to freeze. Now I'm warming my eyes with my gloves, hoping they'll open. Steps are a slog, walking a workout. I feel icy and hot, a frost chill in my nose, the fragrance of Arctic expanses. Navigating sidewalks feels like an alpine ascent, and I find a quiet street to shuffle in the tracks of two tires. Snow underfoot is now scrunching, a blend of moist and dry—perfect snowball snow. Schools are closed, the children already in parks with dogs bounding through powder. A few determined builders are rolling various-sized rounds into snowpal components, torsos and heads. On the water, each offshore rock wears a snowcap, archipelago alps in the bay. A *whoosh* and a *shoosh* as drifts slough from branches, blusters of second-hand snow. Behind me, the footfalls of no one but me, just impressions that guided me here.

Snow continues to drop, not only snowflakes but drifts off the trees, more weighty than branches can support. I think of the new BC

Place roof, one designed to do this as well. There's a freshness about. Drivers have been advised to stay off the roads. Buses are few—not by scheduling, just unable to get through. City plows are doing their best, incapable of keeping up, given allocation and resources. Meanwhile, trudging along like polar explorers, the people I pass say "hello" or "good morning" with eye contact and smiles, as though we're all sharing a secret.

I add to the growing village of rotund white bodies, building my own little snowpal, mine on a fence with a view of the bay. A woman nearby is patting hers into place on a bench, a life-sized figure reclining against the backrest, taking in the same water view as my own.

On today's quick slog through the neighbourhood, feeling the cold, the fluff of the snow, views take on new perspectives. There's fresh fog on the inlet and bay, another sense of shared intimacy.

Back at home, I shovel the street cornering our building, add salt for insurance. In the parking garage, where snow gear is stored, I run into Byron, a neighbour who works with his family developing real estate around Greater Vancouver. Something about the underground meeting has me feeling that we should be trading spy secrets, exchanging identical briefcases. But I see a chance for another perspective, so I ask for his take on the city, what he's seen as the city's matured.

"Well, I've been in this business since 1999. And if I could go back and talk to myself then, I'd say, 'Buy more real estate!'" He laughs. "But seriously, this city, this market, I don't know how it can keep affording itself. There'll be dips and flat times for sure, but demand, I think, will always outstrip supply. Not only resident families growing, expanding, maturing, but immigrants arriving. We just can't build fast enough. The federal government, though, has support for developers, making funds more accessible to speed up the process. Because we need new homes. Permits slow down the process, but the need is there. I see this all over the globe, or at least around the Pacific. Money coming in from other sources, strong currencies. I just don't see Vancouver ever falling out of favour. I've heard this now over two generations."

**CLOCKWISE FROM TOP LEFT:** a snowpal, looking north from Hadden Park; Kits Beach Park with a blanket of snow; a snowy view of Hadden Beach. *Photos by Bill Arnott.* Snow Day, Kits Beach, 1911. *Photo courtesy of City of Vancouver Archives.*

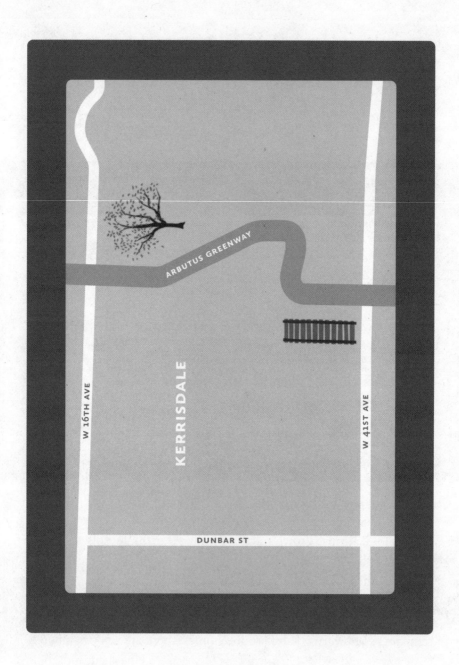

# Kerrisdale

*a merging of trails*
  *footpaths with remnants of rail*
   *some hidden, some found*

THE SNOW HAS disappeared from low levels. Today's a wet day, with crows under grey, as I follow the Arbutus Greenway, where a city sign states, "Connecting the city from False Creek to the Fraser River." Southward, I pass blackberry, cedar, and fir; cyclists in raingear; and dog walkers. There's a community garden with plastic chairs, wooden tables, and a wheelbarrow half-filled with mulch next to the Vancouver Compost Demonstration Garden's ornate arcing gate. Its sign, "City Farmer," in block letters that could be forged iron. A crow caws as I pass a mosaic of homes resembling three structures fused the way trees can conjoin, a copse grown to create a shared trunk. In this case, it's a bookend of builds, 1990s and late 1960s. The next multihome clump is another scatter of decades and timelines, like a mishmash of Lego with a few pieces missing and others added from alternate sets. The trill of a blackbird melds with a robin's aria. Another community garden, with remnants of flowering kale. Around homes, there are some bamboo, a few cypress, and cedar. On one lot, a blue house, a blue shed, and a blue fence are all framed by shrubby blue spruce.

The path flows in a single long curve, a corridor of dense blackberry with a few withered clusters of fruit, like lumpy old raisins. I take a zig and a zag to keep heading south. The path truncates, resumes, allowing for the construction of underground transit on Broadway. I pass St. Augustine School, founded in 1911, new brick with a feel of the old, a bit bright and overly fresh. It should look lovely in about fifty years.

I cross the path of old train lines, trolleys, and the interurban rail. Behind me are the lumps of those "hidden" tracks. Ahead is the smooth concrete of this repurposed greenway, a dotted white line like the world's smallest freeway, only here it's bicycles, scooters, and walkers. A steel vent with the look of an art installation catches my eye. It's just the top of a ground-level HVAC exchange, this one resembling an inverted funnel, the hat of a subterranean Tin Man. Now comes the melancholy of sparrow song, musical nostalgia for me, as this is a sound I awoke to in childhood.

Morning-time smells waft from cafés and bakeries, fresh bread and simmering soups. Cars accelerate south on Arbutus. At the intersection of West 16th, I cross what was once the city's south border and that of the CPR township, a formerly dense forest and a ditch thick with loam.

Side streets are lined with healthy old maple, chestnut, and oak, trees for beautification, for pride of place, for delineating neighbourhoods while shoring up land and property values. Another community garden, with rows of heavy wood planters and a few floppy leaves, a wrinkled zucchini nibbled by something. Chimney smoke from a small house, warm and inviting. A clump of workers priming themselves with a smoke and the aroma of wet leaves. A gas station shut down, fenced and heavily tagged, future home of new condos. Tall, thick cedar hedges, well tended and well aged, with carved pass-throughs that might lead to secretive worlds, lands where lions can talk and kids can learn magic. A looming Georgian home in white stone, double chimney and shutters in nautical blue. A Tudor-style home with a heavy oak door. There are fewer neighbourhood plaques along here, less public art, yet I spot the wheeled grey lump titled *Park* by Marko Simcic. It's one of two, actually, but there is only one here now. The piece resembles the beta design of a car, a prototype carved from a chunk of raw clay, although this

one has axles and wheels. According to the artist, "*Park* explores the nature and value of public and private space in our urban experience."[76] It's a clever use of *park*, as in green space, plus the actual placement of a vehicle, finding literal space between other things. I think about what my journalist friend said, that in the city, it's hard to find parking. Indeed. The innovativeness of Simcic's art is that his pieces actually get moved, repositioned around town to further engage and better exhibit that sense of movement, the restriction and balance of space.

The path veers up a hill, and I climb, the view expanding behind me. Trees are covered in moss, every branch in full, fuzzy green sleeves. Across the walkway, vines scale power poles. A transformer station is tucked into the brush, surprisingly large, yet discreet. Farther on, maple vines wrap around maple trees, maple on maple. Neatly enough, I notice this occurring along Maple Crescent.

The rain ebbs, and birds react with renewed gusto; I hear the *grind chirp* of starlings and chickadees in a chorus. Treed crescents share the names of some streets a few blocks to the north: Maple and Pine. Only here, the sweep and curve of the roads meet and bounce in tangential paths. These geometric designs are the result of an overlap of city survey grids with the intersection of old CPR plots and rail lines. This is the same meshwork that creates acute angles downtown, where city blocks house the vertical wedges of flatiron buildings.

Past Quilchena Park, a frisbee-golf course finds its way between trees. Today a scatter of gulls stand on the lawn, as though midgame on the field. A couple passes with matching umbrellas, offering a smile, a "good morning." A sharp curve twists the path, and I find myself mildly disoriented. My view, which can only be west and north, takes a moment to recalibrate. I've gained ground and altitude from the inlet. The distant wink of Lighthouse Park, the edge of West Vancouver, adds a compass point, setting me right. What I see now in the northwest, I realize, is Howe Sound reaching toward Squamish. The land beyond that is unclear; I'm uncertain whether it's mainland or island. Wan, overcast light leaves it open to interpretation, so it seems. I imagine those early cartographers working the minutiae of sightlines, calibration, and trigonometry, all now but a touch and a scroll in an app on

my phone. The red rectangles of tankers add another landmark—or seamark, I suppose.

I stop in a diner for coffee, a meal, and to create a neighbourhood "tour" loosely based on a path from one of the city heritage books by Michael Kluckner and John Atkin. This one leads me through part of Shaughnessy, here within the borders of Kerrisdale. Ahead of me, the Kerrisdale Community Centre is the site of a former municipal hall. Directly east, over a street and a boulevard, what's now a school and a field was once the CPR gardens, growing food for the railway hotels, passenger shipping, and routes with onboard meals. The large lot is still lined in venerable walnut trees. Another walker is gathering nuts in a bag, sifting through the mottled green husks. These are black walnuts, small, darkly coloured, and sweet. I see a chubby grey squirrel and sus-pect that it lives a very good life in those trees.

The sky has cleared and the sun is out, so no more need for umbrellas. I walk a bit north, a bit west, following photos in the city heritage book, now crossing West Boulevard. I'm on a break from my usual meanders to see a sample of buildings and homes from the previous century, an abridged snapshot of the most prevalent architectural designs.

A monstrous black oak stretches over the street like part of an arch-way or a gate. Beyond are towering hemlocks. An elm dangles a swing low to the ground, possibly for a toddler. A holly tree hugs the sidewalk. Concrete rises and falls in peaks and valleys as roots find their way, indifferent to surveys and grid lines.

A huge Sitka spruce has made an umbrella, a neck-craning canopy, over two properties. Behind me, the tower bell at St. Mary's Kerrisdale gives a clang. I check the time. It's noon. The bell is less symphonic than the blast of the Heritage Horns from Canada Place, but somehow more tonal, a similar chime to the birdsong emanating from the trees, the ringing of a choir. Out in front of the church is a Little Free Library, and next to the street, a red-lettered sign: "Thou Shalt Not Park."

I pass hedgerows and fences in wood slats and stone. In four tidy blocks, I see a range of design. A 1930s starter home. A ubiquitous Vancouver Special, built from the mid-1960s to 1980s to maximize square footage in narrow lots while keeping construction costs low:

two storeys in stucco, often split to house multiple generations or more than one family. A so-called monster home, constructed through the late 1980s and 1990s.

Turning a corner, I find that a great many structures from the photos have vanished, torn down to create something larger; California-style bungalows, for example, and midcentury ranchers have gone and been replaced with lot-filling, high-ceilinged homes in brickwork and lumber. But I find one holdout: a vintage house with a butterfly roof, the same style as what I grew up in, built in the 1950s. The roof acted as a literal catchall for windblown flora, pine cones, leaves, and invariably a ball. And one time, soon after moving in, Mom and Dad, young with no money, found a goose on the roof, injured and flapping its last. I was told the meat was quite tough.

I pass a pair of holly trees, yin and yang, one loaded with berries, one bare, then a spectacular corridor of sycamores, their branches reaching skyward, as though I've found them midsermon, part of a southern gospel, the hallelujah of outstretched arms.

A looping turn north ends this circuit, where a criss-cross of cycle paths merges into laneways, some of those unpaved examples Lorenz von Fersen referred to. I find myself in a bit of a warren as three lanes meet on a slope, eventually spitting me out by a park and a school. Now, away to the north and the west, a cloud forest hangs on the North Shore's westernmost tip, a lone pocket of disgruntled weather. A few students walk by, some laughing, some burdened. I'm now improvising my route around corners and curves. Nothing quite meshes or pairs with the greenway, the ongoing feel of that cross-aligned overlap of township and railway property, train tracks and roadways with different objectives, a scatterplot plunked on the land.

Back to a more or less true north-south street, I follow Arbutus, dodging a construction site: scaffolding, the whine of power tools, the *thud thud* of a sledgehammer smashing through planks, the shouts of orange-vested workers. A crane swings a pallet of pallets, the load at an angle, looking awkward and dangerous. People passing me squint against the sun, now low in the south.

I pass the sign for the Ridge Theatre, now atop condos and retail. My grandfather's home was right there. When the Ridge Theatre was being constructed, Gramps had his house moved, lifted, and trucked around the corner to the north side of West 16th Avenue, just west of Arbutus. The back garden was his passion: sweet peas and apples and pears. The basement held oily tools, paintings, and memorabilia treasure. When we came for a visit, driving to "the city" on a Friday night, we watched theatregoers pass by, off to the Ridge for *The Rocky Horror Picture Show*, every attendee in costume, holding pieces of cold toast, noisemakers, and Glow Sticks. To a country-mouse kid, it felt like wildly exotic metro-chic glam, all enjoyed through a living room window.

From that cluster of new homes and retail, I veer into a quiet residential area: more flowers in planters, well-aged trees, and hummingbird feeders in yards. Crocuses and daffodils push through the grass. Once more past that old city boundary, I head back over rail lines no longer here, at least not above ground. An inversion of development is occurring where old surface rails were once buried; now new tracks have been dug underground, running nearly adjacent to that former city and railway line, a woven meshwork of movement and growth.

**TOP:** a bee at work on a sunflower. **BOTTOM:** a Little Free Library. In the lower left, someone's found a loose photo in a book and attached a lost and found note. *Photos by Bill Arnott.*

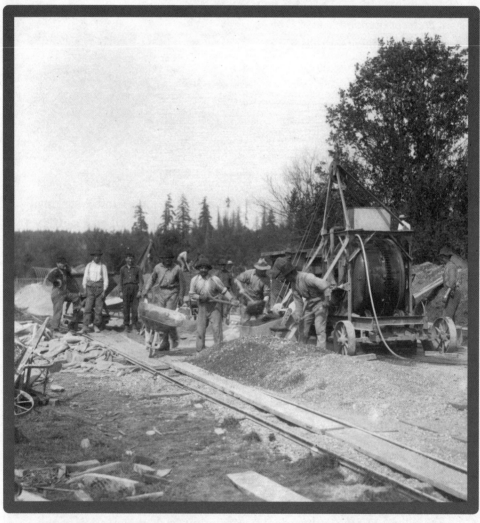

**CLOCKWISE FROM TOP LEFT:** lot for sale in Kerrisdale, 1913; a Kerrisdale boardwalk road with wood sidewalk on the left, 1913–15 (note the footbridges to access each home); laying Kerrisdale utilities, 1911–12. *Photos courtesy of City of Vancouver Archives.*

# Shared Stories

*a crescent of moon*
*lingers by Jupiter's side*
*lights my way onward*

I HEAD OUT as crows span the crepuscular sky, not on their day-starting westerly route, but away from the sun as it sets. It could be a sunrise in reverse, familiar cherry tones but softened pastels, the sun poaching itself in the sea. One crow sails past without flapping, while a diminishing sun backlights the bird as though a stage monologue is about to begin.

For a change from writing my tale, I'm off to hear others share theirs. Tonight is an evening of storytelling at Beaumont Studios organized by Mela Event Collective. The studio's comfy, a space where I've created and performed before. But tonight I'll simply absorb and learn. I recall a term from the Arctic Iñupiat: a space known as *naalagiagvik* is "the place where you go to listen."

It's cold in the twilight, a sliver of ivory moon with Jupiter hanging nearby. I'm bundled up, walking, pursuing my quest. At the moment it's an easterly route along West 7th Avenue, a rise in the land with city views to the north. Headlights and tail lights dot bridges, and buildings are yellow-lit checkerboards. I pass Choklit Park, where tonight the

space seems peculiarly small, a blank in the dark. A car slowly drives onto recycling bins, making a terrible noise as it crushes them into the ground, not once or twice but three times, flattening the heavy blue plastic. The action is somehow vindictive.

I pass other pedestrians, workers at day's end, dog owners with leashes and treats, a family of three all on a single e-bike, solitary walkers in conversation, alone. Some are on their phones, others not.

I arrive ahead of the show. The studios are locked, but a door opens, a face appears with a smile, and I'm welcomed in from the cold. I peer into individual studios from a narrow confluence of stairwells. There is mixed media, the feel of a funhouse or a fair with a decor of oil paintings, collages, and papier mâché. A few city scenes have a Daliesque flair; they depict the view I just walked by, only here it's a melting of acrylics: splashes and mashes of cobalt and teal, two swans on a rippling pond. There are gilt frames and canvas in circles and squares and a two-storey neon display.

My mind suitably stimulated, I get some wine in a cup from a bag and potato chips heaped on a plate—pretty much what I'd be doing at home, only I have proper shoes on. The cozy venue fills, three dozen people here to hear six share their stories. A couple beside me, Beth and Atish, moved to Vancouver one week ago from Johannesburg. I ask them about their experience.

"So far, so good," Beth says with a smile. Atish nods agreement. Beth, an anthropologist, has lined up volunteer work at the Vancouver Aboriginal Friendship Centre Society, while Atish is weighing his options. "Back in South Africa, by not having kids, it's very isolating. Being here, it doesn't feel the same way." I'd guess the two of them are in their midthirties. "Life there is very insular. Gated community. SUV to the office. Lunch in the building, maybe next door. Then home. Nothing like here."

It turns out the couple moved into a place by the coffee shop where I met with Lorenz von Fersen to hear his take on stories like this, as well as what's starting on stage.

Unpolished speakers share their experiences of coming here from elsewhere. Not history, in the words of Lorenz, but *stories*. They've

arrived from Toronto, Chicago, London, and Dublin, not to mention my Johannesburg seatmates. Onstage, a narrative overlap ensues, tales of loneliness, openness, courage.

"I arrived from Kelowna. Moved to Kerrisdale, a Vancouver Special. Accommodation for four, for eight. A house of international students: India, China, Japan, a few locals."

An ex-soldier describes his arrival with respect to past experience, time measured in units of war: "One war later, I was here, loving the city. But there's loneliness among the grandeur."

The next speaker explains, "I grew up in East Van before that was chic."

A woman named Max describes, in her words, what it means to build a home. "Moving somewhere from somewhere else. A figurative home's not as easy. Progress isn't linear. And realizing home is *not* a wrap-around porch or picket fence." She explains part of her path into and out of addiction. "Changing my focus from what I did wrong to what I did right. Then finding home in yourself. After all, home is a mentality."

A man named Miguel takes a turn at the mic. "This beautiful city can feel ugly at times. That's loneliness. But don't underestimate this city; it's full of surprises." And he smiles as he steps off the stage.

In each story, I hear discovery, explorers not looking for through-ways or spoils, but longing to create their own flags and to position them somewhere inviting, somewhere new, and to maybe make a friend on the way. Experience is peppered with humour, sadness, reward, with an unfailing emphasis on open-ended optimism. Perhaps it's the explorer's perspective to know, to believe that there's something out there to find, to even make your own for a while.

Walking home at the end of the night, it's more quiet, with fewer lights in the windows, and noticeably colder. The sliver of moon's spun around, reminiscent of the U-shaped installation, not steel but blue cheese. Passing old houses, an aroma of woodsmoke and hearths, I feel a pull to just call one my home, kick off my shoes, and settle in by the fire. On the curb, recycling is sorted in bins, with deposit items sitting out separate from what the city will gather—donations to those who make a living by collecting them.

A plane buzzes by with the look of a drone, red flashes in night sky. A car stops. A woman gets out, opens the trunk, looks in, and says, "Okay, Steven." I wonder if I'm witnessing an abduction. A pause, and then Steven leaps out. Turns out he's an Irish setter.

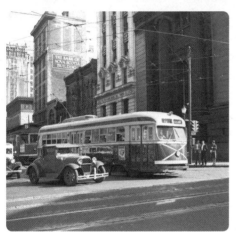

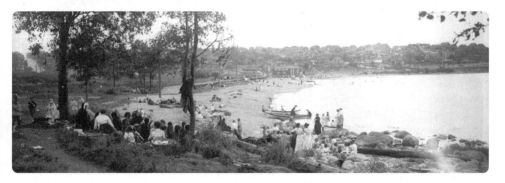

**CLOCKWISE FROM TOP:** Portrait V2K, the City of Vancouver Millennium Project (this story, on heart-shaped granite, is called *Urban Indian*); the DTES Footprints Community Art Project (this mosaic, *The Carnegie*, is a likeness of Carnegie Community Centre, the DTES's living room). *Photos by Bill Arnott*. Kits Beach picnic, 1914; a streetcar, turning from West Hastings onto Granville Street, 1945. *Photos courtesy of City of Vancouver Archives.*

# Stanley Park

*a rain-obscured sky*
*tempers the day in dim grey*
*as crows take their leave*

I'M UP AND out early, under overcast sky, as a crow glides to a landing, in its beak a shiny black mussel. Today I'll explore, or re-explore, Stanley Park, the peninsular west tip of the city, a forest of new growth and old, much of it thinned in late 2006 and early 2007, when heavy storms blew from the sea, violent gusts acting as loggers. The park is expansive, its area comparable to London's Hyde Park and New York's Central Park combined.

I'll be walking the perimeter clockwise, meandering between the Seawall and the park's serpentine roads. My first glimpse to the north toward what should be the twin peaks of the Lions reveals nothing but fog, a low shroud with delicate rain. Apart from the chill and the cloud, it feels like a desert mall in the American Southwest, with unseen misters to keep shoppers hydrated and cool, able to carry on spending.

I pass two crows on a lamppost, one tenderly grooming the other, beak combing the sides of its face. Starlings and pigeons are browsing through aerated grass. Daffodils blanket a south-facing slope, while the heavy *Inukshuk* watches the English Bay bight.

At the moment, the park is quintessential Pacific Northwest: steely sea with evergreen fog. A corridor of venerable chestnut trees fronts the bay. Branches reach up, intertwine, as though I'm passing under raised and crossed swords.

A high-rise is wrapped in geometric design, a mural of squiggles and diamonds. Passersby pose for photos at the bronzes of *A-maze-ing Laughter*, no one deterred by the rain. I pass the Sylvia Hotel's red-brick facade with a lacing of vine. Hugging the beach, the walkway and cycle path widen, expanded and pedestrian friendly. Two geese cross the road at a zebra-striped crosswalk. Traffic comes to a halt as the two thwack along, behaving like everyone else.

A blue heron rookery lofts in the trees. I count thirty nests and suspect I see only half. All around, a two-note sparrow song plays on a loop, a musical score as peaceful and grounding as the circles of trees in those parks on False Creek.

The bust of David Oppenheimer stares in my direction. The second mayor of Vancouver, his term was in the 1880s and '90s. Past some ash trees and arrowwood plants, a sign on the sand enumerates shoreline birds around English Bay and Burrard Inlet: oystercatchers, goldeneyes, herons, grebes, and surf scoters.

The tide has slackened, now low, with shoreline rocks in green algae and kelp. A ship puffs in the bay. I pass lawn bowling and tennis courts, empty and quiet in the rain. Someone glides by on rollerblades. There's a beech on the beach, and a hoot rolls across the water from what looks, through low cloud, like a tug.

It doesn't feel particularly cool, yet my breath is visible, like that of the ship in the bay. The forest too is dense with its own heavy breathing. Dirt trails deviate from paved walkway. A white ash leans toward the water, a perfect half sheath of moss on its northerly side, a true compass point. A few good mornings exchanged as I pass other walkers. Some of those birds from the sign are paddling the shallows as I approach the Second Beach Pool. Ducks in singles and pairs, indicating there are no eagles around; when they cluster, a raptor's nearby.

There's a litter of stumps on the beach, with tractor tracks on the sand in spirograph twirls. There's a play space with swings nearby, a

concession stand as well. On the sand: bits of driftwood, crushed shells, maple leaves. An arbutus shines, coppery red, in the rain. Lost Lagoon is off to my right. I stick to the seaside, bearing northwest, maintaining my lopsided loop.

A jogger does circuits up and down stairs, while a driver twists his car in slow, tight turns in an empty parking lot, navigating a jerry can like a pylon. He catches me staring, stops, pokes his head out the window. "I'm practising," he says, his face a broad grin. I give him a thumbs-up, and he returns to his sharp reverse turns.

A big stump looks like a fort, crenellations in its withering bark. Were the world still on lockdown, I wouldn't be here, doing this; during the pandemic the park was closed to walkers as coyotes took over, reclaiming terrain.

A fir with a drenching of pitch down one side has the look of a gigantic candle. And another old stump, this one a cedar, resembles a throne. Around the Teahouse and Third Beach, I'm now at the westerly point of the park, where tankers in the bay are noticeably closer, looming in rust reds and blacks. One time, I sailed among them, the ships all at anchor, in a skiff launched from Jericho Sailing Centre on the south side of English Bay. I felt like a pedestrian next to skyscrapers; each freighter loomed, aptly enough, to the height of the Marine Building, a visual like in one of those films where the protagonist finds they've reached the very end of the world and realizes they're in fact contained in a huge gilded cage in a much wider cosmos.

The roar of a Helijet, basso and throaty, skims the trees under cloud, aiming toward the Port. The sea at the moment is oil calm, breezeless and slack. There's something about the near silence, the low mist—what I expect to be muting is in fact amplifying the world, a volume increase in each little noise. Maybe it's just that I'm farther from the ambient hum of downtown.

Two cormorants stand beak to beak on an islet of rock, with the look of castaways gauging the tide. The ground here is a mess of patched grass with fir bows and cones, a coarse Berber carpet of pine. A salal hedge forms a natural wall, following the shore in a curve. And a float

plane groans to Coal Harbour as I pass a gazebo with a coarse wooden bench, a jerry-rigging of driftwood and carvings.

A map of the park pinpoints where I am, still a good distance to go. Signage indicates that liquor consumption is permitted in some city parks, not in others. Two coast guard vessels race by, trailed by paddling outriggers. Another Helijet roars. Away to the south is the green jut of UBC with its Endowment Lands. Now comes a slight movement of water, rising tide, or a residual wake from the boats, a soft mumble on rocks.

Through a wide-open gate with the Lions depicted in steel, a sign warns of rockfall. Beside me are smooth, rocky cliffs of sandstone and granite. Next to this, a few alder. I could be staring at an Emily Carr, one larger than any canvas.

Two geese stand atop Siwash Rock like figures crowning a wedding cake. A lone leafy tree tops the rock like a figure with unruly hair. A herring gull watches me pass. Water ricochets on the shore. Up ahead, rocks circle out to the water, ancient Salish fish traps with the smooth sand slope of a hand-built canoe launch that could be four thousand years old. The stones, heavy and round and much like the granite used for V2K installations, were rolled into place in a broad semicircle, a narrow weir gap. I suspect the system still works. High tide brings fish. A net keeps them in. Dropping tide turns the sea into a larder, and wild fish are naturally farmed.

At the base of the Siwash Rock pinnacle, a bronze plaque shares the stone's legend: "An imperishable monument to 'Skalsh the Unselfish,' who was turned into stone by 'Q'uas the Transformer' as a reward for his unselfishness."[77]

Next to this is a small beach with a cover of coarse rock and fine shells. Rock lumps and seams in the cliff to my right look like tree trunks and undulating waves. I pass a brass kilometrage marker. I've seen two now, counting down. Six kilometres. Four kilometres. I continue clockwise around the park, uncertain what my starting point was. For this stretch of park, likely ten.

More cautionary signage: "Slippery surfaces ahead." Another warns, "Don't feed the wildlife." Snowberry and blackberry cling to the cliffs.

The water near shore is glass clear. I'm able to peer through the shallows, make out tiny rocks on the sea floor, as well as ripples of sand, mottled stone, a speckle of barnacles, and a few stubby strands of bull kelp the colour of steeped tea. Looking back, I see red alders gathered close to the shore and a gull standing at one end of the old Salish fish trap.

Just east of here, on a previous walk, I watched dozens of salmon leaping—maybe feeding, maybe ridding themselves of sea lice. They were coho or pink, likely "jacks," male salmon not yet four years old, still thriving in saltwater before heading upriver to spawn.

Away to the north is a perfect horseshoe cloud hanging sideways, neither bad luck nor good, open to interpretation, even manifestation. A yacht putters by, its slow and steep wake slapping the Seawall and shore with a sibilant sound. The Lions are sheepish in the lingering cloud, woolly and just out of sight. I pass under the bridge that bears their name. The water is the same tone as the bridge, a sharp jade. Here I'm able to watch surf scoters dive for a snack, an aquarium show with no bleachers or tickets required.

An odd speckled rock directly offshore gives a nostrilly exhale: a harbour seal, about five metres away, that follows me east. I smile, enjoying the company. Now it dives, disappears. There's a plaque here for the ss *Beaver*, "First Steamship in the Pacific Northwest." Ahead, a squat lighthouse is blinking, while a trawler motors out to the bay.

Two crows scale a rock face, climbers with no rope, where fern dangles from sandstone in a tangle of ivy and vines. Sawdust from fleshly trimmed timber is visible on a high rocky ledge, a residue of lumber and chainsaws in action.

The Lions Gate Bridge is now behind me; ahead, Brockton Point Lighthouse. Farther east are the towering orange cranes of the Port, where CRAB Park at Portside meets the inlet. Between here and there, scalloped beaches. Immediately south are the Stanley Park Totem Poles in a copse, a tall, slender gathering of storytellers and family trees. To the north, more tankers unload and reload.

Offshore, a bronze lounges on rock. This statue has several names: *Girl in a Wetsuit*, *Girl in the Wetsuit*, and, according to a plaque on the walkway, simply *Girl in Wetsuit*. A lifelike piece by Elek Imredy, unveiled

in 1972, it does look as though the woman, a diver, is sitting right there, looking west, watching the narrows and bridge, maybe waiting for that seal to resurface. The plaque also shares a shutterbug hint: "Use a tele-photo lens and focus on the figure then recompose to fill frame." With a sigh, I aim my phone—*click*—and move on.

A float plane curves from Coal Harbour, turning west to split the bridge uprights like a perfect overtime field goal. Rain picks up as I move east and now south, through Lumberman's Arch and a corridor of moss-freckled sycamores. Like various landmarks for meeting around town, here in the park, Lumberman's Arch is a place where countless people have gathered. Its design is simple but clever. The massive lash-ing of timber, now reinforced with steel bolts, resembles a felled tree, which serves as a historical marker as well. For it was here, more or less, that Captain Edward Stamp created his first attempt at a sawmill. The idea was that this location offered easy access to Burrard Inlet, the First Narrows, a seemingly efficient spot for not only raw mate-rial but boat and dock access for shipping. But the tides here are too strong. That, combined with an unpredictable reef, made Stamp's mill plans unfeasible.

He moved his plant farther east, near the site of the modern-day port, but still it didn't succeed. Stories vary. Some claim Stamp lacked business acumen. Other accounts indicate he was impossible to work with, or for. Whatever the reasons, his ventures failed. However, his endeavour did eventually succeed, with others in charge. Hastings Mill opened in 1865; many consider it the seed from which Gastown began, and, as I've learned, our libraries as well.

The Vancouver Aquarium is to my left. Up ahead on my right is the park's rose garden. On a slope facing downtown sits a Robbie Burns bust. Behind that, a statue of Lord Stanley watches the Georgia Street cause-way, his arms spread wide with benevolence, regifting unceded land.

On the point to my left sits the Nine O'Clock Gun, the Naval Museum at HMCS *Discovery*, and a statue of Harry Jerome, the teacher and sprinter from North Vancouver who set seven world records in track and field. Ahead is the Vancouver Rowing Club, here since 1899,

along with its predecessor, the Vancouver Boating Club, established in 1886, when the city changed its name to Vancouver.

A few stumps sit like pier pilings, peppered with woodpecker holes, looking like firing range targets. To the east, half-hidden in mist, is the lump of Burnaby Mountain, SFU on its peak. I return to the north edge of the park, where a perfect sand knoll has been naturally decorated with driftwood, something from a tourist ad. Next to this is a kids' play space and water park. Road bisects the green on a low, pristine stone overpass.

There's a stretch of commemorative benches here for lives in memoriam. One has a bouquet of flowers: red, yellow, mauve. I turn east, another loop in a loop, where the column of the Japanese Canadian War Memorial stands silent and sentinel. Once more past the aquarium, with some ducks in a pond and manicured poplar and laurel.

Now comes a long stretch of maples with lights strung from the branches. Compact bridges cross water, giving a sense of the Sun Yat-Sen Garden, but rather than spartan, this view is bursting with flora, a palette of greens, less yin and yang, more of a jungly abundance.

The BC Hydro Salmon Stream project offers up signage, depictions of spawning and ladders, and I think of those fish I watched leaping through the inlet, wriggles of silver in flight. Taking one more little turn, like the practising driver, I exit the park with a rotating view of Coal Harbour and the convention centre sails beyond.

More rain. I switch from hood to umbrella, passing a stump that could be a crustacean; its limbs look like multikneed legs. Under the causeway, a resident has set up home, a small camp with blankets and groceries. I round Lost Lagoon, bookending that link to the beavers and the Science World dome, and head through the West End, slanting south and receiving a nod from a man in a kilt with an umbrella decorated with Salish art. At the north end of Burrard Bridge, four herons brood in high hemlocks, feathered hands behind backs, silent undertakers scanning False Creek. I work hard to avoid their attention.

**TOP:** Lumberman's Arch in Stanley Park, where Captain Edward Stamp first built a sawmill.
**BOTTOM:** Siwash Rock at Stanley Park, a natural monument to Skalsh the Unselfish.
*Photos by Bill Arnott.*

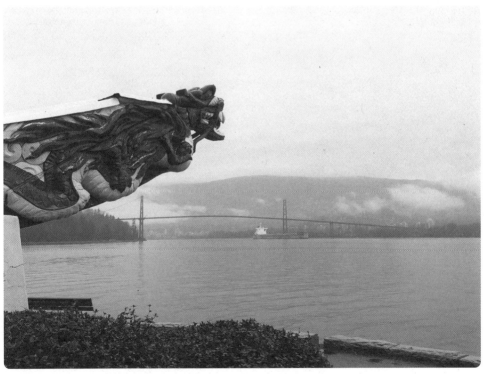

TOP: *Girl in a Wetsuit*, looking north from Stanley Park. BOTTOM: the ss *Empress of Japan*'s figurehead, with the Lions Gate Bridge in the background. *Photos by Bill Arnott.*

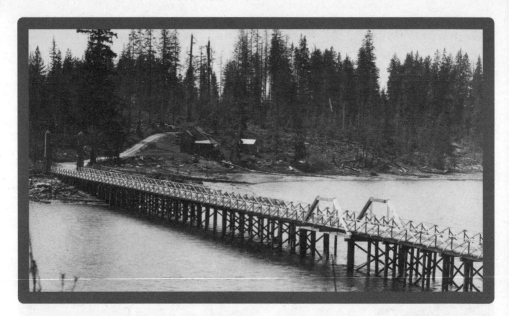

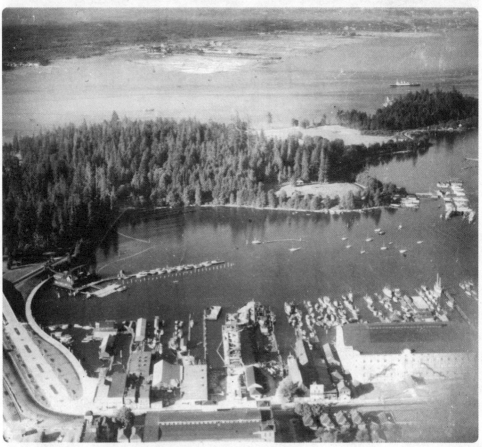

**TOP:** the Coal Harbour to Stanley Park boardwalk, 1889. **BOTTOM:** Coal Harbour and Stanley Park, 1924. *Photos courtesy of City of Vancouver Archives.*

Georgia Street into Stanley Park, 1940. *Photo courtesy of City of Vancouver Archives.*

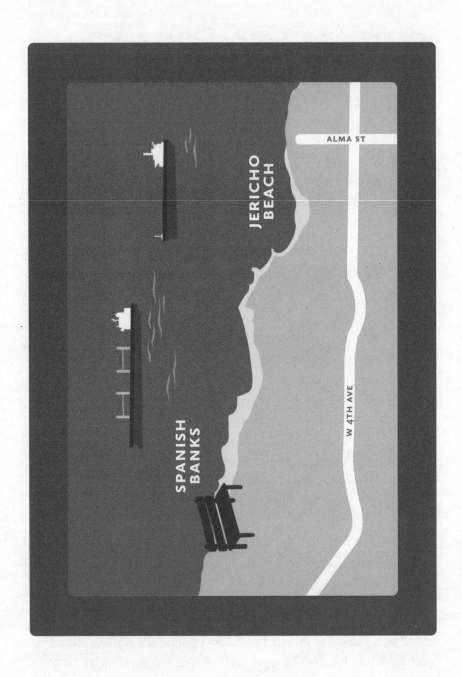

# Jericho Beach and Spanish Banks

*on sea-dusted plaques*
*memories cling to the shore*
*where loved ones live on*

I OPEN A weather app. A question prepopulates: "When should I go for a walk?" Really? I sigh, incapable of *not* clicking the link. An automated reply: "If you don't mind the possibility of rain, you can go for a walk in the morning or early afternoon." Hmm. I'm pretty sure that if you don't mind the possibility of rain, you can go for a walk anytime. Inexplicably, I keep reading. "Please note that weather forecasts are subject to change, so it's always a good idea to check." Glad I didn't pay for the app. I'll stick with eyewitness weather, thanks. And keep checking the flight of the crows.

Outside, it feels like the calendar's flipped a new page to a hint of spring promise. Still chilly, but there's new growth, with blossoms. I'm heading back to the south of False Creek, today bearing west. North of me, English Bay and Burrard Inlet commingle in lustrous blue. The sky is clear, the sun doing its thing. Maybe I'm jumping the seasonal gun, but it feels like a day for the beach. So I follow the water, continuing westward from Kits to a series of north-facing beaches: Jericho, Locarno, and Spanish Banks. En route, a new park is being constructed, with

digging and planting connecting two parks into one. The new swath is an undulation of green truncating the roadway. From above, the park looks like a cello.

A bit farther west, I leave the sidewalk behind, where a long line of sandbags is reinforcing the green space set back from the beach. What do they know about that I don't? Residual snow melt? King tides? I've never seen this much reinforcement. No doubt, it's to shield the homes fronting the water. There's no city signage in sight. Maybe it's a private initiative.

Leaves litter the ground through the parks, connecting the beaches in dollops of treacly sand. Leafless trees reveal their crow's nests, not the kind atop masts but the real ones, latticework sticks in a peep show of avian homes.

Two eagles converse in a high warble chirp, their voices mismatched with their bodies, like giants singing falsetto. A flicker swoops in uptempo, laughing its hyena cackle. And a crow stops flapping midflight, drops in a sinter of black with the look of a leaf falling from a height.

A container ship lumbers into the inlet, its wake a powder-blue curtain. Over the inlet, to the north and the west, sun strikes Lighthouse Park. Evergreens bracket the mountains, crimping the land, where crags are now frosted in snow. The white windmill topping Grouse Mountain is idle. I have a glimpse of the Lions Gate Bridge with its mountains, the Lions, beyond. The paired summits are also known as the Sisters, the Twin Peaks, and *Ch'ich'iyúy Elx̱wiḵn*, the Twin Sisters, in *Sḵwx̱wú7mesh*, or Squamish.[78]

Here at the beach, barkless logs sit in high, tidy rows, backrests for hot, sunny days. A gang of seniors are enjoying some coffee, everyone talking at once. The concession café is closed. The group must've brought their own drinks.

The honk of two geese ricochets. Sand gives a scrunch underfoot. Joggers in shorts are shivering while I'm bundled in layers. Cyclists splash through some puddles. A crow skims the beach, where bunchgrass sprouts from the sand. And a gull is close-hauled to the wind, fixed wing like a sail as it circles the sailing club once, twice, ensuring that I can't miss the metaphor.

From across the street comes a hammer of construction: repairs and new builds. The hum of a Helijet crosses the bay, bearing south. A terrier chases a squirrel, the dog's owner shouting in vain. More bike tires buzz by on gravel.

I cut through the grass, scuff the sand from my soles. Campers and trailers are lining the road. Overnight stays? Permanent residents? I stop for a sit on a bench, one in a very long row, where sand slopes to the water. I glance east. A few crows are flying that way, ahead of the flock, toward a slow blushing sunset with a blistering white moon.

Benches here not only stop me but lure me onward. There are commemorative plaques on the back of each seat, epitaphs and memorials, stories and lifetimes fanned open. I read dates between bookends, birthdates and deaths, some lengthy, some disturbingly brief.

Bob and Don. Brothers, sailors, adventurers. This beach shaped our lives.

Remembering Ken. Look around you. Feel the wind, smell the air. Listen to the birds and watch the sky.

I continue west, same as the sun, now easing downward.

Adrian's bench. This was his hood & favourite spot to skinboard. Missed by many! "It's all about how you treat people in life."

In loving memory of Judy. Happiest in the sun, near the sand and the sea.

At the edge of that final plaque, where *sea* has been etched, the writing is dusted in spindrift, a pinch of salt seasoning.

Next I come to a generous lump of white granite in the spheroid shape of a rugby ball. On it is a plaque cast in bronze commemorating Charles Borden, considered the "grandfather of BC archaeology."[79] Professor emeritus at UBC, Borden's work included extensive salvage excavation of the Great Fraser or Marpole Midden, site of the ancient

Musqueam settlement on what's now the Marpole neighbourhood of South Vancouver, part of that 1929 city expansion.

The Musqueam village, called c̓əsna?əm in the First Nations language-amalgam of hən̓q̓əmin̓əm̓, or Halkomelem, thrived for four thousand years until smallpox eradicated its residents two centuries ago. The Midden was first excavated by settler scientists in the late nineteenth century, but it wasn't until Borden shared his research and cataloguing through the 1950s, '60s, and '70s that the greater populace came to better understand links between artifacts and the culture of present-day Indigenous Peoples.

The placement of Borden's memorial here, on a commemorative seaside, couldn't be more fitting. Century-old cedars stand guard like castle towers, the benches and buttresses of logs like a barbican wall, the ocean a moat. Not a bad resting place, even though Borden's remains are elsewhere. I'm certain he'd value this nod to the past, a historical plot on traditional Coast Salish territory.

I consider a term I've read many times, the notion of "a place off the map"—dreamy, evocative. Only here, I find it could fit. Of course, where I'm standing is noted on countless street guides and atlases, and no doubt a satellite image is currently bouncing to Google with a view of the top of my head. But it was here, just offshore, that George Vancouver met with the wonderfully named Spanish explorers Dionisio Alcalá Galiano and Cayetano Valdés y Flores Bazán for a genteel shipboard meal and to compare mapping and charts, part of the reason this beachfront is called Spanish Banks. Yet rather than thinking of this area being mapped from above or here by the shore, I consider the work of the archaeology team, finding what lies under the surface—a notion that could apply to many of my citywide strolls.

Fittingly, a Spanish quote comes to mind, something I read in a travelogue: *Caminar es atesorar.* "To walk is to gather treasure."[80] So maybe, I don't have to dig after all. That quote was shared by Robert Macfarlane, an author known for exploration and treks, who also stated, "We don't need to walk thirty miles to find things out, six paces will do just as well."[81] If only I'd remembered that closer to home.

Now on a blend of tamped trail and sand, I come to another Biennale exhibit, this one a loose cluster of enormous carved and shaped wood called *Public Furniture | Urban Trees – Vancouver*, the creation of Brazilian artist Hugo França. Outsize furnishings are ingeniously coaxed from the inherent curve in select tree trunks and timber. I imagine them as ideal for those Granville Island *Giants*; it's but a stroll to here if those behemoths ever need to take a load off. França's preferred medium is reusing natural material, most frequently salvaged and fallen trees, to create newly envisioned sculptures, in this case, enormous functional furniture, which I see as a humanist spin on nurse logs and the natural decay of totemic poles—things that began as one thing repurposed into something new. Artistic rebeautification.

I recall the work of Chris Booth, whose art I first saw south of here in VanDusen Botanical Garden. Booth uses chunks of felled timber and rock to create innovative showpiece designs, raw material like construction toys dumped on the earth, if those building blocks were great shards of stone and wood slabs, reconstructed and styled into wordless visual poems. Landscape artistry is the only way to describe it. Not the architectural imprint found in classical Asian gardens, but rather a bottom-up approach to re-engineer treed scrubland into inviting, attractive, and useable space. If only a couple of artists like this had had a go at those pockets of forest downtown that were burned, beginning the Great Fire, I wonder how many of those first township buildings might still be standing.

"Sustainable design" is a term used to describe work like this. Here, França also used tree roots and trunks that drifted ashore, grandiose beachcombing in water-and-land mixed media. An adjacent Biennale descriptor adds this:

> França's process of working respects the natural features of the wood, promoting minimum waste. It also brings to light the beauty of the natural organic forms, lines, holes and cracks of the trees. Their memory remains alive with their uniqueness, being offered back to live together with people in a harmonious way.[82]

At the moment, most of the art is unoccupied, but one gargantuan piece holds a small woman seated in the lotus position, eyes closed, face to the sky. The carving she sits in could pass for an enormous roughly shaped burl, this one the shape of a retro-style hand chair, with the palm as the seat and the fingers the backrest, all of which make her look minuscule, in a fairy-tale framing, a heroine in the hand of a giant.

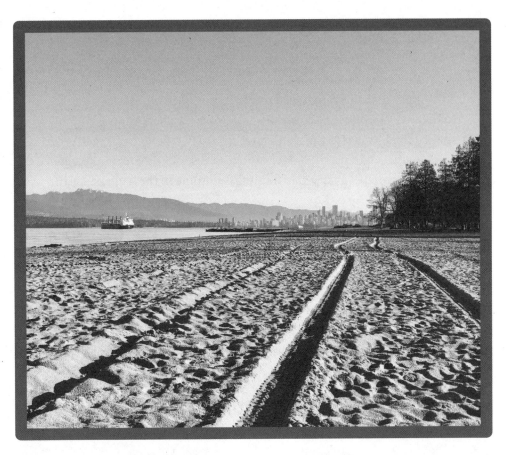

**CLOCKWISE FROM TOP:** a quiet day on Jericho Beach, looking east; Jericho Beach, looking west, with tankers anchored in the distance; Locarno Beach, looking east. *Photos by Bill Arnott.*

**TOP:** a commemorative bench at Spanish Banks. *Photo by Bill Arnott.* **BOTTOM:** before CAA, a car stuck on West 4th Avenue, southeast of Jericho Beach, 1910. *Photo courtesy of City of Vancouver Archives.*

# Forest Art

*footfalls in forest*
*mimic brush strokes on canvas*
*a path is revealed*

TODAY COULD BE a mystery. Morning mist shrouds the city. The highest buildings peer through low cloud, crenellating downtown. From a diner in Kits, I see nothing but chalk white and blurred buildings, a myopic view. By squinting through beech, I can make out a window. Two, in fact: one of glass, fronting a unit that once was my home; the second, not glass, but a glimpse into the past, neither transparent nor fully opaque.

The fog brings its own mood, matching the blur of the windows. It hauls me forward, outside, leaving the diner behind. A snap of breeze on the inlet, a spray of spindrift on shore, where I long for a boat, but land underfoot draws me on, momentum churning in thought.

A chevron of ducks flies high overhead. On a smooth slick of water, a pool creates a meniscus-like bulge, maybe a current or a submerged rock. The inlet now mirrors the birds in a *V*. Misty sun makes a cameo, reflecting onto steel, welder pinpricks and flashes of gilt. Parents and children walk toward schools. Joggers puff by. Crows caw in some maples, the hum tranquil, peaceful in the morning-time rush.

Scant precipitation moistens my face, more a notion than actual rain. I cinch my coat, my pace matching the sound of the surf. A crow flies so close I can feel it, the same shush as the waves. I'm not being buzzed; I'm just in the way. The bird alights in a willow, and the branch droops, suggesting a tightrope performance.

A fresh gust throws spume as I round a small bight in the bay. Over granite-grey water, Stanley Park pushes seaward, an evergreen prow smashing breakers. In this mist, the deciduous trees have a soft glint of amber and garnet. With evergreens and a sapphire churned sea, the vista has the look of an heirloom, a faceted family ring. Beyond the bow of the park, gusts shred dark clouds into tatters. In increasing wind, I tilt forward, take on an italicized lean.

Soft earth underfoot turns to trail, the park that I'm in framed by water. The inlet, the bay, push inland. Stanley Park is no longer an island, which it was for millennia, a tidal causeway transforming the last lump of peninsula into a twice-daily untethered landmass, a vessel of timber and rock. From a distance, the semi-island resembles a slow swimming turtle, a green lump on the blue. Low tide still reveals oysters and clams, mussels as well, clinging to igneous rock. But the turtle-shell profile is, to a degree, fabricated by a hundred years of arboriculture, giving the skyline a trim (back and sides, if you please).

More than horticultural health and reducing the risk of deadfalls, this tree work is allegedly largely cosmetic, pleasing to the eye, particularly for those with a view from prime real estate. Legend has it that when Captain Vancouver arrived, sailing his hundred-foot sloop, the local Coast Salish launched their dugout canoes, and in a peaceful greeting, feathers were thrown on the breeze, the plumage of seagulls and crows a monochrome welcome.

A new day. Today I'm in a forest, a bit farther west from my previous walks. Once again I have the sensation of walking through Emily Carr paintings, timber in sun-streaked garth greens, olive, tea leaf, and pea, with cedary leather-brown strips the texture of seed pods and cones.

There may be a path but no trail, just a song line, space to be found between trees.

Clouds shift in the distance like jellyfish pulsing on blueness. I pass potted plants where bees dance in geraniums and lilacs. A patch of clover is fragrant with puffy white blooms. A dog barks. There's a trace of a siren from a long way away. Through bushes of thick rhododendron poke a few flowers in purple and blue. A gust shifts a nearby wind chime handmade from driftwood, its song melancholy, a call to sharing or to prayer.

This feeling of connection's what I sense when I gaze at the actual artwork of Carr, which is frequently featured at the Vancouver Art Gallery, the former courthouse and north end of Erickson's concrete. Born in 1871, Carr's best known for her paintings of trees like those decorating Stanley Park, that turtle of temperate rainforest. Her inspiration, most often, was Indigenous culture. But the stylized, borderline abstract pieces capturing totems in trees, melding places and times, became her signature style: brush strokes akin to the movement of branches; tones of timber and terrain; depictions of landscape, history in topography, sentiment in texture and feel. I've spent many hours among her exhibits. And each step on a forested trail has the feel of *living* her work and her vision, an easel propped in salal, a few rays of sun as companions.

I recall four half days spent tramping the undulations of the Baden Powell Trail across North and West Vancouver, as though I completed that final leap through her lens, visuals daubed onto canvas. It was the closest I've ever been to a bear, a lumbering beast smashing through undergrowth. It was a black bear, so unlikely deadly, but it was the first time I felt intense, jagged, raw fear, something so deeply seated and primal that it was a rush both foreign and frighteningly familiar. *Big* was the only thought I could muster, hearing the snap of tree limbs increasing and nearing. And doing oddly precise math, knowing my speed could never exceed that of what was approaching. But as the perceived danger passed and my defensive wavering singing subsided, the exhilaration that coursed through my body was, for me, unparalleled. And I understood, somewhat, the allure of extreme, adrenalin-fuelled activities. Mind you, once was enough.

The next time I felt inextricably linked to Carr was during a trek across Haida Gwaii through old growth and raven conspiracies, where some of her most impactful work was completed, starting in 1912. I was there a century later, at the pebbled shore of Louise Island and the village of K'uuna Llnagaay. As I scrambled on scree, I spotted the place I'd seen on a canvas. The alders had grown leafy and tall, but the cliff by the sea was the same. I had an intense feeling of returning to a place I'd never been. Yet I *knew* that space. Another tending toward home. The tree growth and passage of time became meaningless, a concise line in a song.

Leaving the mortuary poles and totems of K'uuna Llnagaay, I could hear the voice of that carver: "Maybe it stands for one year. Maybe one thousand. That's not for us to decide." An echo of that erosion, stories melting in bark mulch. From that island of ghosts, I took a motorized RHIB, then a car, then I hiked, to a place called the Edge of the World: a curved finger of beach, beckoning beyond that invisible wall I once sailed to.

There on the beach at the Edge of the World is where the Haida Creation Story is set, where Raven coaxed humans from a huge shore-line clam, captured in a yellow cedar slab designed by Bill Reid called *Raven and the First Men*. But this story has no ellipsis. Something I love about the carving, now at UBC's Museum of Anthropology, is that cracks in the wood continue to open and to heal. Cultural art lives on and breathes, sharing a story of timelessness.

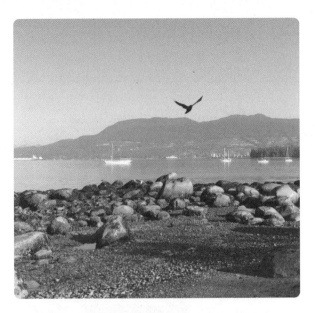

**CLOCKWISE FROM TOP:** a crow takes flight at Kits Beach; an art drop: a painted-rock ladybug among maple leaves. *Photos by Bill Arnott.* A fire engine responding along West 2nd Avenue, 1910; a Douglas fir, midcut, 1919. *Photos courtesy of City of Vancouver Archives.*

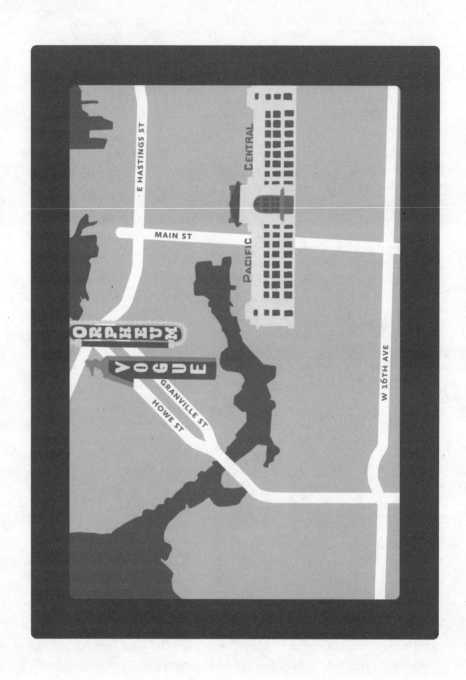

# Granville, Main, and Murals

*portrayals in paint*
*wrapping walls, hugging hoarding*
*in blurs of space-time*

I'M MAKING MY way to the Downtown Eastside. The crows seem to already be where they're going. The sky's mostly clear, with a few cirrus wisps, while dark clouds hug the south a safe distance away. As I cross Burrard Bridge, heading north, sun strikes the railings abutting the walkway, creating a horizontal strip of light, the look of interior illumination, the reflection warm and inviting. Scanning the Sen̓áḵw building site, gone is the yawning pit excavation I saw a short time ago; now construction is already above the height of the bridge deck. Past the goliath of Burrard Place, I admire the twist of Vancouver House, now catching the sun on three sides.

At Burrard and Nelson is the grey stonework of two churches: St. Andrew's-Wesley United to the south, and First Baptist to the north, now with a towering column of condos and a high exterior arch nesting the venerable church in what looks like a new Gothic nave. Along the streetscape are black-and-white photos from the past hundred years, an outsize pixelation with a few spray-painted tags. The shots capture not only the building but this stretch of road in a concise pictorial

storyboard, as though time capsules have been opened, examined, and left for the next wave of archivists.

Here's the hustle of commuters on foot, scooters, and bikes, all of us finding our trails, timing traffic lights, the chirp of a crosswalk signal, and skirting sidewalk closures and construction. The waft of a garbage truck pairs with a sharp honk as it threads through an alley. Glints of sun strike the glass at VPL Central Branch, as though the place radiates knowledge. Across the street is a playhouse and another urban church in revamped architecture. Bearing east, the Sun Tower has lost some of its restorative wrap, renos nearing completion, as though it's removing its scarf as the weather improves.

By Hastings and Main, I settle in at a diner built in 1942, with a long counter and round stools fixed into place. Half the space is fitted with tight wooden booths with rigid backs, like a vintage train station canteen. Once again I'm transported to that second Hotel Vancouver, AR dropping me into the past, only here I'm not watching a screen. Here the voices and people are real, the food hot and tasty. Not 1940s pricing, mind you, but still excellent value.

Sufficiently fuelled, I set out on an improvised neighbourhood quest, today to plot murals from various Vancouver Mural Festivals, artistic initiatives that occur in conjunction with special events across the city, the re-creation of which I spotted on Granville Island. I've downloaded another app, this one with an interactive map, and am working my way through familiar areas, only now I have pinpoints to guide me. But it doesn't take long to realize that most of what I'm looking for is gone, many of the outdoor paintings being transient—some by intention, others not, simply the by-product of real estate turnover. One of these is *East Van Pigeon*, a painting on brick by Haida artist Corey Bulpitt. On my phone I can see it, like those photos of the church from the past: white on two shades of charcoal, with one brilliant orange eye, as the bird was painted in profile. The design is distinctly Coast Salish.

From the artist's statement:

I created the east van pigeon for the urban people. It is my way of linking our traditional crest system using modern mediums (spray

paint) and the pigeon which is seen as a symbol of the urban environment. I believe it will be a mural that people in the community can connect with due to the link of modern and traditional and for the iconic imagery.[83]

I read this with an echo, as the piece is no longer here. I'm staring instead at another levelled lot with a crane and the seeds of construction. What resonates is the intention of the artist, an aspiration to link the traditional with the modern. In this case, *modern* surpasses the visual symbol itself, yet tradition remains, something more lasting than spray paint on brick. And on cue, so it seems, a few pigeons take flight, snapping their wings in a burst of applause.

The next piece I find has suffered a similar fate, but it continues to live in new form. *The Healing Quilt* covered the side of a ten-storey mid-rise. Considered a giant mural, it was a collaboration by Sharifah Marsden, Jerry Whitehead, and Corey Larocque. The artwork was vibrant: navy and turquoise, red, yellow, and orange. Topping the piece was a thunderbird, while the central design was that of a star blanket.

Recognized by many Indigenous Nations, a star blanket is a traditional quilt whose design features a radiating star, representing not only a rising celestial body associated with morning but also the eye of the Creator. The whole indicates a commemoration of the recipient, with both the physical coverage of a blanket and spiritual shelter, being holistically ensconced by higher powers. In other words, star blankets keep us connected, protected, and safe. I find a description of the piece:

The Star Blanket Mural is a co-creation between many artists and organizations working in communities affected by the Fentanyl Overdose crisis. The mural is both a memorial to those who have died during the ongoing crisis and a big beautiful bright gift for the folks who call the streets home.[84]

Once again, I'm frustrated to find the building no longer standing, the mural now gone—although not entirely. In this case, a new team has reinvented the piece, its significance here in the neighbourhood

too great to let disappear. What I see now is a horizontal version of that imagery, landscape in lieu of portrait, like the bright band of sun on the bridge that lit my way here. The restoration of *The Healing Quilt* is now close to the ground, two storeys high, and wraps wooden hoarding that surrounds the construction site, an actual blanket of sorts. The building will be part of a housing development. Again, positive strides. The art redesign is the work of the Vancouver Chinatown Foundation in conjunction with another wave of proactive artists. According to the installation team, the new graphic allows for the continuity of the original mural, reaffirming the community memorial to those who have died during the ongoing fentanyl overdose crisis. In addition to the narrative, the visual is compelling, a reallocation of components, quilting squares no longer in columns but in rows, somehow less on display while more interactive, as though the artwork, the message, remains achingly close, both shared and intimately personal.

~

Following Main Street, I'm treating this thoroughfare not only as trail and a guide but a natural border as well, the east edge of my wandering ways. I'd gotten together with fellow writer and friend Nick Marino, author of *East Side Story*, near here. We realized with a chuckle that we were effectively on an east-west dividing line—his recent memoir focuses on the city's eastern expanse, while I am walking my way through its western reaches—as though we'd inadvertently established authorly "turf." I felt obligated to make a finger-snapping Sharks and Jets reference, and I suspect Nick was fighting the urge to burst into song.

I circle back to the off-kilter mesh of Alexander, Powell, Water, and Carrall Streets known as Maple Tree Square, another one of those city-township intersections, acute angles meeting obtuse, a wedge plugged with a flatiron building. Signage now hangs in tree branches with words in a decorative font: "Engage, Peace, Love." Sentiments hanging as ornamental reminders.

I stand on a small rise of red sidewalk brick the size and shape of a pitcher's mound. This modest lump previously supported a statue

of John "Gassy Jack" Deighton, a life-sized sculpture in copper. Some consider this the birthplace of the city, former site of Deighton's pub, the Globe Saloon, constructed in 1867 to serve railway and mill workers along with new township residents. But in 2022, the statue was hauled down in a protest shedding light on the fact that Deighton played a role in atrocities committed against Indigenous people. And I take a moment to absorb the words dangling from those branches, the script a hint of reconciliatory healing.

I return to Main and head south. Next stop, Hogan's Alley. Or rather, what was Hogan's Alley. Here, a Heritage Foundation plaque shares a slice of the story:

> Hogan's Alley was part of the ethnically diverse East End, centred between Prior and Union and Main and Jackson. It was home to much of Vancouver's Black community and included businesses such as Vie's Chicken and Steak House on Union and the Pullman Porters' Club on Main. The neighbourhood was a popular cultural hub before mid-twentieth century urban renewal schemes and the Georgia Viaduct Replacement Project demolished many of its buildings.

In this, I read the same layers as the alluded-to civic plans to destroy Chinatown. Where I am is Strathcona, considered the city's oldest neighbourhood. If I were to sift through boxes of James Matthews's dust-covered records, I'd find jotted notes, the archivist deducing that the micro neighbourhood of Hogan's Alley was established and thriving by 1914, the same time the *Komagata Maru* was trying to dock in Burrard Inlet.

This early part of the city became its own cultural centre, drawing Black immigrants from America in the late 1850s, not unlike the draft dodgers protesting the Vietnam War conflict who came here around the Summer of Love. The mid-nineteenth century influx happened mostly in 1858, as African Americans moved north from California, fleeing freshly inked anti-Black legislation. While many new arrivals went to Salt Spring Island and Victoria, a large percentage moved here, settling along Main Street with its straddle of side streets and laneways, making

it likely that by the time Matthews was scribbling in margins, Hogan's Alley was already fifty years old. Many of these immigrants, however, arrived from the east, getting here via rail, as the trains employed many Black workers as porters on passenger lines. Like each neighbourhood I've walked through—Chinatown, Japantown, Hogan's Alley—not only did culture contribute to the creation of community nuclei, but discrimination too drew clear lines onto regional boundaries.

Eateries and speakeasies became de facto community hubs, not unlike the current Carnegie Centre, seen as the DTES's living room. One of these was Vie's Chicken and Steak House, on the corner of Main and Union. In much the same way Dal Richards's ballroom was the place to be atop the Hotel Vancouver, so too was Vie's in this part of town. Owned and run by Vie and Bob Moore for thirty years, it was a place where anyone and everyone was made welcome. What made headlines, however, were the celebrities who came through for a meal and to socialize: Louis Armstrong, Mitzi Gaynor, Sammy Davis Jr., Cab Calloway, Lena Horne. As though people came *here* for the after-party following a night at the Cotton Club. The restaurant would open for business at five p.m. and stay open until five a.m. There was no liquor licence, but mixers and ice were on offer for BYO patrons. Meals included steaks, roast chicken, buttermilk biscuits and salad, sautéed mushrooms and onions, with fries, most of it plated in single servings.

Vie herself was a heritage snapshot, born on Salt Spring Island, her parents among the early American emigrants. I've read stories of the restaurant, of Vie employing only women and treating her staff as friends. To round out the musical lineage of her establishment, records indicate that Vie's dishwasher was Nora Hendrix, grandma to Jimi, the left-handed boy who tired of violin lessons and switched to guitar, which he turned upside down, in every sense of the word. A neat link to those future airwaves TDM would spin from that airy building across town.

Farther south along Main, I pass under the Dunsmuir and Georgia Street Viaducts, those bits of concrete and roadway that didn't get thwarted, that did displace residents. And yet a few unhoused locals have made it a home once again: tarps, tents, umbrellas, and fabric

shelters, no doubt where houses once stood next to places of business. It's an easy stroll to Vie's for a platter of food or perhaps a celebrity sighting and a story to share with friends.

But there's no need to rely solely on imagination; I reopen *Circa 1948*, my time-portal app. This time, I parachute here, drifting toward Vie's. A blast of music plays, what could be the opening riff of a Louis Armstrong cornet solo, as I find myself here in the night. Through the AR, I'm walking an alleyway, light seeping from windows. A dog barks. I turn a few corners, past backyards with vegetable plots and laundry on lines. I overhear conversation. Two women are discussing sex work—contraceptives, allusions to opium, personal safety as well. At another back door, a cop questions a man with a small liquor still. A bribe changes hands, along with information—concern over other distillers, lethal liquor, and questionable purity. I imagine *The Healing Quilt*, think how bathtub gin was at times a forerunner to fentanyl.

Pulling myself to the present, I keep moving south. On either side of the street is a scatter of hostels and down-at-heel hotels. I read a sign on the door of the American Hotel: "Please, don't be a dick, thanks." Fair enough, I can try.

There are a few newer storefronts among the forlorn, indications of patience and optimism. Directly east is Pacific Central Station, the former CN terminus, a short walk to each iteration of those railway hotels along Georgia. Originally it was called False Creek Station, and the water extended to here, though the marshy shore was eventually filled in and built on, not unlike the area by the Marine Building, where the giant globe spins and *The Drop* forecasts rain. Now the station is a heritage building; it still looks as though a steamer like Engine 374 could chug in at any moment.

I enter the multi-use station—rental cars, taxis, buses, and trains—for a snack and a touch of nostalgia. It was here that I recreated one of those trips, a version of what those first westbound engines accomplished. Boarding a VIA Rail train in Winnipeg, I spent the next two days getting home. The sleeper cabin felt like posh camping: fold-out bed, fold-out sink, fold-out toilet. Not quite the same view as those Hadden Beach dogs, but it did provide a pleasant shimmy to the business at hand.

Beside the old station, a new glassy building is being constructed to house the relocated St. Paul's Hospital. I wonder when Pacific Central might resemble that second Hotel Vancouver, mid-1940s, a refuge for people in long-term transition. And I'm reminded of that odd block of buildings on Hornby comprising government offices, high-end residential homes, social assistance agencies, and makeshift accommodation for unhoused people. The reality, perhaps, of Erickson's vision in concrete; in theory it should all jigsaw seamlessly, the outlook ideal, yet in practice, there's a long way to go.

Sauntering south, I bisect a transition of neighbourhoods, Strathcona to Mount Pleasant, another angle of old township and rail at Kingsway and Main, a Y junction for traffic. But in lieu of a tall flatiron, the triangled structure is a cozy glass coffee shop. It's decorated with an Indigenous art mural in teal, red, and black called *Travellers in the Space Canoe*, by Bracken Hanuse Corlett.[85] From an artist statement, I glean a deeper understanding of what's on display. It's a depiction of ancestral icons—the Skipper, the Trickster, the Hunter, and the Dancer—all travelling toward the unknown. Elements form one whole, the result a transcendence of space and time. In two dimensions, I feel I've found mythic companions, without an app or AR. Here the narrative being threaded through culture spans two storeys of colourful paint.

By the triangular street intersection sits a steel installation. A vertical plaque lets me know this is Gertrude Guerin Plaza.[86]

Chief, politician, community advocate, fierce protector of First Nations people and culture, Gertrude Guerin was a Squamish woman who married Victor Guerin, a Musqueam man. She became one of the first Indigenous women elected as Chief in Canada and was a founder of both the Native Education Centre and the Aboriginal Friendship Centre.

Ahead to my right, at Main and Broadway, is the tall brickwork Lee Building, completed in 1911, the same time James Matthews was unpacking in Kits, wondering where to store all his stuff. It's another

time warp but in two tones of brick, the colours of beachside and desert. A blue plaque offers more:

> Merchant Herbert Lee erected Mount Pleasant's tallest building in 1911 on the site of his former grocery store, soon after 9th Avenue became Broadway and Westminster Avenue became Main Street. The Lee family lived on its top floor until they lost ownership of it during the Great Depression. Like the Quebec Manor apartments at 7th and Quebec, the Lee Building demonstrates the optimism of Mount Pleasant's developers a century ago.

Even now, with Broadway temporarily disembowelled, awaiting the installation of a subway, the Lee Building looks hopeful. Futuristic optimism, even at a century old, is mortared in brick, with a string of banners on lampposts: "Mount Pleasant, Since 1888."

A bit south, a vast mural hugs the west side of Main. This one is in parallel panels, depicting two individuals: Paisley, a young Salish woman, and Bob, a grey-haired optometrist, both of them Mount Pleasant residents, bookends of generation and lineage. Entitled *The Present Is a Gift*, it's the creation of Jay Senetchko and Drew Young, Young also being a VMF curator. The two describe their work in its simplest terms, downplaying the depth of expression and colour: "*The Present Is a Gift* is a play on words to bring awareness to the present moment; to live in the now."[87] It's as though I've found another two guides; the work grasps the ambiguous nature of time and place while planting the "right here and now" in a slather of paint, an unbranded neighbourhood flag.

Backtracking, I make another chess-like move, two blocks north and one east, to a green clapboard building known as the Western Front. Not a war memorial, but a studio and a refuge for artists. There's a Heritage Foundation plaque to tell me more:

> The Western Front was founded in 1973 by eight artists who wanted to create a space for the exploration and creation of new art forms. It quickly became a centre for poets, dancers, musicians and visual artists interested in exploration and interdisciplinary practices. The

building, which dates from 1922, was originally a Knights of Pythias Hall. The Western Front continues to be an active force in Vancouver's cultural community and one of Canada's leading artist-run centres for contemporary art and new music.

I imagine the building's completion in 1922, the last nails hammered, fresh paint applied, while across town a few thousand people were paying their respects to Joe Fortes. Aptly enough, this modest three-storey building was funded by the service organization whose motto is "Friendship, Charity and Benevolence," words that could well have been spoken as part of Joe's service.

The building itself is understated yet evocative, a space that hints at an uncertain reality. I find a quote from Hank Bull, a multimedia artist best known for painting, photography, sculpture, and music who apparently still lives here. Says Bull, "You feel a sense this is an unusual building, it's a little mysterious, it's a little bit dark. There are a lot of doorways and where do they lead? It's got a kind of magic that's very interesting and can be intimidating but also can be beguiling."[88] Of course I want to go in, take a peek, maybe mooch some tea and read the leaves. But instead I walk on.

⌐

I circle back to downtown and loop Maple Tree Square, let it serve as third base, which I'm rounding for home. Past the gnarled silver maple by the lumpy brick mound to the steam clock. A left and a right to Gaoler's Mews and Trounce Alley, whose nickname is Blood Alley. Why, no one seems certain, but the mystery lingers. Past the angel and soldier, the third CPR building, now Waterfront Station. Up some stairs to the north side of Canada Place, where the Heritage Horns are silent, for now, with a glimpse of the Port to the east. Mountains stare from the opposite shore, while in front of me looms what was the Pacific Press, home to the *Vancouver Sun* and *The Province*, all newspaper signage now gone. The building could pass for the world's biggest set for a reboot of *Hollywood Squares*. It's somewhat Orwellian too.

Turning, I head south along Granville, treating this as a touchstone, the old city moniker, the trolley line, an invisible handhold or guy wire. Past Sinclair Centre, posing for its close-up, the handsome Edwardian baroque building anchoring Hastings and Granville. I take a photo of its copper-domed clock tower, its weather vane hinting at southerlies. The clock is a monster, with the largest internal workings, or movement, in Western Canada, its dimensions comparable to *Gate to the Northwest Passage*, the gigantic steel square strolling through Vanier Park.

I imagine an electric trolley car making the turn, veering from Hastings to Granville, its direction the same as my own. Kitty-corner from the big Sinclair clock are the Parthenon-like columns of Birks, with its own modest clock at the corner, another popular meeting locale. Although it's been moved a few times, the slim clock has been here for a century.

Continuing south, I'm at the CF Pacific Centre mall, retail and offices stretching for blocks underground. The Hudson's Bay Company (HBC) building stands to my left, its Corinthian-style columns in tan terra-cotta. An HBC store has stood here since 1893. What I'm looking at now was constructed in stages, from 1914 through to the 1920s. And I can't help but think of that beaver I saw on False Creek.

I head through the pedestrian crush of Georgia and Granville, now pillared in financial towers. The Hotel Vancouver is away to my right, whispering memories of predecessors and altered reality. Next is the Vancouver Block building, with its own looming clock overhead. In a previous life, I made deliveries to an office next door on a high floor, its panel windows facing this clock, and from inside the office the enormous clock face was all you could see, glaring through broad banks of glass. So of course I would ask people in the office to tell me the time.

I cross Robson Street. To my left is BC Place with its Terry Fox statues. On my right is the pedestrian throughway, a glimmer of *Canopy*'s lights, with Erickson's concrete law courts and art gallery. More vintage brick as I keep moving south, low- and mid-rise construction. Ahead are signs for the Orpheum and the Vogue Theatre, this being the city's neon heart, with more fluorescent signage installed here in the 1950s than anywhere else in the world.[89] Twenty years later, civic ordinance

eradicated much of the signage, but an absence of street lamps made this thoroughfare overly dark. Now a balance seems to have been struck; soft neon aids the street lamps through the dim of nighttime, rainfall, and winter. On the east side of the street is the Commodore Ballroom, its second-storey facade in checkerboard salmon brick. On a plaque, I read this:

> Built by the Reifel family and designed by architect H.H. Gillingham, the Commodore Ballroom has been a focal point for music and entertainment on Granville Street since it opened in 1930. From 1969, showman Drew Burns managed the Commodore and, over the next 25 years, worked with local promoters to attract countless legendary bands and musicians, turning the venue into an important stop for touring acts, as well as a home to some of Vancouver's favourite local performers.
>
> With its storied dance floor and Art Deco inspired interiors, the club has been recognized as one of North America's most influential music venues.

A pivotal piece of Vancouver's music scene, its impact still surpasses its modest vertical profile. Accommodating a thousand concertgoers, the ballroom has seen countless acts come through. I remember seeing April Wine here; the Marshall-stack amps left me deaf for two days. What made me laugh was the fact that the queue to get in went forever, but the line for the men's room was longer. Fans with minimal hearing but an abundance of prostate.

A delta wing of geese passes over, as a man digs a fervent but minuscule ditch in the crack of the sidewalk, the slender oblong hole now a tiny archaeological dig. I suspect he's looking for pipe remnants, but maybe my interpretation is hasty. Maybe there's something there I can't see. This gritty man could well be an alternate Charles Borden, but without university funding or a plaque set on granite.

There's a tangle of clothes in a tree's upper branches, apparently tossed from a high apartment. I thought that only happened in movies.

I overhear a conversation as a couple walks by.

"So, my dad called. Said he was dying. Put on his suit, lay on the bed, and passed away. Saves us having to dress him, I guess."

I consider suggesting a poetry class and giving them Evelyn Lau's info.

On Granville Street Bridge, I pass students flowing into University Canada West, a structure with its own glassy flatiron wedge tucked between on-ramps. Beneath where I am is the outsize *Spinning Chandelier* by local artist Rodney Graham, adding glitz to the underside of the bridge.[90] Midway across the span, a maple leaf seems to accompany me, twirling on updrafts and dervishing south.

I double-check my heritage facts and find this:

The current Granville Bridge opened in 1954. It is the third crossing of False Creek at Granville Street, replacing a 1909 bridge that itself replaced an 1889 bridge ... By the 1870s, settlers had established sawmills and logging roads on either side of False Creek, however the south shore remained densely forested and little developed, until Lauchlan Hamilton set up camp in 1885 to begin surveying the land for development.[91]

I stop on the bridge's western side and take in the vista. Beneath me is the coming and going of ferries, Granville Island with its market, studios, shopping, and restaurants. English Bay at the mouth of False Creek is now under sunshine. Tankers on the bay in red, northern mountains in blues, with a pincer of forested greens: UBC slightly south, Stanley Park slightly north. Turning east, I trace the jog of the inlet, curving toward Science World, behind it the old CN station.

I was here a few days ago too, heading downtown on my way to meet friends, going north on the bridge. It was sunset, heavily overcast, raining, and I happened to be at this spot, halfway over the bridge, when the crows made their afternoon pilgrimage, flying away from the sun despite its being hidden in cloud. The sky was cast iron, but the rain started to ease, when a voluminous rainbow took shape, covering the city in a full, vibrant band, from the West End over the bridges—Burrard, Granville, Cambie. The peak of its dome was where

I stood, as it plotted its path toward gold, I presume, somewhere just south of Mount Pleasant. The crows flew under the rainbow, directly over my head, a feathered scatter of night coming on.

Then a trunk rumbled by and struck a puddle, dousing me in a great wall of water. *Fwoosh!* As though I'd been dropped into a dunk tank, saturated. And I laughed. What else could I do? If not for the wonder on display, I might've felt different. But that moment, that day, reaffirmed my love for the city. A scene too easily missed. I kept watching as the crows slowly thinned, the rainbow fading as well. And I carried on, squelching my way into town, where I'd drip for a solid half-hour, still content, and still smiling.

Picking up where I was, southbound on Granville, an unnamed mural adorns a ramp pillar. The scene: a family peering through a window, their backs to the viewer. Gazing at the piece, I see the view as well as the family admiring the same outlook, a visual set of nesting dolls.

Continuing along Granville, I pass more buildings with murals, of eagles and bears poised midhunt. Beyond this are galleries with historical and contemporary art, along with restaurants, retail, and a few papered windows, more real estate awaiting redevelopment. At the corner of West 7th, I find a historical plaque describing South Granville:

> The southern slope was popular as a business and residential street. Early businesses on the slope included the Valley Dairy on the west side ... and the Roxy "Moving Pictures" Theatre on the east side of the street.

A convenient stop, I suppose, for fresh milk and jittery movies with captions. In 1911, when the theatre first opened, new releases were *Dante's Inferno* and *Pinocchio*. Everything then was black and white. Now all I see is bright colour. On one building, a painting of salmon on a background of aquamarine, four fish the colour of each season.

Nearby is a community garden with a hundred planters. In the loam are the rainbow remnants of chard.

At Broadway and Granville, a high new build is redefining the throughway east-west and north-south. *X* marks the spot to what's on the horizon: plans for a transit and real estate hub.

The breeze picks up with fresh rain, and my umbrella is now useless. I fold it away, facing the wet and the wind, past the neon of the "Risty" sign and another historical plaque, this one from the neighbourhood BIA, describing the "restrained streamlined Art Moderne style" of the building that preceded what I see now, a late-1930s development in which

> the best known tenant was the Aristocratic, one of a chain of elegant and affordable coffee shops which first appeared on Vancouver streets in 1932. The Broadway location was the last remaining restaurant in the chain and when it closed, its famous top-hatted, monocled mascot "Risty" was moved to the Vancouver Museum for preservation.[92]

But a likeness of Risty is still here, tipping his hat to pedestrians.

Farther south, I pass the Stanley Industrial Alliance Stage (commonly known as the Stanley Theatre). Opened in 1930 for movies, it now serves as a stage for live concerts and plays. Its signage in white lights, brickwork, and small rooftop cupola still resonate with the feel of mid-twentieth-century marquee events, and it's now a heritage building. Two "Stanley" signs in red neon face north and south at slight angles. At the moment, the southerly sign is only half lit, shining "Stan," less formal than its northerly twin.

At 13th, a side street is severed into a park with sitting areas, art installations, and an exterior wall in a grey-and-white mural, now reflecting the sky. Someone has dropped a purple glove on the concrete. Remarkably, the index finger is pointing in the direction I'm walking, as though reaffirming my direction.

I stop for another V2K installation, the legend of Bob Brown and Athletic Park, what's now the on-ramp I passed getting here. Brown bought the land, cleared it, and laid out a sports field with wooden

bleachers for six thousand fans. The sign shares the story of when the stadium seating caught fire in the middle of a soccer game. Attendees stepped back as the bleachers burned to the ground. Firefighters hosed it all down, and the match resumed, the spectators then standing on the smouldering ash at ground level, with kids in the front for best viewing. Despite surviving two similar fires in 1926 and 1940, Athletic Park was most famous for being Canada's first sports ground with floodlights, allowing for nighttime games. Eventually it would be replaced by Nat Bailey Stadium, part of Riley Park in the neighbourhood of Little Mountain.

To my left is another cross-street transformed into a park, this one with columnar murals, giving a freestanding Grecian feel. Signage explains that what I'm looking at is a leftover Lunar New Year celebration; each chubby column depicts a red paper lantern.

Strong scents from delis and fast food restaurants mix with passing exhaust. An aroma of rain clings as well, a white-noise susurration. I reach the old city township and railway boundary of 16th Avenue, where two shop fronts read "Turnabout." So I do. I take a flat-footed half spin to the north. Ahead is another installation, the story of Ben Rogers, the "city speeder" who, in 1907, raced his new Pierce-Arrow motorcar north on Burrard in excess of ten miles per hour, no doubt leaning on the horn. *Awooga!* He was pulled over by a constable on horseback and given a ticket.

A patch of grass holds a tumble of windblown branches, all straight and clean and just the right length, looking like discarded walking sticks. A southbound electric bus, Granville to Marine, glides past with a memory-whisper of trolleys and interurban connectors.

On a vintage low-rise, ochre brick is mortared into decorative diamond shapes. The sidewalk underfoot heaves at the sides from tree roots, mostly red maple. A side street is spray-painted in daisy-toned polka dots, compelling me to play Hopscotch or Twister.

Approaching Broadway from the south, I read *Claudia's Story*, another V2K installation plaque:

I am a landed immigrant from Mexico. I moved to the False Creek area in 1995. Since then I have felt comfortable with this community. I believe that the people who come to False Creek Community Centre and live around this area are what make this community a healthy, friendly and safe place to live.

I still remember the first time I arrived at False Creek. I was walking on the Seawall, amazed by the green areas, the creek, the sunlight reflected on the buildings across the water and the mountains. When I got to Granville Island, my first impression was that time stopped here. I loved the old-fashioned factory buildings, the art studios, the public markets and the bridge, all combined to make this place a unique spot in Vancouver. I thought, I want to stay.

In Claudia's voice, I hear reverberations of previous visits and shared storytelling. Most city residents, myself included, have come here from elsewhere to find and make a home, with courage, openness, bravery, and a sense of engagement that, as TDM stated so clearly, makes this city, *our* city, much better. And as the first crows fly east, I too turn home and head toward the end of the day.

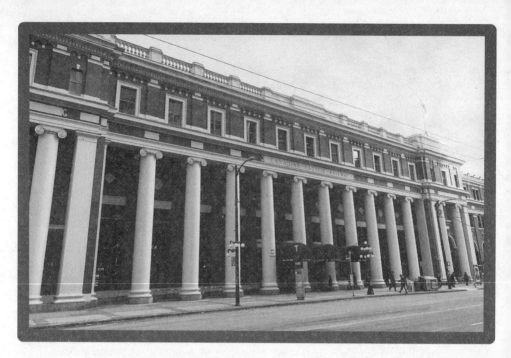

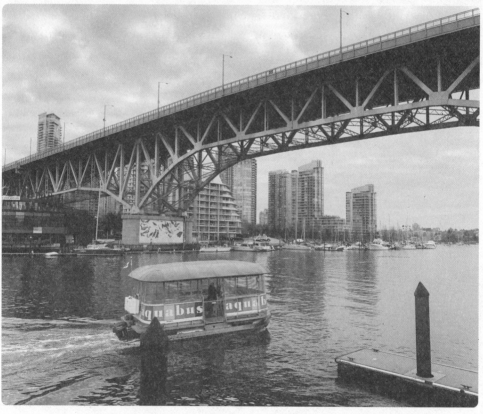

**TOP:** Waterfront Station, the third CPR terminus. **BOTTOM:** an Aquabus heading east under Granville Street Bridge. *Photos by Bill Arnott.*

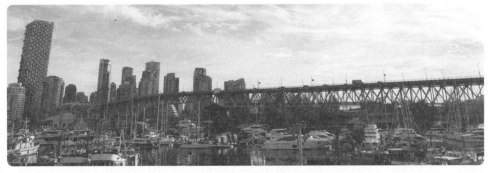

**CLOCKWISE FROM TOP LEFT:** a DTES Footprints Mosaic (this one, *Phoenix*, shares the story of the Great Fire in 1886 and Coast Salish rescuers); the Vancouver *Province* Building, at one end of Granville Street; a mural in Hogan's Alley (note Vie Moore with a platter of food in the top centre and Nora and Jimi Hendrix with railway porters in the upper right); Granville Street Bridge from a distance. *Photos by Bill Arnott.*

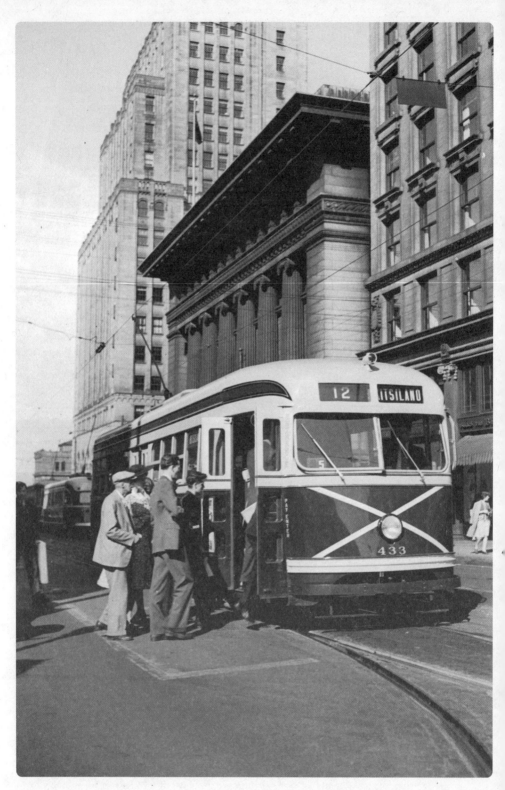

Kits streetcar, southbound on Granville, 1945. *Photo courtesy of City of Vancouver Archives.*

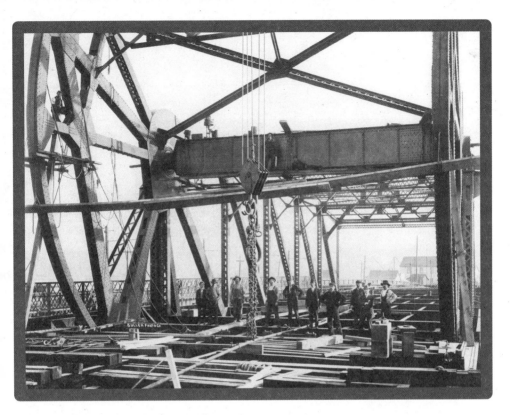

**TOP:** constructing Granville Street Bridge, 1909. **BOTTOM:** CP Waterfront Station, 1923. *Photos courtesy of City of Vancouver Archives.*

# Museum of Vancouver

*mist-shrouded showers*
*sound of soft susurration*
*silences footsteps*

IT'S A RAINY day, as though that promise of spring is on hold for the moment. It's late in the morning, still dark, and I hear the crows before I can see them. Rain swirls; my umbrella is no more than a deterrent, redistributing water and soaking me through.

I stop to dry off and drink espresso, even though I'm en route to have coffee with historian John Atkin. Having worked with the city for thirty years, John's been instrumental in a range of initiatives, from zoning to development plans as well as the preservation and maintenance of heritage buildings. For a lot of those years, John worked with Lorenz von Fersen, the two responsible for showcasing Vancouver at more than one exposition. Ingenuity, hard work, and initiative resulted in things getting done, in spite of changing councils and shrinking budgets.

We meet in Chinatown, just off Main Street, during the bustle of morning-time coffee breaks. People are waiting for take-away orders and watching videos on their phones; others are laughing and chatting. I tell John I've been reading his books to source new walks. We discuss what I've been up to, and the conversation lands on where we are now,

a Venn diagram intersection of neighbourhoods present and past, specifically Strathcona, Chinatown, Japantown, and Hogan's Alley.

John smiles and nods when I tell him of my time travel through *Circa 1948*.

"Stan Douglas did a great job with the research. In-depth and thorough. What's important to remember is that it captures a *moment* in time, like so much research. What concerns me is the Americanization, or fetishization, of the place and the time. Extrapolating experiences elsewhere and putting that stamp on Vancouver."

I scribble *fetishized* in a notebook, while John continues.

"Hogan's Alley, for example. I keep finding sources that say the city's Black residents were more or less contained in this area. Not so. You can look at business licences issued then, the early to mid-1900s, shops and restaurants owned and run by Black locals, mostly women, all over town, from here to the West End. What's more accurate is to refer to Black Strathcona, not Hogan's Alley. People pick up the Hendrix lore, fill in the gaps, and next thing you know, it's presented as history."

I admit that I liked how it fit with my narrative and tell John as much. Then I ask, "What about Nora, Jimi's grandma, working at Vie's?"

"Nah! Never happened. At least, I can't see it. Bob and Vie ran the place. You wouldn't have staff in a place that size, a small house serving meals. You cook food, you serve it."

Granted, I can't imagine a front of house, back of house restaurant hierarchy, but in every restaurant kitchen I've worked in, big or small, there's always been a dish pit and a dishwasher. You can't have a server or a cook doing dishes, and a mom-and-pop operation certainly couldn't have enough cutlery and plates to serve meals for twelve hours with no cleanup. But I let that go, remembering that experts know much more than most, but not *all* there is to know.

"Besides," John continues, "Nora gets all the attention because she was active, visible in the community. But so was Ross, her husband. Prominent positions around town, as well as Quilchena Golf Club, a CPR holding. I could see Nora being friends with Vie, but not working there. And the notion of the viaduct intentionally disbanding the neighbourhood? That doesn't make sense. It may've happened elsewhere, but

to assume it was happening here ignores the fact it was the most direct route, along BC Electric and then BC Hydro land and their work yards."

I refer to Bruce Chatwin, known for experiencing unique things in his travels, yet not averse to letting imaginative leaps cement his supposedly "personal, first-hand accounts."

John chuckles. "True. Even James Matthews, our archivist, made the occasional leap, or may have simply forgotten. He refers to a stroll through Chinatown, describing a turn in the street that simply didn't exist at that time. Again, you can find records, licences usually, zoning permissions, that date the creation of that laneway much later. It couldn't have happened the way that he said it did."

"Errors based on memory?" I ask, remembering my visit with Lorenz, discussing the sharing of oral stories, transcription, and record keeping, how holes appear, stopgaps and guesswork residing alongside best intentions.

"Yup," John replies. "And if you can't find it through records, usually a map can separate fact from fiction. In that Major Matthews's example, we know from an aerial view that Canton Alley was along there, Yip Sang developments and tenements that he built. Later, a theatre was there."

I describe installations I've let guide me through town, artwork, heritage plaques, and the v2k stories and stones.

John nods. "Yeah, that's all well sourced. Solid research. Verifiable."

This leaves me with a sense of validation, as though my work and my walks have been ratified.

Another cup of coffee, a discussion of travel, and we part ways with a handshake and smiles. I've learned a lot. Unwavering in his expertise, John knows a great deal, a researcher through and through. And while I've had questions answered, more have arisen, queries that may be impossible to answer. Leaving me in what might be another intersection of knowledge and speculation, envisioning things in a nebulous way. What's for certain, what's likely, and what might be is the most reassuring space to inhabit.

Despite the blossoms on trees, there's a chance of late-season snow. The sun is shining, but frigid air gusts from the south and the west. The crows are having a time of it, forced to flap double time or to simply lock their wings and sail with the wind at a comical speed, moving in fast-forward. Many of the birds have resorted to walking, same as me.

I'm off for more coffee with another city expert, the author, reporter, and podcaster Eve Lazarus. As well as enjoying Eve's publications, I invariably find new discoveries in her research. The spot where we meet is busy midmorning; it's a neighbourhood hangout, inviting and bright. A high ceiling with floral paintings makes me feel as though I'm on another wander through murals.

Eve arrives. It's our first meeting, a good visit. Where we are is outside of my walking terrain, offering fresh views with more insight, further connections in our comparatively compact community—to architectural professionals, for example, engineers working to keep landmark buildings true to their original design, and to underground history, intrigue, and crime, underworld stories surprisingly close to the surface. I think of that amethyst glass I walked over, the subterranean skylights in Gastown, murky windows onto an underland.

Conversation swings into writing, publications, presentations, future projects. Soundbites and blurbs. A snippet of gossip. Reflections on the past. Until it's time to get on with our days, Eve returning to her research, me to my walking. I'm left with a sense of having chatted with someone I've known for much longer than this sliver of chronological time, and I wonder in what space we might have our next interaction.

⌐⌐

I'm now a short distance from home. More blossoms on trees. No more icy air. Soon the cruise ships will arrive for their season. No longer will I have those pieces of town to myself, at least not for a while. The convention centre, both east and west, the seawalk of historical plaques, even the brickwork of Gastown—all of it will be busy from late spring through fall. Some days, an additional ten thousand walkers will make their way from the berths through the north of downtown, many

heading to Stanley Park's forest, some to the retail of Gastown, others to Yaletown restaurants, and even more toward Granville Island to pose for photos and memories.

On a quick detour through Kits, I find a corner lot that seems vacant but is in fact intentionally designed. It's the Pollinator Project, a bee initiative.[93] Bright-yellow paintings adorn an exterior wall, a mural of bees, where a plaque explains more:

> A healthy pollinator population is important for food and seed production. The Vancouver Park Board worked with UBC students through CityStudio Vancouver to create three prototypes for housing some of these tiny yet critical Vancouver residents. UBC School of Architecture and Landscape Architecture students produced these designs and are testing them here.

Blanketing the lot is a scraggle of tussock and grass with a covering of evergreen spurge, trumpet-like blossoms in clusters of green with dense, slender fronds. The shrubs look exotic, something from a children's book or the planet Pandora. And while I'd like to see more initiatives in this vein to create homes for people, I appreciate the importance of these yellow-and-black critters. In its way, it's another wave of renewal.

Recircling Granville Island, I find an installation I'd missed previously commemorating tugboats and their critical role in the area. And only now do I realize these maritime stalwarts have been chugging nearby for most of my wanderings, often from a distance, occasionally in fog. Once or twice, just the haunt of their horns leaving those of us within earshot to imagine what exactly is out there.

It's a clear day. Most of the crows have paired off, so it seems, standing on phone lines and lampposts in couples, occasionally cawing as I pass. Street banners announce the Vancouver Cherry Blossom Festival, each swath of signage the same pinky hue as the blooms. There's a sense of

anticipation, as though spring is peering from the side of a stage, await-
ing its cue for the spotlight.

A slight deviation today, across Main Street into East Van, along the
Union-Adanac cycle route, a quiet corridor of vintage homes and heri-
tage touchstones. The green dogleg of Strathcona Linear Park bisects
my path with the property of the former Railway Porters Club, all
within a short walk of the old CN station, stirring memories of Hogan's
Alley and Vie's.

I stop at an eclectic coffee shop cum thrift store—clothing, bric-a-
brac, music, and books—and strike up conversation with Maddy and
Tim, on a six-month excursion from Sydney, currently en route to
Mexico. A five-hour Vancouver layover has brought them into the city.

"Didn't want to hang around the airport," Tim explains.

"What are your plans while you're here?" I ask.

Maddy chuckles, looks at Tim as she browses through sweaters.
"First, warm clothing. Then a walk, smoke some legal weed, and eat
some Chinese food."

"Sounds like a perfect itinerary," I say with a smile.

"Yeah." The two nod in tandem.

Crossing the street to a new venue, I arrive at the coffee house at
the same moment as the person I've come here to meet, visual art-
ist, author, and activist Michael Kluckner. With respect to the city,
Michael's résumé seems to cover it all: history, heritage, preservation,
all of it ongoing. Founding president of the Heritage Vancouver Society,
former director and chair of the Heritage Canada Foundation and the
Vancouver Heritage Foundation, he's now president of the Vancouver
Historical Society, a role he's had for a number of years. Michael's a
writer and an illustrator, a talented, successful one too. Like a lot of
Vancouverites, I've owned and treasured many of Michael's books: visual
art, historical references, guidebooks, graphic novels, mixed media. This
is another person I consider to be a Vancouver cornerstone; spending
time together is a privilege.

We chat books and publishing, the industry, domestic and interna-
tional. And I ask Michael about the city, what he sees, with an eye to a
then-and-now viewpoint.

"I feel for younger generations," he says. "Gen Y or Millennials, with respect to that dream of home ownership. Getting a foothold, a toehold on that ladder." Then he adds, wryly, "If you haven't chosen your parents particularly well ..."

I nod, recalling a line from a sarcastic comic: "I don't understand all the economic worry. If something's too expensive, just dip into your inheritance."

I tell Michael about my walks, the area, other people I've visited with, things I've learned, particularly through the installations and informative plaques that Michael too has had a hand in creating. I quote a reference to stories differing from history.

Michael smiles. "I think it was Voltaire who said, 'History is a pack of lies agreed upon,' or words close to it. But I'd say it's more stories versus *artifacts*. And the importance of intangible cultural heritage."

"Well said," is all I can add, and I scribble it all in my journal.

A car alarm wails as a nondescript vehicle is dragged by a tow truck. I think of my reporter friend's frustration about parking and hope it's not *her* car that's now getting towed. Better yet, what if it were that moveable art installation, the car sculpture called *Park*? Now *that* would be avant-garde.

Michael and I walk on the street for a while. The sun is out, but it's still cold. I thank him, which somehow doesn't feel adequate. His work has improved citywide libraries, coffee tables, and bookshelves and added curated bread crumbs to my trails: history, stories, artifacts. Not to mention the preservation of buildings, touchstones of people and places and times. Each facet contributes to my amalgam of perfect days, enriching experience with a whiff of speculative dreaminess, as though another wave of spring blossoms has opened anew.

⌒

I'm making my way to the City of Vancouver Archives, a nearly subterranean building tucked into Vanier Park, sharing green space with the Museum of Vancouver. Although the air's chilly with a trace of late winter, new growth adorns trees that I pass: chestnut and maple, a scatter

of pine. The sky's mostly bright, but a raft of nimbus is heading this way, surly cloud looking to make trouble.

At the archives, a bust of James Matthews greets me at the top of some stairs leading downward, where I meet with Chak Yung, the friendly and knowledgeable archivist who helped me to source each historical photo I've selected to accompany my narrative walks. The space here is utterly tranquil, making every library I've been to seem like a rave in comparison. I peruse a few photos, shots of tankers and ships that've made the Port of Vancouver their home, and a picture of the Vancouver skyline, looking north from this location, as though one of the room's windows happens to look onto the past.

I pick up Lisa Anne Smith's book, *Hastings Mill: The Historic Times of a Vancouver Community*, and read of the Old Hastings Mill Store, which became a museum, now housed at Hastings Mill Park, where I walked to Jericho Beach, heading to Spanish Banks.[94] The store, floated to that spot via the inlet, was moved from its former location by the current city port. Considered the very start of the settler city of Vancouver, the store/museum remains Vancouver's oldest building. And I like that its lineage shares, in a manner, common traits with the home of Nana and Gramps, a storied framework transplanted from elsewhere.

From the archives, I walk a curved path to the city museum, which is today heaving with schoolkids going to the planetarium. I turn a sharp right to the relative calm of museum exhibits to add a visceral footnote to my physical footsteps. This is a place I know well, a cross-section of city anatomy. It's as though I've been cramming for a great many years, preparing for an exam version of the game Operation. I feel that sense of interconnection—not so much the plastic body parts of "butterflies in stomach" or "funny bone," but historical cartilage fused onto cultures and land.

The first exhibit I pass is a dugout canoe next to signage that reads, "Sḵwx̱wú7mesh: History at Seṉáḵw," acknowledging that where I stand is "atop the ancestral village of Seṉáḵw, which became part of the Kitsilano Indian Reserve #6 in 1896." Outside the museum, the new Seṉáḵw development continues to grow, the rebirth of a waterside village.

I carry on, to "c̓əsnaʔəm: The City Before the City," describing the Musqueam village and Great Midden where Charles Borden broadened archaeological findings. A video plays, melding timelines and introducing newcomers to this area, while a sign reads, "c̓əsnaʔəm: The City Before the City aims at 'righting history' by creating a space for Musqueam to share their knowledge, culture, and history and by highlighting the community's role in shaping the city of Vancouver."[95]

Without having to dig, I examine collections of ancient tools, fish lures, and jewellery, then a wall display of the hən̓q̓əmin̓əm̓ alphabet, a kind of Indigenous-language Rosetta stone laid out like Scrabble tiles in columns and rows. Each "letter" is a concept or symbol, sometimes one or more words, not unlike hieroglyphs or the Chinese characters in the Sun Yat-Sen Garden.

Turning a corner, I pass a huge slab of timber. Behind it is a sawblade and descriptions of early settler industry with another hybrid exhibit, this one a creative blur I could interpret as canoe paddles being hoisted, their blades thrust in the air, and yet each has the look of a feather, an adornment for a dance akin to that alleged welcome, perhaps, for Vancouver.

Beyond this, another video plays, with bench seating and a faux firepit, a space to share stories. I'm transported back to the studio event, the welcoming face at the door in the cold, the food and drink and coming together of strangers to share tales and make new history. It reminds me of Michael's reference to "intangible cultural heritage"— storytelling and artifacts, and walking as well, floating in tandem like crows on a breeze. And with warm recollections, I return over sidewalk and grass, by the water with the eagle's nest tree, and choose a new path toward home.

**TOP:** the Museum of Vancouver and H.R. MacMillan Space Centre.
**BOTTOM:** outside the Vancouver Maritime Museum. *Photos by Bill Arnott.*

**TOP:** a bald eagle's nest in Vanier Park. **BOTTOM:** suggestions and directions. *Photos by Bill Arnott.*

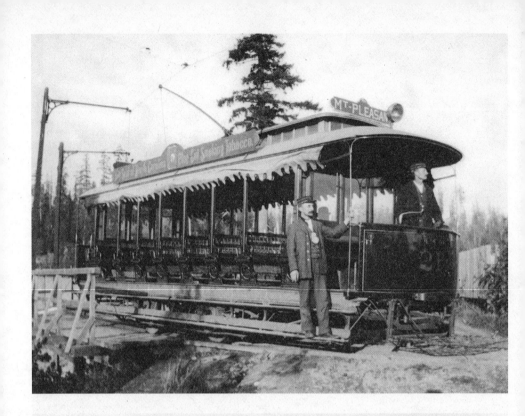

TOP: an electric railcar outside Stanley Park, 1899. BOTTOM: looking west along Hastings Street, before the Marine Building, 1913. *Photos courtesy of City of Vancouver Archives.*

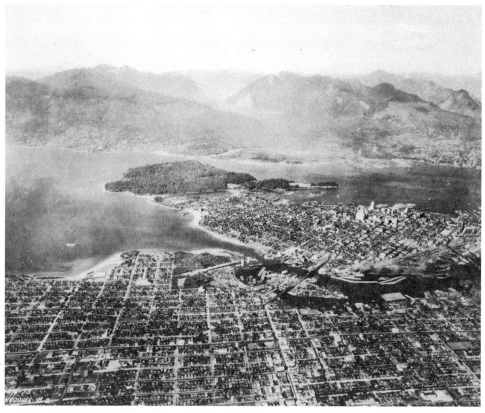

**TOP:** the Port of Vancouver, looking east from Coal Harbour, 1931. **BOTTOM:** the City of Vancouver, looking north, 1932. *Photos courtesy of City of Vancouver Archives.*

# CONCLUSION

BACK TO THE bedside book stack creeping its way toward the ceiling, reminiscent of new builds and reinforced crow's nests nearby. I peruse a Nick Hunt book I love, *Walking the Woods and the Water*, in which the author retraces Patrick Leigh Fermor's epic stroll across Europe, from the Netherlands to Turkey. Hunt describes his sojourn in terms of his pace, gait formulating experience and, with it, the slow revelation of destinations: "At walking speed, arrival is a process that happens only gradually, and bits of me staggered in at different times."[96]

That quote rang in my mind every time I ventured out on this regional quest. I admit that, apart from a desire to explore and get better acquainted with the city, my trek lacked a definitive goal. That open-endedness is something I tend to insist on, as I've read too many accounts of people "needing" to go on a trip to search, pursue, or heal—justification for simply doing what appeals. But many of us do need a reason to venture into the world, an excuse to wander, discover, and play.

It's my hope that *A Perfect Day for a Walk* might alleviate that, providing encouragement or even a slice of permission. Not that any of us needs permission to go and explore, or to suss out a story. Every time I head out, so it seems, a story evolves. Not necessarily a traditional tale, with protagonist, antagonist, and story arc, but invariably it's a comprehensive adventure, revealing itself like a fiddlehead frond, one I enjoy not only undertaking but also sharing, confident that the sentiments relayed are what each of us, what all of us, experience and feel. Even on familiar roadways.

In *Walking the Woods and the Water*, Hunt reshapes the words of the Greek philosopher Heraclitus, who said something along the lines of "No one ever steps on the same road twice,"[97] a quote most of us can relate to. We traverse similar places, similar days, and yet every experience, each discovery, is new.

And because certain things are better in threes, I share one more modified quote, from Robert Macfarlane, a reference to the inherent nature of storytelling that accompanies walking, cinching together my city stroll threads, each encounter with people I meet, visit with, laugh with, and learn from. A walk not only binds stories but *makes* them, tracing trails left by others that overlap with our own, forming tales in the hourglass shape of a sole. "Following footsteps, we are reading the earliest stories, told not in print but in footprint."[98] Modern stories as well, with a glance to the past. And those still waiting to be written.

# ACKNOWLEDGMENTS

WRITING A BOOK requires one person. Publishing a book takes a team. And producing a book that not only looks good but is enjoyable to read requires a great deal of effort from an exceptional group of professionals. I'm immensely grateful to be working with one of those exemplary teams at Arsenal Pulp Press. Brian Lam, Catharine Chen, JC Cham, Robert Ballantyne, Cynara Geissler, and Erin Chan, thank you for making me feel welcome and for creating the book I envisioned. With special thanks to Jazmin Welch, whose design expertise and good-humoured kindness have made this book visually beautiful and a genuine pleasure to take part in creating.

People I've visited with and learned from throughout my neighbourhood wanderings have also contributed immensely to making this book memorable. My sincere thanks go to Terry David Mulligan, Evelyn Lau, Lorenz von Fersen, Gilles Cyrenne, John Atkin, and Michael Kluckner. In addition, I'm thankful for my encounters with Gerry, Fiona, Toni, Mitch and Heidi, Byron, Beth and Atish, Max, Miguel, Eve, and Maddy and Tim. With extra gratitude to Chak Yung at the City of Vancouver Archives, who helped to make sourcing historical photos not only feasible but fun.

Heartfelt thanks also go to my supportive friends who were among this book's first readers, bestselling authors Grant Lawrence, Nick Marino, and Michael Kluckner. Thank you for your time, encouragement, and enthusiasm.

And thanks, with love, to my wife, Deb, who not only makes everything worthwhile but makes the space I return to pretty much perfect.

# ENDNOTES

1 William Fiennes, *The Snow Geese* (New York: Random House, 2002).

2 "Symbols of the City of Vancouver," City of Vancouver, accessed April 11, 2024, https://vancouver.ca/news-calendar/city-symbols.aspx.

3 "Seńákw," Skwxwú7mesh Úxwumixw Squamish Nation, accessed April 11, 2024, https://www.squamish.net/partnerships-entities/partnerships/senakw/.

4 Tom Zoellner, *Rim to River: Looking into the Heart of Arizona* (Tucson: University of Arizona Press, 2023).

5 See "Centennial Totem Pole Conservation Project," Parks, Recreation, and Culture, City of Vancouver, accessed April 11, 2024, https://vancouver.ca/parks -recreation-culture/hadden-park-centennial-totem-pole-conservation-project.aspx.

6 See "Gate to the Northwest Passage," Public Art Registry, City of Vancouver, accessed April 11, 2024, https://covapp.vancouver.ca/PublicArtRegistry/Artwork Detail.aspx?ArtworkId=110.

7 Larry Wong, "The Life and Times of Foon Sien," *British Columbia History* 38, no. 3 (2005): 6–8.

8 See "Early Chinese Canadian Experiences in British Columbia," Learning Portal, Royal BC Museum, accessed April 11, 2024, https://learning.royalbcmuseum.bc.ca /pathways/chinese-canadian-experiences/.

9 "Major Matthews' House," Places That Matter, Vancouver Heritage Foundation, accessed April 11, 2024, https://placesthatmatter.ca/location/major-matthews -house/.

10 See Gordon Price, "A Bump in the Road: Kits Point's Hidden Streetcar Line," Viewpoint Vancouver, April 6, 2021, https://viewpointvancouver.ca/2021/04/06 /a-bump-in-the-road-kits-points-hidden-streetcar-line/.

11 John Mackie, "This Week in History, 1890: Vancouver Gets Cutting Edge with an Electric Streetcar and Light System," *Vancouver Sun*, June 30, 2023, https:// vancouversun.com/news/this-week-in-history-1890-vancouver-gets-cutting -edge-with-an-electric-streetcar-and-light-system.

12 See "First Sikh Temple," Places That Matter, Vancouver Heritage Foundation, accessed April 11, 2024, https://placesthatmatter.ca/location/first-sikh-temple/.

13 See Hugh Johnston, "Komagata Maru," The Canadian Encyclopedia, last modified October 12, 2021, https://www.thecanadianencyclopedia.ca/en/article/komagata -maru.

14 See "Seaforth Peace Park," Places That Matter, Vancouver Heritage Foundation, accessed April 11, 2024, https://placesthatmatter.ca/location/seaforth-peace-park/.

15 See "Banto Betty Gill," Obituaries, *Vancouver Sun*, November 26, 2016, https://vancouversunandprovince.remembering.ca/obituary/banto-gill-1065957935.

16 See "Jab Sidhoo: A Legacy That Is Shining a Light on India's Wartime Contributions", give UBC, University of British Columbia, accessed April 11, 2024, https://give.ubc.ca/donor-spotlights/jab-sidhoo/.

17 Grant Lawrence, "Positively 4th Avenue: The Rise and Fall of Canada's Hippie Mecca," October 22, 2016, https://grantlawrence.ca/2016/10/positively-4th-avenue-the-rise-and-fall-of-canadas-hippie-mecca.

18 Grant Lawrence, "Positively 4th Avenue: The Rise and Fall of Canada's Hippie Mecca."

19 "Tommy Chong Remembers Vancouver Drug Squad Officer Abe Snidanko, the 'Narc' of the 'Narcs'," *As It Happens*, CBC Radio, August 10, 2017, https://www.cbc.ca/radio/asithappens/as-it-happens-thursday-edition-1.4241899/tommy-chong-remembers-vancouver-drug-squad-officer-abe-snidanko-the-narc-of-the-narcs-1.4241904.

20 "Granville Island," Places That Matter, Vancouver Heritage Foundation, accessed April 9, 2024, https://placesthatmatter.ca/location/granville-island-public-market/.

21 Granville Island, CMHC-Granville Island, accessed April 9, 2024, https://granvilleisland.com/.

22 "Granville Island," Places That Matter.

23 See "Choklit Park," Places That Matter, Vancouver Heritage Foundation, accessed April 9, 2024, https://placesthatmatter.ca/location/choklit-park/.

24 See "Original Jewish Community Centre," Places That Matter, Vancouver Heritage Foundation, accessed April 9, 2024, https://placesthatmatter.ca/location/original-jewish-community-centre/.

25 See "King Edward School Wall," Places That Matter, Vancouver Heritage Foundation, accessed April 9, 2024, https://placesthatmatter.ca/location/king-edward-school-wall/.

26 See "Laurel St. Landbridge," Places That Matter, Vancouver Heritage Foundation, accessed April 9, 2024, https://placesthatmatter.ca/location/laurel-st-landbridge/.

27 See "Protecting Vancouver's Views," Home, Property, and Development, City of Vancouver, accessed April 11, 2024, https://vancouver.ca/home-property-development/protecting-vancouvers-views.aspx.

28 "Habitat Island," ParkFinder, Vancouver.ca, accessed April 9, 2024, https://covapp.vancouver.ca/parkfinder/parkdetail.aspx?inparkid=241.

29 Squamish Atlas, Snichim Foundation, accessed April 10, 2024, https://squamishatlas.com/.

30 See "Union Zindabad!" BC Labour Heritage Centre, accessed April 11, 2024, https://pressbooks.pub/unionzindabad/chapter/husain-rahim/.

31 "Expo Legacy – Science World," Places That Matter, Vancouver Heritage Foundation, accessed April 10, 2024, https://placesthatmatter.ca/location/expo-legacy-science-world/.

32  "Expo Legacy – Science World," Places That Matter.

33  "Expo Legacy – Science World," Places That Matter.

34  See "East Park," Shape Your City, City of Vancouver, last modified April 17, 2024, https://www.shapeyourcity.ca/east-park.

35  "BC Place Stadium," Places That Matter, Vancouver Heritage Foundation, accessed April 11, 2024, https://placesthatmatter.ca/location/bc-place-stadium/.

36  See "Giants," Vancouver Biennale, accessed April 11, 2024, https://www.vancouverbiennale.com/artworks/giants/.

37  OSGEMEOS Official Channel, "OSGEMEOS – Vancouver Biennale," September 2, 2014, YouTube video, 1:51, https://www.youtube.com/watch?v=yLUmxodDZAW.

38  "Yaletown Viewpoint of Giants," Vancouver Biennale, accessed May 1, 2024, https://www.vancouverbiennale.com/artworks/yaletown-viewpoint-of-giants/.

39  A False Creek, City of Vancouver, accessed April 11, 2024, https://afalsecreek.ca/.

40  "Welcome to the Land of Light," Public Art Registry, City of Vancouver, accessed April 11, 2024, https://covapp.vancouver.ca/PublicArtRegistry/ArtworkDetail.aspx?ArtworkId=213.

41  John Punter, *The Vancouver Achievement: Urban Planning and Design* (Vancouver: UBC Press, 2003).

42  Bethany Lindsay and Andrew Weichel, *Everything British Columbia: The Ultimate Book of Lists* (Cloverville: MacIntyre Purcell Publishing, 2019).

43  See "Echoes," Vancouver Biennale, accessed April 11, 2024, https://www.vancouverbiennale.com/artworks/echoes/.

44  See "217.5 Arc x 13," Vancouver Biennale, accessed April 11, 2024, https://www.vancouverbiennale.com/artworks/217-5-arc-x-13/.

45  See "Engagement," Vancouver Biennale, accessed April 11, 2024, https://www.vancouverbiennale.com/artworks/engagement/.

46  See "Inukshuk," Public Art Registry, City of Vancouver, accessed April 11, 2024, https://covapp.vancouver.ca/PublicArtRegistry/ArtworkDetail.aspx?ArtworkId=172.

47  "A-maze-ing Laughter," Vancouver Biennale, accessed April 11, 2024, https://www.vancouverbiennale.com/artworks/a-maze-ing-laughter/.

48  See "Barclay Manor," West End Seniors' Network, accessed April 11, 2024, https://wesn.ca/barclay-manor/.

49  See "Mission and History," Roedde House Museum, accessed April 11, 2024, https://www.roeddehouse.org/mission-and-history/.

50  Ratcliffe, Della, "Just for Today ... Hold Space as an Isumataq," *Inner Journey Events Blog*, March 26, 2015, https://innerjourneyevents.wordpress.com/2015/03/26/just-for-today-hold-space-as-an-isumataq/.

51  Diana E. Leung, "Recovering Evicted Memories: An Exploration of Heritage Policies, Intangible Heritage, and Storytelling in Vancouver, BC" (master's thesis, UBC, 2008), https://open.library.ubc.ca/soa/cIRcle/collections/ubctheses/24 /items/1.0066356.

52  Barbara Constantine, *A Hurricane in the Basement and Other Vancouver Experiences: Stories and Photos from the Millennium Collection* (Vancouver: City of Vancouver, Office of Cultural Affairs, 2000).

53  Constantine, *A Hurricane in the Basement and Other Vancouver Experiences.*

54  See "West End Laneways to Be Named After Prominent Locals," CBC News, last modified October 25, 2019, https://www.cbc.ca/news/canada/british-columbia /west-end-laneways-to-be-named-after-prominent-locals-1.4425573.

55  See "West End Lane-Way Feature: Vivian Jung," The West End, July 22, 2020, https://westendbia.com/vivian-jung/.

56  "Davie Street Village," Places That Matter, Vancouver Heritage Foundation, accessed April 11, 2024, https://placesthatmatter.ca/location/davie-street-village/.

57  "Celebrities," Places That Matter, Vancouver Heritage Foundation, accessed April 11, 2024, https://placesthatmatter.ca/location/celebrities/.

58  "Robson Square," Places That Matter, Vancouver Heritage Foundation, accessed April 12, 2024, https://placesthatmatter.ca/location/robson-square/.

59  See Kenneth Chan, "Canopy of 3,000 Colourful Twinkling LED Lights Now Illuminate Robson Square," Daily Hive, November 28, 2023, https://dailyhive.com /vancouver/canopy-catenary-lights-robson-square-vancouver.

60  Just Jash (@justjash), "Situated on Robson Square Plaza (800 Robson) in front of the Art Gallery, 'Canopy' aims to bring light and inspiration to the darker days of the year," Instagram, January 25, 2024, https://www.instagram.com/reel /c2iVnEBSK6x/.

61  See "Circa 1948," National Film Board of Canada, accessed April 12, 2024, https:// www.nfb.ca/interactive/circa_1948/.

62  Circa 1948, version 1.0.4 (Stan Douglas, NFB Digital Studio, 2014), https://apps .apple.com/ca/app/circa-1948/id836688265.

63  "The Drop," Public Art Registry, City of Vancouver, accessed April 12, 2024, https:// covapp.vancouver.ca/PublicArtRegistry/ArtworkDetail.aspx?ArtworkId=438.

64  See "Heritage Horns," Canada Place, Vancouver Fraser Port Authority, accessed April 12, 2024, https://www.canadaplace.ca/experience/heritage-horns/.

65  Gastown, Gastown Business Improvement Society, accessed April 12, 2024, https://gastown.org/.

66  See "Angel of Victory," Public Art Registry, City of Vancouver, accessed April 12, 2024, https://covapp.vancouver.ca/PublicArtRegistry/ArtworkDetailaspx?Artwork Id=24.

67 "First City Hospital," Places That Matter, Vancouver Heritage Foundation, accessed April 12, 2024, https://placesthatmatter.ca/location/first-city-hospital/.

68 Donna and Aurlie Young, "Vancouver BC Canada – Sidewalk Moaics," Mosaic Art Source, December 15, 2006, https://mosaicartsource.wordpress.com/2006/12/15/vancouver-sidewalk-mosaics/.

69 See "Chinatown Memorial Monument," Public Art Registry, City of Vancouver, accessed April 12, 2024, https://covapp.vancouver.ca/PublicArtRegistry/Artwork Detail.aspx?ArtworkId=548.

70 "Let's Heal the Divide," Vancouver Biennale, accessed April 12, 2024, https://www.vancouverbiennale.com/artworks/lets-heal-the-divide-2/.

71 See "Dr. Sun Yat-Sen Classical Chinese Garden," Places That Matter, Vancouver Heritage Foundation, accessed April 12, 2024, https://placesthatmatter.ca/location/dr-sun-yat-sen-classical-chinese-garden/.

72 "Carnegie Community Centre," Parks, Recreation, and Culture, City of Vancouver, accessed April 12, 2024, https://vancouver.ca/parks-recreation-culture/carnegie-community-centre.aspx.

73 See "Crab Park – The Great Fire," Places That Matter, Vancouver Heritage Foundation, accessed April 12, 2024, https://placesthatmatter.ca/location/crab-park-the-great-fire/.

74 See "Crab Park – The Great Fire," Places That Matter.

75 urbanizta, "History of Crab Park and Crab-Water for Life Society, by Don Larson, June 2018," City Hall Watch, June 28, 2018, https://cityhallwatch.wordpress.com/2018/06/28/history-crab-park-and-society-don-larson/.

76 "Park," Public Art Registry, City of Vancouver, accessed April 12, 2024, https://covapp.vancouver.ca/PublicArtRegistry/ArtworkDetail.aspx?ArtworkId=431.

77 "Siwash Rock in Stanley Park," StanleyParkVan.com, accessed April 26, 2024, https://stanleyparkvan.com/stanley-park-van-attraction-siwash-rock.html.

78 See David Crerar, Harry Crerar, and Bill Maurer, *The Glorious Mountains of Vancouver's North Shore: A Peakbagger's Guide* (Surrey: Rocky Mountain Books, 2018); Chuck Davis, *The Greater Vancouver Book: An Urban Encyclopaedia* (Surrey: Linkman Press, 1997); Aaron Nelson-Moody, Glenn George, and Tewanee Joseph, *People of the Land: Legends of the Four Host First Nations* (Penticton: Theytus Books, 2009); G.P.V. and Helen Akrigg, *British Columbia Place Names* (Vancouver: UBC Press, 1997).

79 Roy L. Carlson, "Charles E. Borden," Canadian Archaeological Association, accessed April 13, 2024, https://canadianarchaeology.com/caa/about/awards/recipients/smith-wintemberg-award/charles-e-borden.

80 Robert Macfarlane, *The Old Ways: A Journey on Foot* (New York: Penguin Books, 2013).

81 Macfarlane, *The Old Ways.*

82 "Public Furniture | Urban Trees – Vancouver," Vancouver Biennale, accessed April 13, 2024, https://www.vancouverbiennale.com/artworks/public-furniture-urban-trees/.

83 "East Van Pigeon," Vancouver Mural Festival, version 1.0.33 (Create Vancouver Society, 2020), https://apps.apple.com/us/app/vancouver-mural-festival/id1521928486.

84 "The Healing Quilt," Vancouver Mural Festival, version 1.0.33 (Create Vancouver Society, 2020), https://apps.apple.com/us/app/vancouver-mural-festival/id1521928486.

85 See "Travellers in the Space Canoe," Indigenous Public Art, Indigenous Public Art Repository, accessed April 13, 2024, https://indigenouspublicart.com/public-art/travellers-in-the-space-canoe/.

86 See "Gertrude Guerin," The Canadian Encyclopedia, last modified January 22, 2020, https://development.thecanadianencyclopedia.ca/en/article/gertrude-guerin.

87 "The Present Is a Gift," Vancouver Mural Festival, version 1.0.33 (Create Vancouver Society, 2020), https://apps.apple.com/us/app/vancouver-mural-festival/id1521928486.

88 "The Western Front," Places That Matter, Vancouver Heritage Foundation, accessed April 13, 2024, https://placesthatmatter.ca/location/western-front-society/.

89 "Vancouver Neon Signs Take Us Back to the 1950s (PHOTOS)," HuffPost, May 15, 2014, https://www.huffpost.com/archive/ca/entry/vancouver-neon-signs-take-us-back-to-the-1950s-photos_n_5318385.

90 See "Spinning Chandelier," Public Art Registry, City of Vancouver, accessed April 13, 2024, https://covapp.vancouver.ca/PublicArtRegistry/ArtworkDetail.aspx?ArtworkId=823.

91 "Granville St. Bridge," Places That Matter, Vancouver Heritage Foundation, accessed April 13, 2024, https://placesthatmatter.ca/location/granville-st-bridge/.

92 See Allie Turner, "Here's the Story Behind the Neon Sign in the Window of Indigo on Granville St," Vancouver Is Awesome, November 16, 2022, https://www.vancouverisawesome.com/history/aristocratic-neon-sign-indigo-granville-vancouver-6113151.

93 See "Pollinator," HiLo Lab, UBC School of Architecture and Landscape Architecture, accessed April 13, 2024, https://blogs.ubc.ca/hilolab/pollinator/.

94 Lisa Anne Smith, *Hastings Mill: The Historic Times of a Vancouver Community* (Vancouver: Ronsdale Press, 2022).

95 See "ćəsnaʔəm: The City Before the City," Museum of Vancouver, accessed April 13, 2024, https://museumofvancouver.ca/csnam-the-city-before-the-city.

96 Nick Hunt, *Walking the Woods and the Water: In Patrick Leigh Fermor's Footsteps from the Hook of Holland to the Golden Horn* (London: Quercus Publishing, 2017).

97 Hunt, *Walking the Woods and the Water*.

98 Macfarlane, *The Old Ways*.

# BIBLIOGRAPHY

Anderson, Lindsay, et al. *Vancouver Like a Local: By the People Who Call It Home.* Toronto: DK Eyewitness Travel, 2023.

Constantine, Barbara. *A Hurricane in the Basement and Other Vancouver Experiences: Stories and Photos from the Millennium Collection.* Vancouver: City of Vancouver, Office of Cultural Affairs, 2000.

Douglas, Stan. NFB Digital Studio. *Circa 1948.* Version 1.0.4. National Film Board of Canada, 2014. https://apps.apple.com/ca/app/circa-1948/id836688265.

Kluckner, Michael, and John Atkin. *Heritage Walks Around Vancouver.* Vancouver: Whitecap Books, 1992.

Kluckner, Michael, and John Atkin. *Vancouver Walks: Discovering City Heritage.* Vancouver: Steller Press, 2003.

Lazarus, Eve. *Vancouver Exposed: Searching for the City's Hidden History.* Vancouver: Arsenal Pulp Press, 2020.

Lindsay, Bethany, and Andrew Weichel. *Everything British Columbia: The Ultimate Book of Lists.* Cloverville: MacIntyre Purcell Publishing, 2019.

Smith, Lisa Anne. *Hastings Mill: The Historic Times of a Vancouver Community.* Vancouver: Ronsdale Press, 2022.

Sníchim Foundation. Squamish Atlas. Accessed April 10, 2024. https://squamishatlas .com/.

Thirkell, Fred, and Bob Scullion. *British Columbia 100 Years Ago: Portraits of a Province.* Victoria: Heritage House Publishing, 2002.

Vancouver Heritage Foundation. "Vancouver Heritage Foundation Weekly: Markers in Time." Vancouver Is Awesome. September 27, 2013. https://www.vancouver isawesome.com/real-estate-news/vancouver-heritage-foundation-weekly-markers -in-time-1927535.

Westerkamp, Hildegard. "Soundwalking." Hildegard Westerkamp: Inside the Soundscape. January 1, 2001. https://www.hildegardwesterkamp.ca/writings/writingsby/?post _id=13&title=soundwalking.

## WEB SOURCES

Changing Vancouver: Then and Now Images, https://changingvancouver.wordpress.com/.

City of Vancouver Archives, https://searcharchives.vancouver.ca/.

Hogan's Alley Memorial Project, https://hogansalleyproject.blogspot.com/.

Places That Matter, Vancouver Heritage Foundation, https://placesthatmatter.ca/.

"Streets and Transportation," City of Vancouver, https://vancouver.ca/streets-transportation.aspx.

Vancouver Biennale, https://www.vancouverbiennale.com/.

# INDEX

*Page numbers in italics refer to maps and photographs.*

**BILL ARNOTT** is the bestselling author of *A Perfect Day for a Walk: The History, Cultures, and Communities of Vancouver, on Foot*; *A Season on Vancouver Island*; and the award-winning Gone Viking travelogues. Recipient of a fellowship at London's Royal Geographical Society for his expeditions, Bill's a frequent presenter and contributor to magazines, universities, podcasts, TV, and radio. When not trekking with a small pack and journal or showing off his cooking skills as a culinary school dropout, Bill can be found on Canada's West Coast, where he lives near the sea on Musqueam, Squamish, and Tsleil-Waututh land.